Ft Trumbull Ft Griswold

Lyndes Pt Griswolds Pt

field Pt

Black Pt

Light Ho

Bartlets Reef

N.Y. to Stonington

Ferry from Greenport to Allens Pt 30 miles R. Thames

130 m.

The Race

Lit. Gull I.

Plum Gut

Plum Fishers I.

Orient House

Oyster Pond Pt to Stonington 30 m.

G. Gull I.

Isle

Bens Pt

Greenport Oyster Pond Pt.

Long Beach

Gardiners Pt.

G A R D I N E R S

Ram head

Gardiners

B A Y

3000 Acres

Cedar Pt. Eastern Plain Pt.

Hog Cr. Pt. Island

West hav Plum

The Spring Ram I. Culloden Pt.

Neapeague Har. False Pt.

ville Bay Port P. Grea MONTAUK
PT.

Hampton H A M P T O N N

Amagan Napeague Beach

A N

Hamptons Bohemia

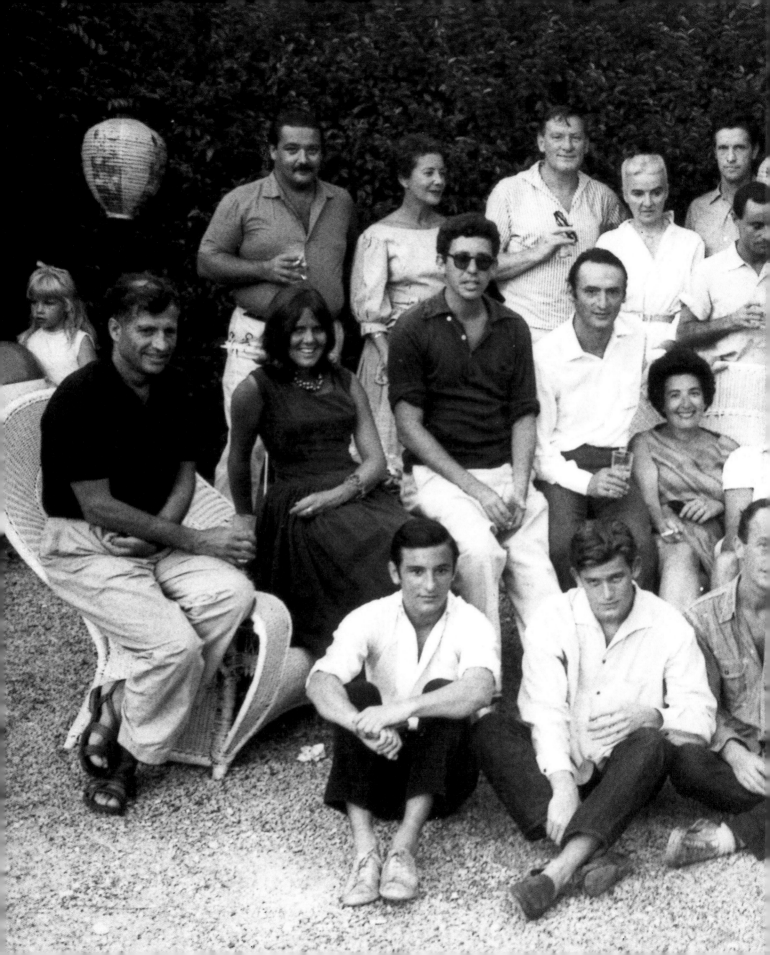

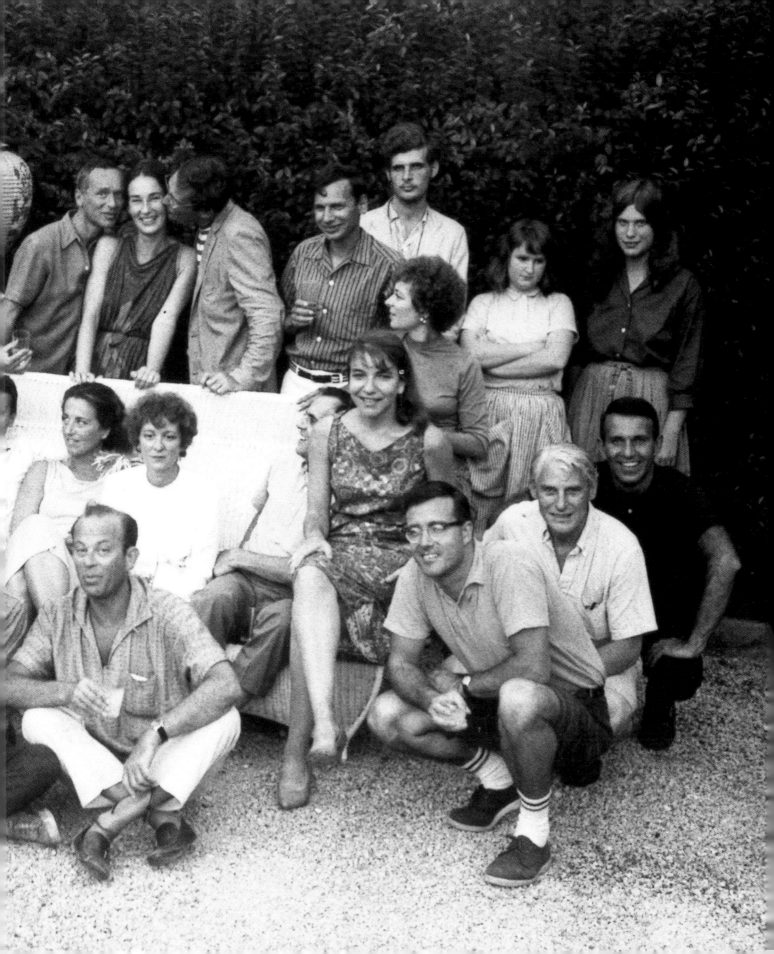

HAMPTONS
DRIVE-IN

8 ACADEMY AWARDS
CABARET R
BEST ACTRESS LIZA MINNELLI
WITH
ADY SINGS THE BLUES

Hamptons Bohemia

TWO CENTURIES OF ARTISTS AND WRITERS ON THE BEACH

by Helen A. Harrison &
Constance Ayers Denne
FOREWORD BY EDWARD ALBEE

CHRONICLE BOOKS
SAN FRANCISCO

PAGES **2–3**: Birthday party at the home of John Gruen and Jane Wilson. Back row, left to right: Lisa de Kooning, Frank Perry, Eleanor Perry, John Myers, Anne Porter, Fairfield Porter, Angelo Torricini, Arthur Gold, Jane Wilson, Kenward Elmslie, Paul Brach, Jerry Porter (behind Brach), Nancy Ward, Katharine Porter, friend of Jerry Porter. Second row, left to right: Joe Hazan, Clarice Rivers, Kenneth Koch, Larry Rivers. Seated on couch: Miriam Shapiro, Robert Fizdale, Jane Freilicher, Joan Ward, John Kacere, Sylvia Maizell. Kneeling on the right, back to front: Alvin Novak, Willem de Kooning, Jim Tommaney. Front row: Stephen Rivers, William Berkson, Frank O'Hara, Herbert Machiz, Water Mill, N.Y. 1961. Photograph by John Jonas Gruen.

PAGES **4–5**: Howard Kanovitz, HAMPTONS DRIVE-IN, 1974. Detail; see page 115.

Library of Congress Cataloging-in-Publication Data available.

ISBN 0-8118-3376-3

Printed in the United Kingdom.

Produced by Sideshow Media
EDITORIAL DIRECTOR: Dan Tucker
PROJECT EDITOR: David Brown
DESIGNER: Patricia Fabricant
PHOTO RESEARCHERS: Sarah Longacre, Lily Kane

Distributed in Canada by Raincoast Books
9050 Shaughnessy Street
Vancouver, British Columbia V6P 6E5

10 9 8 7 6 5 4 3 2 1

Chronicle Books LLC
85 Second Street
San Francisco, California 94105

www.chroniclebooks.com

To
Ronald G. Pisano
(1948–2000)
Scholar, connoisseur, friend

Frank Dayton
(1903–1992)
Neighbor, friend

Acknowledgments

Writing a book on such a large topic, spread out as it is over several centuries, required help from many generous sources. We are deeply grateful to Joseph H. Mintzer, founder and copublisher of *Hampton Shorts*, who hatched the idea of a joint literary and artistic history of the Hamptons and contributed his energy, enthusiasm, and expertise to every stage of the project. The Sideshow Media team, headed by Daniel Tucker, gave the concept both form and substance. Sarah Longacre and Lily Kane found images that bring the story to life, and Patricia Fabricant created an elegant design that complements the content. David Brown skillfully edited our texts into a coherent narrative that was immeasurably enriched by the comments and suggestions of Helen S. Rattray, former editor and now president of the *East Hampton Star*.

For their help with our research, we thank Diana Dayton and Dorothy T. King of the East Hampton Library; Kevin Verbesey and Susan Habib of the John Jermain Memorial Library; David Cory and Lois Underhill of the Sag Harbor Whaling and Historical Museum; David E. Rattray and Alice Ragusa of the *East Hampton Star*; Mike Solomon of the Ossorio Foundation; Chris McNamara of the Parrish Art Museum; Simon Taylor and Elizabeth Mann of Guild Hall Museum; Ryan Schmitter of LTV; Barbara and Ursula Britton; Oliver Broudy; Nancy Crampton; C. J. Denne Jr.; Dallas Ernst; Eric Fischl; Averill Dayton Geus; Alastair Gordon; April Gornik; John Jonas Gruen; Herbert Hirsch; Leif Hope; Gordon Hyatt; Hugh King; Laurie Lambrecht; Ernestine Lassaw; Sara Matthiessen; Megan McFarland; Roy Nicholson; Val Schaffner; Grace Schulman; Joan Ullman Schwartz; Harvey Shapiro; Tom Twomey; and Jane Wilson, each of whom generously shared their knowledge, advice, resources, and time.

We would also like to thank Sarah Malarkey, Anne Bunn, Vivien Sung, Jay Schaefer, and Drew Montgomery at Chronicle Books for their support of this project.

Contents

Foreword

I AM NOT AN ENTHUSIAST of the more bizarre sciences. Phrenology, for example, as the lady in the song says, "leaves me totally cold." The reading of tea leaves may be fun after a cuppa, but it impresses me as a wise guide to the future no more than Tarot cards or messages from the Ouija board (apologies to Jimmy Merrill there). And the advice one reads in the horoscope column seems to me to be couched ambiguously enough to be on target for whatever you want it to mean.

I am, however, a Pisces—a water sign—and I am unhappy when I am land-bound. Mountains and deserts are all very well, and I have enjoyed them both, but unless they abut an ocean I become impatient. Simply, I must be either near or by (or on!) large bodies of water most of the time to be a happy man. Coastal cities find me more content than even the great ones fed only by rivers—Moscow, for example.

I was adopted into a wealthy family when I was a baby, and grew up in Larchmont, New York, in a big house on Long Island Sound, and in an oceanfront house in Palm Beach, Florida. My first ten ocean crossings were by great ships and I lament their passing.

I am a Pisces, so you will understand the following: One weekend I drove to Montauk, at the far end of Long Island, through and beyond the Hamptons, to persuade a great actress to be in a play of mine. This was forty years ago and I was young and the Hamptons had not yet become suburbs of New York City. There

were vistas of potato fields and not walls of faux-rustic houses blocking the eye. It was, indeed, still country out there: trucks outnumbered Land Rovers; local stores had not been replaced by upscale chain copies, and the "fancy people" — the newly rich, the gossip-column fodder—were probably still in Bucks County, or somewhere.

As I mentioned, this was forty years ago, and the only road to Montauk after the Napeague Strip (itself still houseless!) was a two-lane road (itself pretty houseless) along the ocean. (The big highway came later.)

The actress was pleased to be in my play and I was more than pleased by Montauk. I sought out a house agent and found a four-acre parcel on the ocean, on a hill sixty feet above the beach. On it was a small house and an even smaller one and I knew immediately that I had found The Great Good Place. I could barely afford it—it was $40,000 for the whole thing—but I could not afford not to have it. I have lived there ever since—oh, in New York City as well, with trips to Europe and wherever, but that hill in Montauk overlooking the endless Atlantic Ocean has remained the place I most long to be.

Edward Albee at work in his Montauk home. Photograph by Jill Krementz.

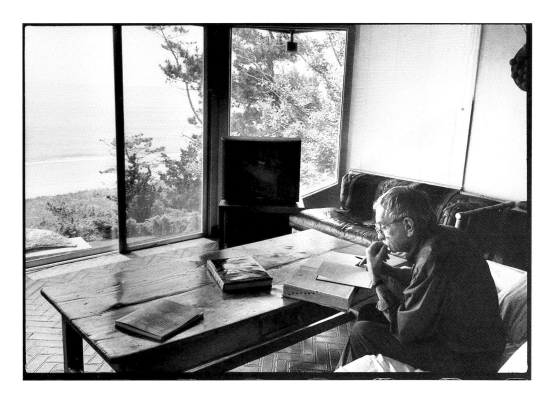

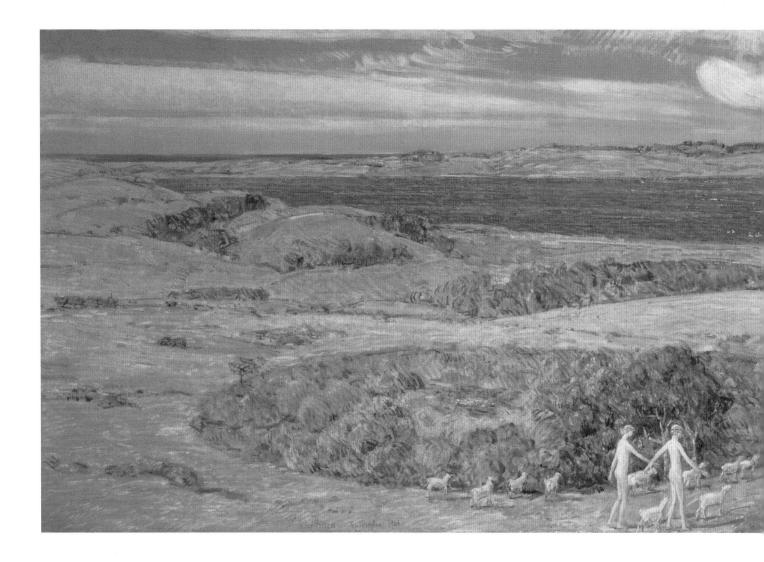

Water. Ocean. By it. On it. In it. Pisces.

This splendid book tells us much about the Hamptons—its histories, its follies, its triumphs—and makes it palpable to us why so many people in the arts have gravitated there. It is still intensely beautiful (when you can see it) and close enough to the great cultural center that is New York City (when the roads are not parking lots) to give one both isolation and access to that nourishment.

I'm convinced that it is not only Pisceans who need that contrast of land and sea, but creative people of all signs. To walk along the beach in the Hamptons or Montauk (preferably off-season) with the wind and the sand blowing, the gulls wheeling, and the surf crashing is cleansing and revivifying. I don't think that whatever creativity I possess would come into proper focus without it, and if I become churlish over the suburbanizing of the area, its preposterous excesses, its denaturalizing, it is simply because fewer and fewer of the young, still poor, not yet

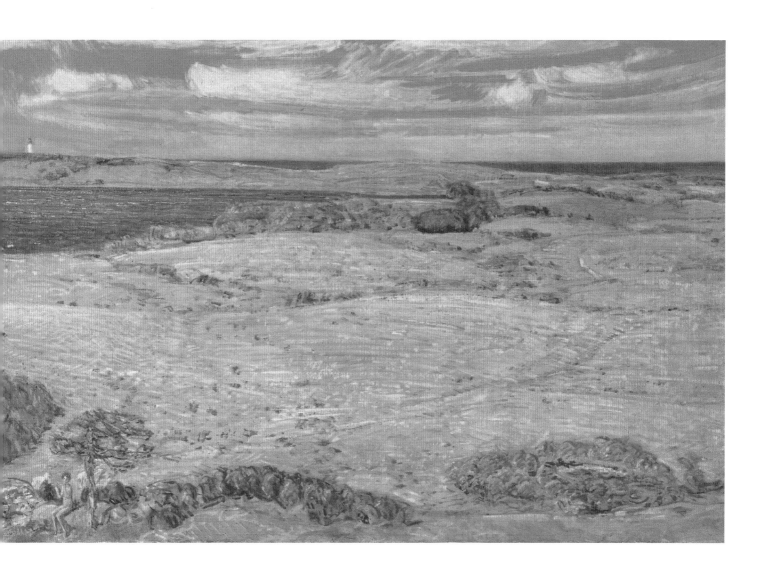

Childe Hassam, ADAM AND EVE WALKING OUT ON MONTAUK IN EARLY SPRING, 1924. Oil on wood panel, 21¹/₂ x 65¹/₂ inches.

famous creative artists on whom our culture depends are able to know its wonders.

In my forty plus years in the Hamptons I've been privileged to meet and become friends with many of the fine creative people who have relished the area as much as I. They are growing old now—those still alive—and my lament is how fewer of them are being replaced.

My Edward F. Albee Foundation maintains a residency in Montauk where, for over thirty years now, young painters, sculptors, and writers have come for the summer months to work and be nourished. Few of them have cars, but some of them bus into East Hampton to see what it all was.

Perhaps you see them from time to time.

—*Edward Albee*
New York, 2001

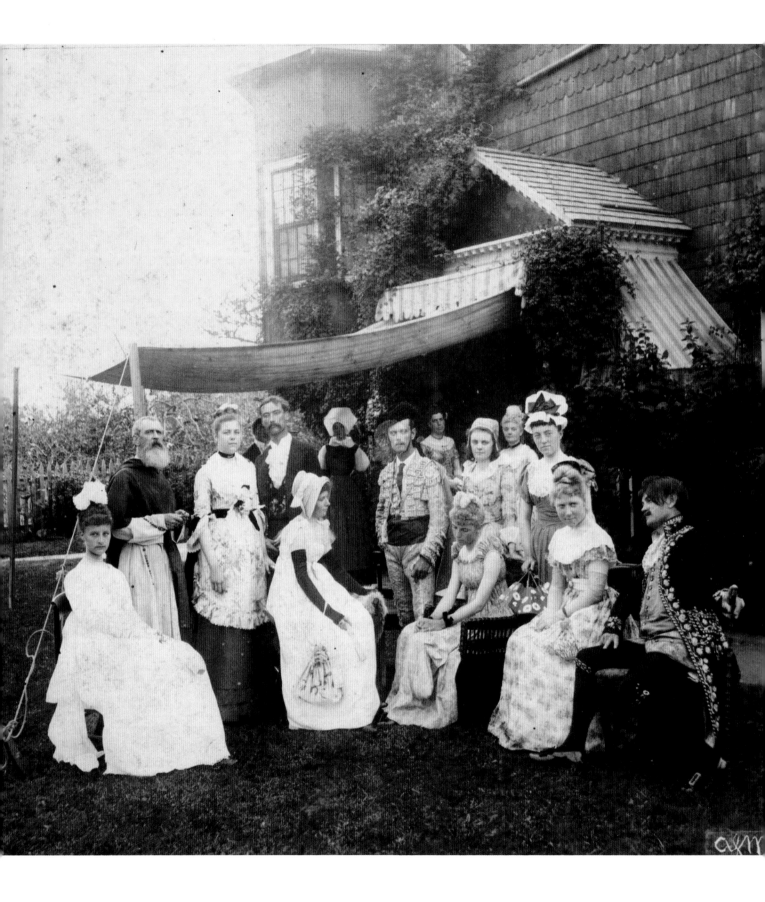

Introduction

I N THE 1959 EDITION of the *Paris Review*, essayist Patsy Southgate observed that "artists, having an affinity for one another, tend to gather in colonies where they can love and hate each other most conveniently." She might have added that the same is true for writers, as she knew from personal experience. Her droll commentary on creative eccentricity was based on first-hand knowledge of life in the bohemians' favorite gathering place—the southeastern end of Long Island, now internationally famous as The Hamptons.

Two factors have made the Hamptons the premier retreat for America's artistic and literary luminaries. Perhaps the most significant is its ideal placement vis-à-vis the nation's cultural capital, New York City—near enough to be readily accessible by road, rail, and air, farther away than a suburb; not so remote that one feels cut off, but distant enough for perspective. In short, a healthy remove. The second thing is its natural beauty—sea and bay, farm and forest, and spectacular light. Such an environment is undeniably appealing, but it is hardly unavailable elsewhere. It is the unique combination of beauty and accessibility that has lured creative people to the South Fork, the East End, the Hamptons—call it what you will—for more than two centuries. And they are not the only ones to appreciate its advantages.

Hamptons Bohemia is a survey of artistic and literary activity on the East End from its earliest recorded times to the present. And it is an examination of how living and working here has contributed to individual artists' and writers' creative development. For some, the influences have been profound, while others have responded to their surroundings intermittently, indirectly, or not at all, at least not overtly. In illustrating and discussing this range of achievement, we make no pretense at comprehensiveness. For every artist and writer mentioned, there are scores, even hundreds, unnamed. Those whom we have chosen to highlight are representative of a large and diverse creative community that extends far beyond the confines of this volume.

Members of the Moran family and friends in costume for tableaux vivants, in the garden of The Studio, East Hampton, ca. late 1890s.

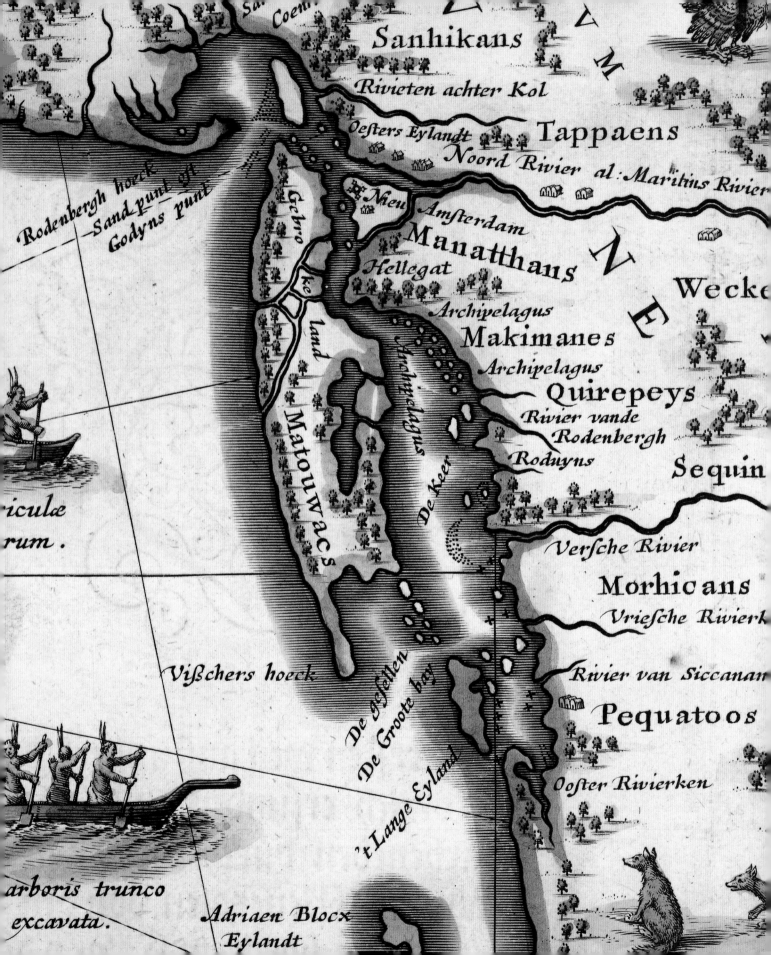

Sanhikans

Rivieten achter Kol

Oesters Eylandt Tappaens

Noord Rivier al: Maritius Rivier

Rodenbergh hoeck Sand punt oft
 Godyns punt

Nieu Amsterdam

Manatthans Wecke

Hellegat

Archipelagus

Makimanes

Archipelagus

Quirepeys

Rivier vande
Rodenbergh

Roduyns

Sequin

Versche Rivier

Morhicans

Vriesche Rivierk

riculæ
rum.

Gebro
ke
land

Matouwacs

Archipelagus

De Keer

Visschers hoeck

De Gesellen

De Groote bay

Rivier van Siccanan

Pequatoos

Ooster Rivierken

't Lange Eyland

arboris trunco
excavata.

Adriaen Blocx
Eylandt

Paumanok Rising

THE EARLY
YEARS

N EAR THE END of *The Great Gatsby*, F. Scott Fitzgerald imagined Long Island at the moment of its sighting by European adventurers, before the white man came, before the villages were founded, and long before its easternmost reaches became The Hamptons: "the old island here that flowered once for Dutch sailors' eyes—a fresh, green breast of the new world. . . . For a transitory enchanted moment man must have held his breath in the presence of this continent . . . face to face . . . with something commensurate to his capacity for wonder." Since then, the beauty and bounty of the land and the sea have drawn settlers from everywhere on earth. In particular, the East End of this "fresh, green breast of the new world" has become home to hundreds of artists and writers, people of special imagination—perhaps because, as Fitzgerald suggested, it is indeed a place that engages one's capacity for wonder.

This is the story of some of the most notable of the artists and writers who have chosen to live and work here, both those whose talent and imagination have been stimulated by the place itself—and by their assocation with each other—and those who have been attracted simply by the beauty of the landscape. Many of these artists and writers are among the most illustrious in the nation; the story of their lives and work on the East End thus constitutes an important chapter in the history of American art and literature.

The story begins, as it should, with the Indians, the East End's earliest residents. Fitzgerald's vision did not take notice of the Native Americans who had inhabited Long Island for at least twelve thousand years. Still, their literature was not entirely neglected by the early settlers. Long Island Indians spoke two of the

Gebrokeland and Matouwacs, now known as Long Island, and some of their native inhabitants are shown on a 1635 Dutch map of New Netherland and New England.

Algonquin languages, which were used throughout eastern North America. Algonquin is now almost extinct, spoken only by a few descendants of the Delaware Indians who were driven out of western Long Island in the 1640s, first to Ohio and later to Canada. The only remains of the eastern Long Island dialect are place-names and 271 words written down by Thomas Jefferson in 1791. Traveling with James Madison, Jefferson found a small band of Indians near Mastic; "[there are] but three persons of this tribe now who can speak its language," he wrote. "They are old women." Unfortunately, most of Jefferson's glossary was lost when one of his trunks was stolen.

The visual record of Indian culture on Long Island is woefully limited. Some inscribed slate and clay tablets illustrate their picture writing, and the markings and images on pottery shards hint at a decorative tradition, but that is all. The few Montauk stories that survive were recorded by the earliest white Long Islanders who were interested in words and literature. One of the first to pay attention to the Indians was the English settler Lion Gardiner, who in 1639 bought a small island off the eastern end of Long Island from the Montauk sachem Wyandanch. In 1650, Gardiner wrote to the governor of Connecticut, John Winthrop Jr., asking him to persuade a young minister whose reputation he knew to come to East Hampton. The bait to catch the preacher, Thomas James, was Gardiner's library. "Being he is but a young man," Gardiner wrote, "hapily he hath not manie books, tharfore let him know what I have. First the 3 Books of Martters, Erasmus, moste of Perkins, Wilsons Dixtionare, a large Concordiance, Mayor on the New Testament. Some of theas, with othar that I have, may be ucefull to him." James, East Hampton's first preacher, arrived the next year.

Both Gardiner and James respected the Montauks, learned their language, and became their self-appointed protectors. Gardiner's 1660 *Relation of the Pequot Wars* is one of the earliest written accounts of Indian lore. James's mastery of the language enabled him to translate into Montauk a catechism that was later printed in London. The preacher remained in East Hampton for forty-six years, becoming a landowner and whaling shipowner and amassing a sizable estate before his death. In 1696, James was succeeded by Nathaniel Huntting, who had studied theology at Harvard under Increase Mather and his son, Cotton. Huntting was the proud possessor of a rare master's degree; he enjoyed literary pursuits and wrote hundreds of scholarly (though mercifully brief) sermons.

When the town's third minister, Samuel Buell, was ordained on September 19, 1746, Jonathan Edwards, the most famous preacher in New England, delivered

Native American slate pendant or amulet with incised decoration found in Montauk, height 4 inches.

the sermon. A hunter and great raconteur, Buell spoke out on the issues of the day, including the American Revolution, during his fifty-year tenure as minister of East Hampton's Presbyterian Church. He was also devoted to finding a permanent place in the community for literature: in 1753 he founded a library and in 1785 the Clinton Academy, a coeducational school that would eventually produce East Hampton's first novelist, Cornelia Huntington.

Three years after Buell's ordination, a twenty-six-year-old Mohegan Indian came to Montauk from Connecticut. Samson Occom was a poet, writer, and preacher who had converted to Christianity in 1741. Soon after his arrival, he became a schoolmaster to the Montauk tribe and married Mary Fowler, a Montauk Indian. Though he had abandoned his Indian religion, Occom greatly respected tribal culture, and in the early 1760s wrote an appreciative consideration of the local Indians' customs.

In his "Account of the Montauks," Occom discussed in detail some of the activities, beliefs, and values of the tribe. He described Montauk marriages, and he related the most important stories of the Montauk, their religious mythology.

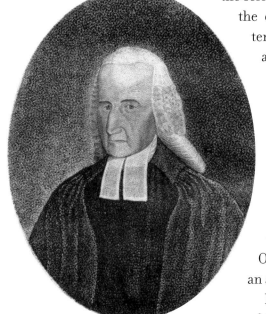

The Reverend Samuel Buell, drawn and engraved by A. Reed from a 1798 portrait by Abraham G. D. Tuthill

I shall begin with their *marriages*. . . . As soon as the children are born, or presently after they are born, parents made matches for their children. . . . The parents of the boy prepare cloathing, ornaments, and other presents; and the other prepare a great feast; and the relations of both parties generally join in making these preparations, and when the appointed time comes, the parents of the girl and their relations bundle up their preparations, and will call as many guests as they please. The other party also gets in readiness with their company, and all things being ready on both sides the parents of the girl take up their child, and march with their company to the man's house, and they go in boldly without any compliments, and deliver their child to the man and his wife, and they receive their daughter-in-law with all imaginable joy, and the mother will suckle the young couple, the one at one breast, and the other to the other breast, and both mothers will take their turns in suckling the couple; and if the children are weaned, they must eat out of one dish; and in the mean time the whole company is devouring the feast, and after the feast they will distribute the presents one to another, and this being ended they have completed the marriage; and every one returns to their wigwams,

and the couple that are just married are kept at their parents' houses till they are grown up, and if they see fit to live together they will; if not, the parents can't make them to live together, but they will choose other companions for themselves. . . .

Concerning their *Gods.* They imagined a great number of gods. There were the gods of the four corners of the earth; the god of the east, the god of the west, the god of the north, the god of the south; and there was a god over their corn, another over their beans, another over their pumpkins, and squashes, &c. There was one god over their wigwams, another of the fire, another over the sea, another of the wind, one of the day, and another of the night; and there were four gods over the four parts of the year, &c. &c.

But they had a notion of one great and good God, that was over all the rest of the gods, which they called *Cauhlun-Toowut,* which signifies one that is possessed with supreme power. They also had a notion of a great evil god, which they called Mutcheshesunnetooh, which signifies evil power, who they say is mischievous, &c.

Occom also discussed the Montauks' rituals of death and burial, and their ideas about the afterlife. "Their souls go to the westward a great way off, where the righteous, or those that behaved themselves well in this world, will exercise themselves in pleasurable singing and dancing forever, in the presence of their Sawwonnuntoh or their western god, from whom they have received their beans and corn, their pumpkins, squashes, and all such things. They suppose the wicked go to the same place or country with the righteous; but they are to be exercised in some hard servile labour, or some perplexing exercise, such as fetching water in a riddle [sieve], or making a canoe with a round stone."

Today, one might consider Occom an activist for Indian rights, for he was adamantly opposed to white encroachment on Indian territory. This had made him extremely unpopular in Connecticut; he was more effective in New York, where he succeeded in preserving some Indian lands. When he was teaching Indians in Connecticut as a young man, Occom developed the idea of a charity school. His superiors approved the proposal, and in 1765 he was sent to England to raise funds. He collected more than $40,000 from various sources—but he got no donations from the English clergy. "I waited on a number of bishops and represented to them the miserable and wretched situation of the poor Indians. . . . But they never gave us one single brass farthing." Occom found them "very indifferent whether the poor Indians go to heaven or hell." Despite a slight pang

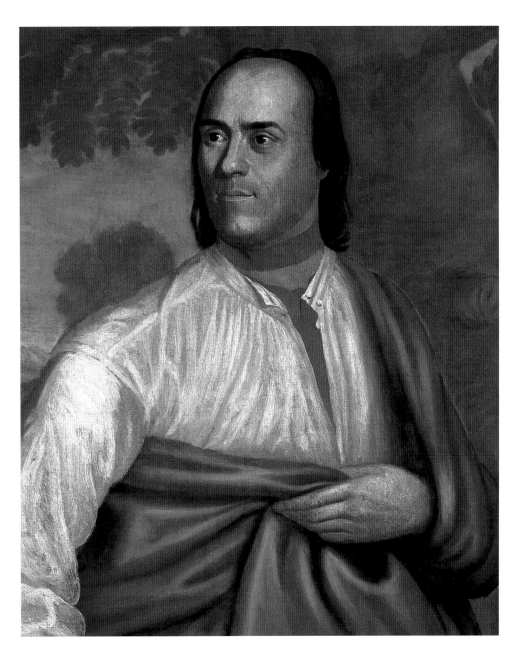

Nathaniel Smibert, THE REVEREND SAMSON OCCOM, ca. 1751–56. Oil on canvas, 30¼ x 24¾ inches.

of conscience at the thought, he wrote, "I am apt to think that they don't want the Indians to go to heaven with them." The money Occom did raise went to the Moors Indian Charity School in Connecticut.

Occom chose to spend his last years in Oneida County in upstate New York, living with other Mohegans, the once-glorious tribe that features in James Fenimore Cooper's Leatherstocking Tales. Occom's earlier writings in Montauk, though, serve as his greatest legacy. The modern critic Bernd Peyer lauded Occom as "the 'father' of modern Native American literature."

THE ATTRACTION for the region's earliest known European artists was not the place but the people. Long before landscape painters began to venture east from New York City in search of picturesque villages and bucolic scenery, local artists were making portraits of dignitaries and prominent families. Among the first of these painters was Abraham Guglielmus Dominy Tuthill, whose portrait of Samuel Buell reflects an ambitious amateur's respect for English precedents. Born in 1776 on the Island's north fork, in the area then known as Oyster Ponds but now called Orient, Tuthill had East Hampton roots on his mother's side. How and why he decided to become a portrait painter is not recorded, but once he had made his plan, he found strong support within the community.

Tuthill's earliest known portrait is a bust of Reverend Buell, completed a mere two weeks before the clergyman's death in 1798. It was commissioned by John Lyon Gardiner, a descendant of Lion Gardiner and a member of one of the area's wealthiest and most influential families. Writing to his brother David, Gardiner noted that he "had a very good likeness taken of Dr. Buell on canvas by AGD Tuthill, as large as the life." Three versions of the portrait are known to exist—in spite of its wooden pose and technical clumsiness, other artists may have copied the painting, probably owing more to Buell's renown than to Tuthill's skill. Nevertheless—and here his family connections may well have played a part—Tuthill soon received commissions from prominent Long Islanders, including the Gardiners, the Derings of Shelter Island, and the Lloyds of Eaton's Neck.

Realizing that he lacked the technical finesse to rise in his chosen profession, the ambitious young artist conceived a plan to study with the portrait painter Gilbert Stuart. Unfortunately for Tuthill, Stuart did not take pupils, but evidently advised him to study in London with Stuart's own master, the American expatriate Benjamin West. With the backing of a local benefactor, Tuthill established a studio in New York City, where friends helped him arrange to train in Europe. Whether or not he actually studied with West is not known, but, as one

ABOVE: Abraham G. D. Tuthill, STYLISH YOUNG WOMAN, ca. 1810. Oil on canvas, height 30 inches.

OPPOSITE, TOP: Lemuel Maynard Wiles, HOME, SWEET HOME, 1886. Oil on canvas, 11 3/4 x 17 1/4 inches.

OPPOSITE, BOTTOM: Lyricist John Howard Payne, famed for his song "Home, Sweet Home."

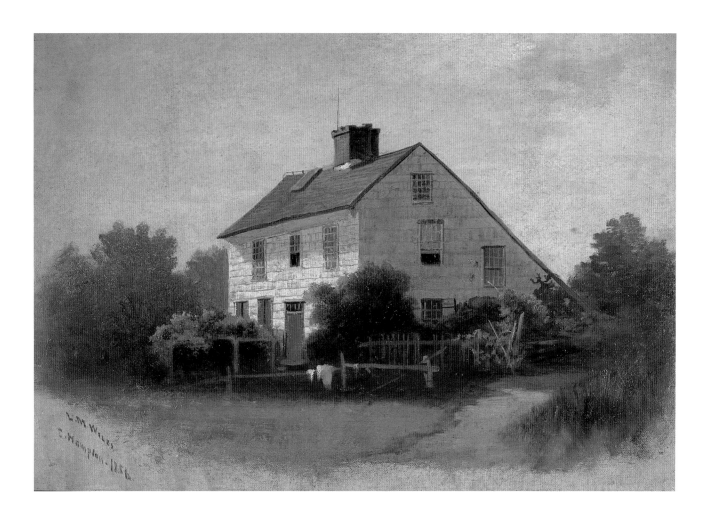

writer on Tuthill has observed, "one thing is certain. Where Stuart had progressed miraculously under West's tutelage, and shed every vestige of his primitive early style, Tuthill did not." After eight years in England and France, he returned to the United States, settled in Vermont, and earned a modest but steady income as an itinerant limner. His paintings never achieved an academic portraitist's sophistication or polish.

SAMUEL BUELL WAS STILL the Presbyterian minister in East Hampton when John Howard Payne was born, in 1791. Later to be widely acclaimed as a poet, playwright, and actor, Payne apparently was not born in East Hampton, since his family had moved to New York City eight months before his birth. But his maternal ancestors, the Isaacs family, had resided in the village for generations, and he was a frequent visitor as a child. Payne's grandfather was Aaron Isaacs, a native of Hamburg, Germany, and East Hampton's only Jewish citizen—at least, until he was converted by the Presbyterians. (And perhaps even

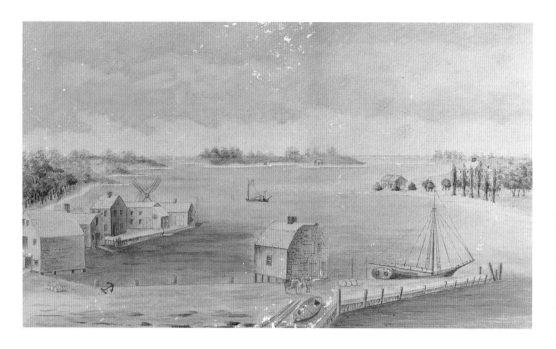

Anna Frances Sleight, LONG WHARF, SAG HARBOR IN 1803, ca. 1895. Watercolor on paper. 10^7/$_8$ x 18^3/$_4$ inches. Copied from a watercolor, now lost, by Elizabeth Sleight.

afterwards: Isaacs's tombstone bears the inscription "An Israelite indeed, in whom there was no guile.") His daughter Sarah had married William Payne, a Massachusetts educator, and their first home was in East Hampton. That small saltbox house on Main Street has become a shrine to John Howard Payne and is now known by the name of his most famous song, "Home, Sweet Home."

Payne wrote the song's lyrics for *Clari, Or the Maid of Milan,* with music by Henry Rowley Bishop. The operetta premiered at Covent Garden in the spring of 1823. According to Payne's friend Charles Brainard, the song was written in Paris "on a dull October day, when he was occupying a small lodging-room." The words rushed into his mind, lifting a depression induced by the weather and loneliness. In the operetta, the song is sung by Clari, a simple girl living in the palace of the Duke who is to become her husband. When her maid asks where she learned it, Clari tells her, "It is the song of my native village." It has become much more than that; its most memorable line—"Be it ever so humble, there's no place like home"—has entered the realm of common sayings.

Something of a social activist and an advocate for the rights of Indians, Payne once traveled to Georgia to show support for the Cherokees, who were being forced out of their territory. Brainard recounts an incident that took place there. One night, twenty-five members of the Georgia Guard, suspicious of Payne's activities, arrested him and John Ross, the chief of the Cherokee nation. As they were being taken to the headquarters of the Guard, one of the soldiers began to sing "Home, Sweet Home." Hoping to influence his captors, Payne asked the men if they knew he had written the song. "It's no such thing," replied the singer. "It's in 'The Western Songster.'"

W HILE ABRAHAM TUTHILL WAS PLYING HIS TRADE in New England and elsewhere, the village of Sag Harbor, on the south fork's northern shore, became one of the new nation's most important ports. As early as 1733, settlements on eastern Long Island had been linked to Brooklyn via the so-called King's Highway, and as the century progressed stagecoach and ferry services made them ever more accessible to New York City and New England. From a wharf on Peconic Bay, protected from storms by the aptly named Shelter Island, Sag Harbor vessels carried produce, lumber, and manufactured goods to ports all along the Eastern seaboard. After the Revolutionary War, Sag Harbor was the United States' first port of entry, and soon distinguished itself as one of the young republic's foremost whaling centers.

The Sag Harbor Whaling Museum contains evidence of the considerable creative activity generated by this flourishing trade. The collection features whale's teeth and bones decorated with delicately inscribed scrimshaw, carved whale-ivory cane handles, and a handsome figurehead portrait of Thomas Jefferson that adorned the prow of the *Jefferson II*, a whaler that made five voyages to the Far East from Sag Harbor between 1845 and 1861. The likeness is not strictly accurate, however, for the famously red-haired Jefferson has been transformed into a brunette, though that may be the result of a later paint job. The artisans who fashioned ships' figureheads are mostly anonymous, but their skill, invention, and craft testify to the region's economic vigor in the nineteenth century.

Oddly, there is no history of ship portraiture in the region. One painting, however, describes Sag Harbor before the whaling trade transformed it into a bustling maritime center. The location of the original painting is not known, but an ink sketch on tracing paper shows the Long Wharf as it looked in the earliest years of the nineteenth century, with a single large warehouse beside it and a sailing ship tied up at the dock. The sketch is either a preparatory drawing or a tracing of a finished work made in 1803 by Elizabeth Sleight, a member of a family of Dutch traders who had settled in the village. The artist, born in 1778, also depicted cooperages, where whale-oil barrels were made, and an oil house, in which the valuable cargo was stored prior to shipment. Another pier, with its windmill and warehouse, stands near the later location of the North Haven Bridge tollhouse, built in 1834. Across

Carver unknown, figurehead of the whaleship JEFFERSON II, ca. 1845. Painted pine and red gum, height 37 inches.

the harbor on Little Hog Neck stands a solitary dwelling, recalling a time when the North Haven peninsula, more easily reached by water than by land, was barely inhabited. In the 1890s, one of Sleight's descendants made a watercolor copy of the original; the later version is in the library's collection. This singular document is charmingly amateurish but filled with fascinating details of Sag Harbor's early years.

Lyman Beecher, an East Hampton pastor and the father of Henry Ward Beecher and Harriet Beecher Stowe.

S AMUEL BUELL'S SUCCESSOR as pastor of the East Hampton Presbyterian Church was Lyman Beecher. A skillful orator whose sermons were widely published, Beecher was the patriarch of one of the most important intellectual families in America. Several of his thirteen children (from five marriages) went on to fame, notably Catharine Beecher, an advocate for women's education; Henry Ward Beecher, who attracted huge crowds to his abolitionist sermons at Plymouth Church in Brooklyn; and Harriet Beecher Stowe, whose best-selling novel *Uncle Tom's Cabin* helped turn public sentiment against slavery.

Lyman Beecher arrived in East Hampton in 1799 and left a little more than a decade later when the town trustees refused to meet his salary requests. But his years there helped launch his reputation as a minister and writer of sermons. The first of his sermons to be publicly acclaimed was "The Remedy for Duelling," preached in East Hampton on April 16, 1806. It was a response to the famous duel, in 1804, in which Vice President Aaron Burr shot and killed his arch-rival, Alexander Hamilton. The event scandalized the young republic.

"When I read about it in the paper," Beecher wrote in his autobiography, "a feeling of indignation was roused within me. I kept thinking and thinking, and my indignation did not go to sleep. It kept working and working, and finally I began to write." It took him six months to complete the sermon; the finished product showcased Beecher's persuasive rhetorical powers:

> And if they will not take the trouble to govern their tempers—if they will not encounter that self-denial which the laws of God and man inculcate—if they will be savages in a civilized land, let them be treated as savages. And when they murder, elevate them not to posts of honour, but to the gallows. . . .

A sacred regard to law is indispensable to the existence of a mild government. In proportion as obedience ceases to be voluntary, and the contempt of law becomes common, must the nerves of government be strengthened, until it approach in essence, if not in name, to a monarchy. We must have protection; and the more numerous and daring the enemy, the more power must be delegated to subdue and control them. That contempt of law, therefore, which is manifested by the duellist, is a blow at the vitals of liberty.

Catharine Beecher, born in East Hampton in 1800, spent her life writing and working to improve educational opportunities for women—she believed young women should receive a sound general education and training in such disciplines as physiology and chemistry. Her 1841 book *A Treatise on Domestic Economy*, which covered all aspects of a woman's domestic life, was reprinted fifteen times. Beecher was also an activist in the causes of abolition and women's suffrage. Although her family moved from East Hampton when she was just ten, Catharine recalled enough to produce a vivid memoir later in her life.

Catharine Beecher, another of Lyman Beecher's 13 children, was an abolitionist and the author of popular books on domestic life.

Occasionally we children were allowed to pass a narrow plank walk across a deep marsh where cranberries grew, but where we were told, if we stepped off to get them, we should sink and be drowned in the mud.

Beyond this we came to hills of sand, covered with beach plums, and then to the hard white sand, where the ocean broke and ran up in ceaseless play. Here we used to go down with the retreating wave, and wait till we saw another coming in ready to break, and then we all scampered to escape the upward flow. Sometimes we were overtaken and drenched; and it was strife with us to see who dared to go the furthermost down to meet the waves.

The special object of fear, for which we carefully watched, was the sea-poose, made by two waves in opposite directions meeting, and then there was a furious race of the waters, sweeping away every thing in their return.

Eastern Long Island's literary life had a kind of official beginning during Beecher's tenure, with the founding, in February 1807, of a literary society in Sag Harbor. But fame came only later in the century, with the success of James Fenimore Cooper and Walt Whitman.

There is no way of knowing whether Cooper knew of the Literary Society when he arrived in Sag Harbor in 1819 to begin a whaling enterprise. Cooper, thirty years old and with a wife and children, had been living on Angevine Farm in Scarsdale in Westchester County. His wife, Susan De Lancey, had many relatives in Sag Harbor and on Shelter Island, and the young couple were frequent visitors to the East End. Cooper, who had tried his hand at several different businesses already, purchased a whaling ship, the *Union*, and took charge of all the details of running it. The ambitious young sailor enlisted the support of an older relative and hired Captain Jonathan Osborne of Wainscott, purchased outfittings, organized the maiden voyage, and literally waited for his ship to come in. Though his letters from Angevine Farm reveal how anxious he was to begin whaling, the results of the enterprise were disappointing, and he eventually abandoned the business.

Cooper's career as a writer began with a challenge by his wife. One evening, while reading a novel to her, he threw it aside in disgust saying, "I could write you a better book than that myself." Susan encouraged him to do it. *Precaution*, his first novel, which he wrote while staying at "Duke" Fordham's tavern in Sag Harbor as he waited for the *Union* to arrive, was published in 1820; *The Spy* followed a year later. With *The Pioneers* in 1823, he launched his famous Leatherstocking Tales, a series of popular novels describing the frontier clashes between Indians and settlers.

Several of Cooper's novels have nautical themes and subjects familiar to East Enders. *The Water Witch* and *The Sea Lions* are based on his time in Sag Harbor; *Miles Wallingford* and *Jack Tier* feature locations in and around Montauk. With these books he was creating a new form of fiction, the sea novel, paving the way for the great achievement of Melville, *Moby-Dick*. Cooper wrote *The Sea Lions* in 1849, just two years before his death. Set in 1820, it incorporates many of his memories of his whaling days and captures the drama and excitement of the pursuit:

> Few things give a more exalted idea of the courage and ingenuity of
> the human race than to see adventurers set forth, in a mere shell,
> on the troubled waters of the open ocean, to contend with and
> capture an animal of the size of the whale. The simple circumstance
> that the last is in its own element, while its assailants are compelled
> to approach it in such light and fragile conveyances, that, to the

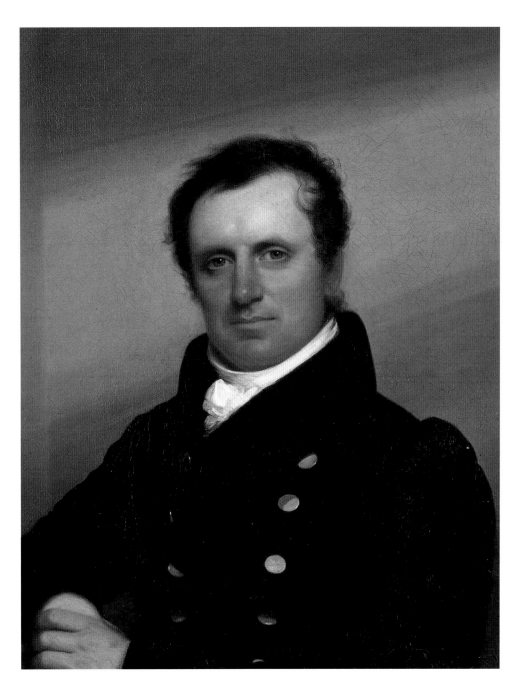

John Wesley Jarvis,
JAMES FENIMORE
COOPER, 1822.
Oil on canvas,
30 x 25 inches.

unpracticed eye, it is sufficiently difficult to manage them amid the rolling waters, without seeking so powerful an enemy to contend with, indicates the perilous nature of the contest. But, little of all this did the crews of our four boats now think. They had before them the objects, or *one* of the objects, rather, of their adventure, and so long as that was the case, no other view but that prevailing could rise before their eyes.

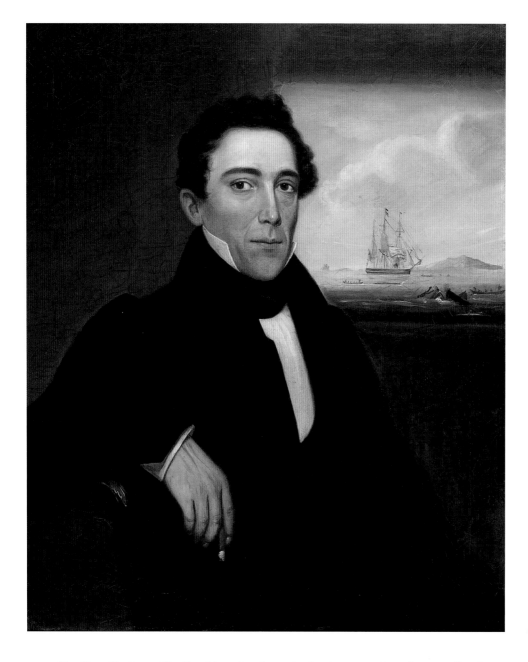

Hubbard Latham Fordham,
CAPTAIN JEREMIAH
W. HEDGES, ca. 1850.
Oil on canvas,
$34\frac{1}{2}$ x $28\frac{1}{2}$ inches.

For East Enders, *The Sea Lions* is of particular interest for what it tells about Sag Harbor in Cooper's day. "Success in taking the whale was a thing that made itself felt in every fibre of the prosperity of the town," he wrote. "[A whaler's] peculiar merit, whether with the oar, lance, or harpoon, is bruited about, as well as the number of whales he may have succeeded in 'making fast to,' or those which he caused to 'spout blood.'" But even as Cooper celebrated the seagoing glory of Sag Harbor, he was also lamenting the encroachment of the rapidly modernizing world. By 1849, the railroad had been extended to Greenport, and he decried this progress: "How many delightful hamlets, pleasant villages, and

even tranquil country towns, are losing their primitive characters for simplicity and contentment, by the passage of these fiery trains, that drag after them a sort of bastard elegance, a pretension that is destructive of peace of mind, and an uneasy desire in all who dwell by the wayside, to pry into the mysteries of the whole length and breadth of the region it traverses!"

It has been speculated that the colorful Sag Harbor whaling captain David Hand was the prototype for Natty Bumppo, the hero of the Leatherstocking Tales. Though Cooper declared Bumppo to be fictional, Sag Harbor residents certainly saw a resemblance to Hand when they read *The Pioneers*, especially because of Natty's peculiar laugh. Today it is possible to visit David Hand's house in Sag Harbor as well as his grave in Oakland Cemetery. Captain Hand outlived five wives. His epitaph, which he wrote himself, reads, "Behold ye living mortals passing by / How thick the partners of one husband lie."

As Sag Harbor's whaling trade boomed, prosperous businessmen and shipowners began to demand luxury goods, including paintings, for their imposing new houses. Hubbard Latham Fordham, born in Sag Harbor in 1794, answered the call for portraits that would immortalize the local gentry. His youthful artistic talent was recognized early by his parents, who encouraged him to turn it to practical purposes such as sign painting. Determined to become a real artist, Fordham was already making likenesses of local residents in his teens. By 1830 he was doing well enough to justify opening a studio in Manhattan, though there is no record of his having received any formal training.

Fordham's style shows some of the awkwardness typical of so-called naïve portraiture, but his considerable natural aptitude made up for his lack of professional instruction. His likeness of Sag Harbor whaling captain Jeremiah W. Hedges, for example, evidences his skillful modeling of facial features as well as a gift for rendering the generic maritime scenes that served as backdrops for portraits of seafarers and shipowners. As demand for his portraits increased, Fordham established studios in Springfield, Massachusetts (thanks to a commission to paint the state's lieutenant governor), and New Haven, Connecticut. Many of his sitters were relatives, notably from his mother's and wife's families, as well as affluent sea captains, merchants, and their kin. In addition to life-size portraits, Fordham also specialized in miniatures, in spite of being blind in one eye. In later years, he branched out into history painting and biblical subjects. His financial success allowed him to invest in an Iowa farm, but eventually he returned to his native village, put his money into property there, and set up a studio on Hampton Street. After failing eyesight forced him to abandon painting,

he managed a tavern and, until his death in 1872, was one of Sag Harbor's most distinguished and respected citizens.

Fordham's distant cousin, Orlando Hand Bears (sometimes spelled Beers), was another native Sag Harbor artist who cashed in on the port's pre–Civil War economic boom. Born in 1811, he followed cousin Hubbard's example by painting shop signs and carriages, and ran a tinsmithing business with his brother before setting himself up as a professional portraitist. Also like Fordham, his subjects were often family members, including two of his children, Mary and Alfred. Bears, however, was an even more gifted technician and a more sensitive interpreter than Fordham, with whom he reportedly studied painting. As Alice Assael remarked in an essay on Long Island folk art, "the harsh flatness characteristic of much nonacademic portraiture is absent from his paintings, in which a soft, gentle, and personalized interpretation of the subject is evident." The likeness of young Alfred, with his alert, confident expression, lovingly rendered clothing, and an oak branch to symbolize sturdiness, is especially appealing. But Bears's untimely death at the age of forty cut short the promising career of Sag Harbor's finest limner.

In addition to portraits in the formal tradition, Bears produced at least one landscape painting, a panoramic view of Sag Harbor in the mid-1830s. Abraham Tuthill had earlier advertised that he painted scenic "views," but he was then working in the Midwest, so Bears's canvas, dating from around 1835, may have been the first professional landscape painted in the region. The image was evidently popular, for an engraved version also exists. But most of Bears's known landscapes were imaginary—like the pastiche of a local church and homestead transplanted to an Alpine vista behind young Alfred, who might be more plausibly imagined standing in front of the Sag Harbor whaling fleet. A similar mountainous background, this time an unusual moonlit scene, serves as the foil for Bears's imposing full-length portrait of Ephraim Byram, Sag Harbor's celebrated inventor, clock maker, and astronomer, whose telescope attests to his fascination with the cosmos.

Whaling in Sag Harbor had ended by the mid-nineteenth century; it was difficult to man a ship when so many able-bodied men had been lured to California for the Gold Rush. Moreover, the advent of petroleum drilling in Pennsylvania at about the same time soon put an end to the whale-oil market. As the region's economy shifted away from whaling, artists gradually became less interested in immortalizing seamen and instead turned their gaze to the land itself, although landscape paintings were not produced in numbers until after the Civil War. Unlike the scenic Hudson Valley, with its convenient rail and steamship routes direct from Manhattan, eastern Long Island was relatively inaccessible. Before the war, overland passenger travel to East Hampton from the city required an arduous

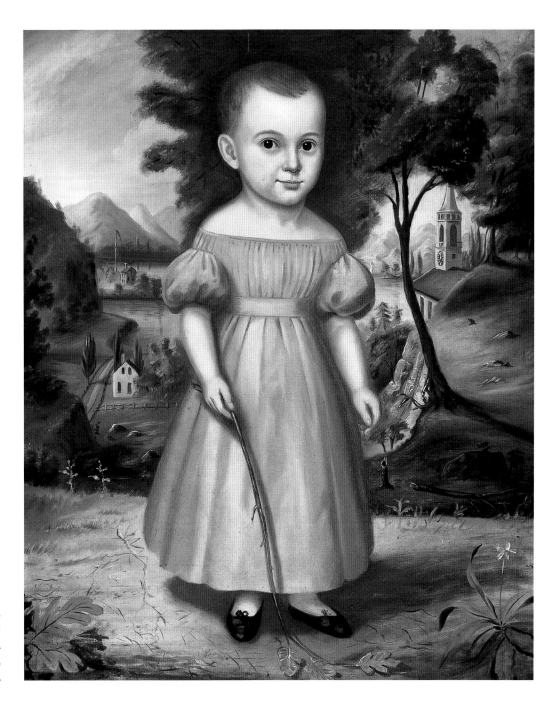

Orlando Hand Bears,
ALFRED WILLIAM
BEARS, 1841-42.
Oil on canvas,
32$\frac{1}{2}$ x 23$\frac{1}{2}$ inches.

three-day stagecoach trip. But by 1870, the South Shore Railroad line had been extended to Bridgehampton and Sag Harbor, bringing with it both increased commercial traffic and a burgeoning tourist trade. When O. B. Bunce asserted—in "Scenes in Eastern Long Island," his 1872 essay for William Cullen Bryant's *Picturesque America*—that eastern Long Island boasted "tracts of seacoast which the foot of the artist has never trod," he may not have been aware that the region's newly established rail service was already attracting painters and tourists alike.

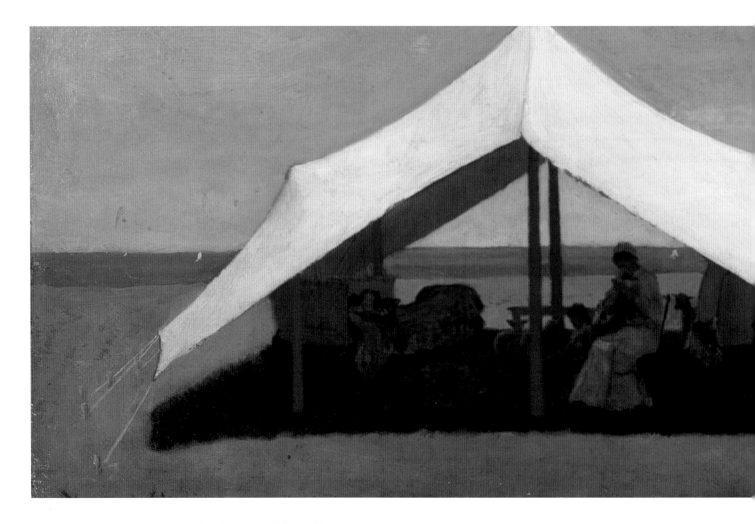

As passenger service improved, boarding houses sprang up on the road east from the Bridgehampton terminus, and in 1874 the enterprising Talmage family began building vacation cottages to rent to East Hampton's growing complement of summer visitors. Among that year's contingent was Winslow Homer, who made several paintings and sketches of bathers, picnickers, and strollers on the ocean beach. Already it was apparent that this novel form of recreation was attracting a sizable number of city folk, who had yet to realize that street clothing was inappropriate for a sun-and-sand environment. Not that swimming costumes of the era were any less cumbersome. They were so bulky, in fact, that safety ropes were anchored above the waterline so surf bathers could haul themselves free of the undertow before their waterlogged suits fatally weighed them down. Families arrayed themselves and their pets amid the clutter of portable cabañas (dragged into position by mule teams), tents and canvas marquees, sun shelters made of poles roofed with leafy oak boughs, and the coaches and buckboards that ran between boardinghouses and the beach. As a destination for artists, East Hampton's oceanfront nicely combined human interest with a

Winslow Homer,
THE TENT, 1874.
Oil on academy board,
$9^{1}/_{2}$ x 22 inches.

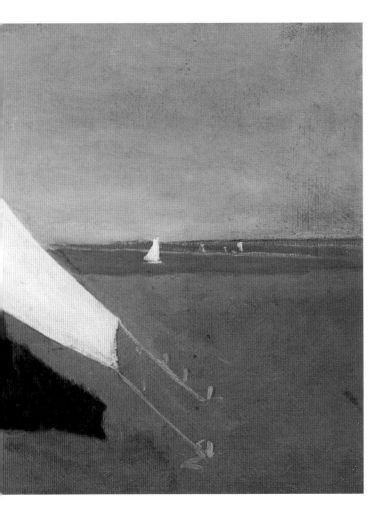

magnificent natural setting, as captured in canvases by Homer, Edward Lamson Henry, John Ferguson Weir, and others during the mid-1870s. They were the entering wedge of what would soon become a significant influx that established the area as one of the nation's most fertile art colonies.

EAST HAMPTON HAD PRODUCED A NOVELIST at mid-century: Cornelia Huntington, who was educated at Clinton Academy. When she was fifty-four, Huntington was persuaded to publish her novel *Sea-spray: A Long Island Village*, in which "Sea-spray" is East Hampton. Published pseudonymously in 1857—although it was written five years earlier—it is a typical nineteenth-century novel of manners. The book's structure is seasonal, allowing Huntington to include the various activities associated with particular months. In June, the summer people arrived. In winter, "Sea-spray was a sad, dull place . . . The great temperence [*sic*] reform had put a dead stop to all roystering games. . . . The last great revival had dealt the death-blow to dancing . . . and whist was voted out of the village." At different points in the novel, Huntington reproduced the speech of people of various classes as well as that of Dury, an Indian cook, who serves as a kind of Greek chorus of experience and common sense.

Early in *Sea-spray*, Huntington provides a pastoral description of the town and its year-round residents after the summer season has ended:

> Steamboats, railroads and turnpikes had brought the world nearer, and
> the restless, itinerating tendency of the times had brought troops of
> seekers after change to explore all the sweet secluded nooks and
> shady retreats of Sea-spray, and to claim and take possession by right
> of discovery. But those who came to rusticate and rest—to breathe the
> pure sea air—to forget the stifling city heats in the blessed ocean
> breeze, and bathe the fevered brow and the languid limb in the dashing
> ocean wave, had fled with the flowers and the singing summer birds;
> and the deserted haunts of the summer loungers were silent now, save

when the fallen leaves rustled along the paths, or the wintry wind moaned through the bare branches of the trees. It was evening, calm and serene, and no sound disturbed the silence, except the sharp stroke of an axe in the distance, busy in thrifty forecast for tomorrow's fuel, or the slow groaning wheel of a loaded wagon, late on its homeward way.

However descriptive and topical *Sea-spray* is, modern readers will probably find themselves following the story line concerning Mr. and Mrs. Copperly and their two children, Sike and Godwin. Huntington, who had read the English feminist Mary Wollstonecraft's *A Vindication of the Rights of Woman*, satirized the misapplication of its ideas through the character of Mrs. Copperly, an ardent feminist who neglects her husband and children, talks a great deal, and is one of those "scribbling women"— a writer. Copperly's husband, required to take care of the baby while she scribbles, is perpetually exhausted. Even when guests arrive, she will not interrupt her writing. Emancipation is her sacred cause. If her husband coughs, she shoves the spittoon closer to him with her foot. Even the suggestion that her husband is dying cannot take her attention from such issues as equal civil rights, political privileges for women, and the evils of male supremacy. Poor Mr. Copperly is an object of sympathy. His wife is no longer what she was when he married her—"The wild notions of the day have ruined her."

Cornelia Huntington, East Hampton's first novelist.

I N 1819, THE YEAR THAT James Fenimore Cooper purchased the *Union*, Walt Whitman, America's epic poet, was born on a farm near Huntington, Long Island. He had a lifelong love for the place of his birth, but more than that, he felt that this rural world had shaped him. In *Leaves of Grass*, Whitman sang the praises of Paumanok, as the native inhabitants called Long Island, which he characterized as the "Isle of sweet brooks of drinking-water—healthy air and soil! / Isle of the salty shore and breeze and brine!" Its easternmost reaches, where rocky bluffs are scoured by the Atlantic Ocean's relentless assault, were especially inspiring to the poet, who described Montauk's "wonders and beauties" in his 1849 book, *Letters from a Traveling Bachelor.* The artists of Whitman's era were similarly captivated by the "freshness and uncontaminated splendor" of the Eastern wilderness, which became the subject of numerous paintings and prints.

Whitman's sister Mary lived in Greenport, Long Island, and the area served as poetic inspiration for him throughout his life. Though Whitman settled in Camden, New Jersey, he recalled his excursions as a young man to eastern Long

LONG ISLAND RAIL ROAD

The Long Island Rail Road, designed to link New York City and Brooklyn to Boston by a combination of train and ferry service, was promoted to investors as a less expensive alternative to constructing a rail line through Connecticut. The first line, opened in 1844, ran to Greenport, followed four years later by the South Shore line, which finally reached East Hampton, Amagansett, and Montauk in 1895.

In *Long Island: People and Places, Past and Present*, Bernie Bookbinder quotes an amusing contemporary account of the opening-day festivities—an early incarnation of the star-studded social events for which the Hamptons are famous:

"The inaugural run took place on July 27, 1844, and featured a special train filled with civic officials, stockholders, celebrities, and newsmen. Spurred by the occasion, the train covered the ninety-five miles in three and one-half hours instead of the scheduled five. Horses and wagons crowded the site of the celebration, and boats of all descriptions crammed Greenport harbor. According to one description, it clearly was a day to remember:

A large tent was spread north of the tracks. . . . Four tables one-hundred-feet-long were spread under the tent, and dinner was served to the parties who had come on the train and a few villagers. The provisions were brought from New York, and included forty baskets of Champagne and half a case of brandy. As a natural consequence, many of the excursionists were so stupidly inebriated that it was necessary to put them on board the cars. . . . The whole affair was discreditable in the extreme."

ABOVE: East Hampton railroad station, February 1899.

Island, which he had written about for the *New York Sunday Dispatch* in the 1840s. Later there had been other summers in Greenport with his sister, in 1855 and 1861, when he was able to relive his boyhood wandering the beaches and farms, fishing, and sailing. Just four years before his death in 1892, he included the poem "From Montauk Point" (see page 36) in a later edition of *Leaves of Grass*.

The sea had always fascinated Whitman. In the autobiographical work *Specimen Days*, he describes his boyish wish to write about the seashore: "that curious, lurking something . . . which means far more than its mere first sight, grand as that is—blending the real and ideal." And he never forgot the joys of seashore life—swimming, lobstering, eeling, clamming, and, of course, eating the fruits of the sea. Like Cooper, Whitman came to know and appreciate the farmers and fishermen he met during his rambles. They became prototypes for the universal characters that populated his future poetry.

It is impossible to read the section of *Leaves of Grass* titled "Sea-Drift" without feeling the enormous impact the imagery of Long Island had on Whitman's

A Paumanok Picture

Two boats with nets lying off the sea-beach, quite still,
Ten fishermen waiting—they discover a thick school of moss-
* bonkers—they drop the join'd seine-ends in the water,*
The boats separate and row off, each on its rounding course
* to the beach, enclosing the mossbonkers,*
The net is drawn in by a windlass by those who stop ashore,
Some of the fishermen lounge in their boats, others stand
* ankle-deep in the water, pois'd on strong legs,*
The boats partly drawn up, the water slapping against them,
Strew'd on the sand in heaps and windrows, well out from
* the water, the green-back'd spotted mossbonkers.*

* —Walt Whitman, 1881*

Walt Whitman

From Montauk Point

I stand as on some mighty eagle's beak,
Eastward the sea absorbing, viewing,
* (nothing but sea and sky,)*
The tossing waves, the foam,
* the ships in the distance,*
The wild unrest, the snowy, curling
* caps—that inbound urge and urge*
* of waves,*
Seeking the shores forever.

* —Walt Whitman, 1888*

Harry Fenn, MONTAUK POINT,
ca. 1872. Illustration from O.B. Bunce,
"Scenes in Eastern Long Island,"
PICTURESQUE AMERICA, October 1872.

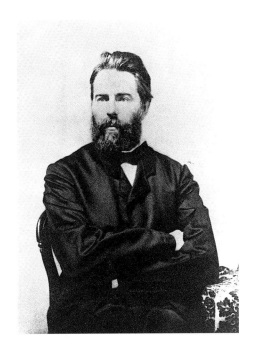

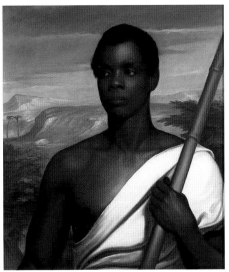

TOP: Herman Melville, whose story "Benito Cereno" was partly based on the saga of the slave ship AMISTAD.

BOTTOM: Nathaniel Jocelyn, CINQUE, ca. 1840. Oil on canvas, 34¼ x 25½ inches.

imagination: birds, sands, fields, briers and blackberries, yellow half-moon, lilac, grass, seashore, sun, sea, stars, breakers, woods, spray, leaves, moonbeams. All of these appear in the poem "Out of the Cradle Endlessly Rocking." Elsewhere in *Leaves of Grass*, "A Paumanok Picture" creates a poetic painting of ten fishermen haul-seining in the sea, a scene he captures so well that it might have been rendered in oil or watercolor by an artist painting on an East End beach.

Whitman's magnanimous and democratic imagination comprehended all of Long Island, rendering it poetically as Paumanok, and, in so doing, creating an epic of America. Real and literary experiences today still resonate with his poetic insights, and those who live on the East End pass their lives in the presence of the images made visible and universal through his art.

Though Herman Melville lived and worked in New York City, one of his classic sea tales has a connection with the East End of Long Island. In the fall of 1855, his story "Benito Cereno," about a slave revolt at sea, was serialized in the popular *Putnam's Monthly*. Melville's main source for the story was the sea captain Amasa Delano's 1817 *Narrative of Voyages and Travels, in the Northern and Southern Hemispheres*. Three other events furnished Melville with additional material: the Santo Domingo uprising of 1791 to 1804; the slave revolt on board the American domestic slave-trading brig *Creole* in 1841; and the revolt on board the Spanish slave-trading schooner *Amistad* in 1839. After the slaves on the *Amistad* had killed its captain, their Spanish owner, ignoring their demand to return them to Africa, secretly set course for America. On August 25, 1839, they landed at Culloden Point, near Montauk, setting off a two-year legal battle that pitted former president John Quincy Adams against the sitting president, Martin van Buren. The fifty-three men and children on board were held in jail until the Supreme Court freed them, after Adams argued successfully that rather than being guilty of the charge of piracy, the Africans themselves had been illegally kidnapped from Africa and the slave-trading captain and the owner were therefore pirates. Today, a brass plaque honoring the slave leader Cinque and the men of the *Amistad* overlooks Block Island Sound from the lawn of the Montauk Lighthouse.

American Barbizon

"Why not go to Long Island?" asked Polyphemus.

"That sand place?" said the Gaul.

"There's nothing there," said the Bone with scorn.

"How do you know?" said Polyphemus.

"Why," said the Grasshopper conclusively, "nobody was ever known
to go there!"

"What," said the Owl. "Nobody ever went there! Then that's the place
of all others to go to!"

WITH THAT IMAGINARY CONVERSATION among William Mackay Laffan (Polyphemus), Walter Paris (Gaul), Earl Shinn (Bone), Edward Wimbridge (Grasshopper), and F. Hopkinson Smith (Owl), the Tile Club announced to readers of *Scribner's Monthly* in January 1879 that the group was proposing to embark on a journey of aesthetic discovery. In fact, their "tramp" to eastern Long Island had taken place the previous summer, and they were well aware that the area offered much more than sand. It was hardly the unknown quantity they made it out to be.

Founded in 1877—at a time when American artists were establishing many important professional organizations, including the Art Students League and the Salmagundi Club—the Tile Club began as an informal gathering of artists and associates who made up amusing and often cryptic nicknames for one another. Laffan, for example, was given the name of Polyphemus, the mythological Cyclops, because

William Merritt Chase demonstrating painting technique to students at Shinnecock, late 1890s.

39

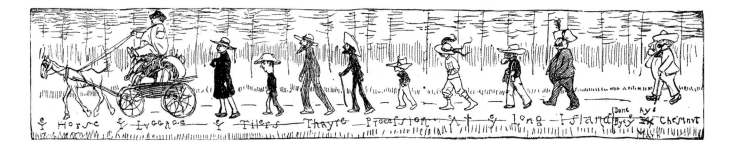

he had only one good eye; Gaul, referring to France, was a pun on Paris's surname. A bohemian group by conventional standards, the Tilers were nevertheless professionals who were keen to advance their careers. Inspired by the growing popular taste for decorative arts and a desire to stimulate interest in American art, they met in one another's studios to decorate ceramic tiles and devise marketing strategies for their work.

As the era's rampant club-founding illustrates, the 1870s were a time of great change and activity for American art. The popularity of the Hudson River school of landscape painting was on the wane. The renewed sense of national pride stimulated by the 1876 U.S. Centennial suggested a new direction for painting and the other arts, focusing on the young nation's social and cultural roots—a landscape style that reflected America's pioneer spirit and the influence of the settlers' transplanted European culture. And for artists based in New York City, by then the country's art capital, the most convenient source of such subject matter was Long Island. The Tilers would no doubt have already heard about Winslow Homer's productive East Hampton trip in 1874, as he was a club member. Moreover, as a passenger agent for the Long Island Rail Road, William Laffan was in the perfect position to advise his colleagues on the region's merits.

Laffan, an art collector and journalist as well as a painter, knew that an excursion to Long Island could benefit both the artists and the railroad. He therefore arranged the passenger tickets for the Tile Club's June 1878 outing and the illustrated article that chronicled it. Written by himself and Earl Shinn, who contributed art criticism to *The Nation*, "The Tile Club at Play"—a lighthearted account of their adventures—appeared in *Scribner's* the following February, with illustrations by Edwin Austin Abbey, R. Swain Gifford, Charles S. Reinhart, F. Hopkinson Smith, and Laffan himself. Of all the places they visited, from Babylon to Montauk, the coauthors described East Hampton as the most charming. In their opinion, "not the Warwickshire landscape, not that enchanted stretch from Stratford to Shottery which was Shakspere's [sic] lovers' walk, is more pastorally lovely." Evidently their companions were equally enthusiastic. "My Wig!" said the Gaul, "I must secure a sketch of some of this!"

The eleven Tile Club members who traveled to eastern Long Island in 1878:

Edwin Austin Abbey
(Chestnut)

William C. Baird
(Barytone)

R. Swain Gifford
(Griffin)

William Mackay Laffan
(Polyphemus)

William R. O'Donovan
(O'Donoghue)

Walter Paris
(Gaul)

Arthur Quartley
(Marine)

Charles S. Reinhart
(Sirius)

Earl Shinn
(Bone)

F. Hopkinson Smith
(Owl)

Edward Wimbridge
(Grasshopper)

One of the village's chief attractions was Home, Sweet Home, erroneously believed to be the birthplace and boyhood abode of John Howard Payne. By the time the Tile Club arrived, more than half a century after Payne wrote the famous song of the same name, the humble saltbox cottage was already a tourist attraction. Nevertheless, the artists initially had some trouble identifying it. "Payne was born in two or three houses of Easthampton," Laffan and Shinn wrote sarcastically, "besides Boston and No. 33 Broad Street, New York." When they finally located what they thought was the genuine article, where they were received cordially, the Tilers "went on to make it their own, artist-fashion. Two or three proceeded to crowd each other up the wide fire-place in their efforts to secure a good position to sketch this nucleus, this ganglion, this node, this vital center of the whole Payne legend," wrote the chroniclers. "They plunged at the well, they assaulted the hen-coop, they crept around the garden to paint the vine-shaded parlor windows," subjecting the property to thorough scrutiny.

In addition to his famous lyric, Payne had written of East Hampton itself as a haven that beckoned from afar. Laffan and Shinn quoted Payne's 1838 article in a London magazine: "Many an eye wearied with the glare of foreign grandeur will, ere long, lull itself to repose in the quiet beauty of this village." To the Tile

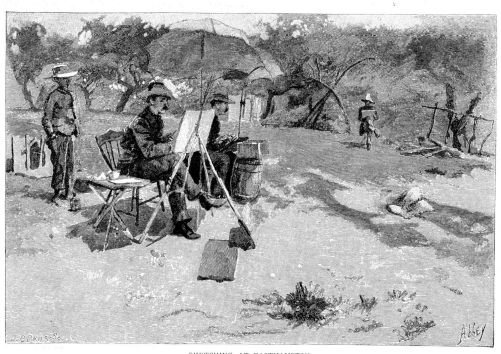

476 *THE TILE CLUB AT PLAY.*

SKETCHING AT EASTHAMPTON.

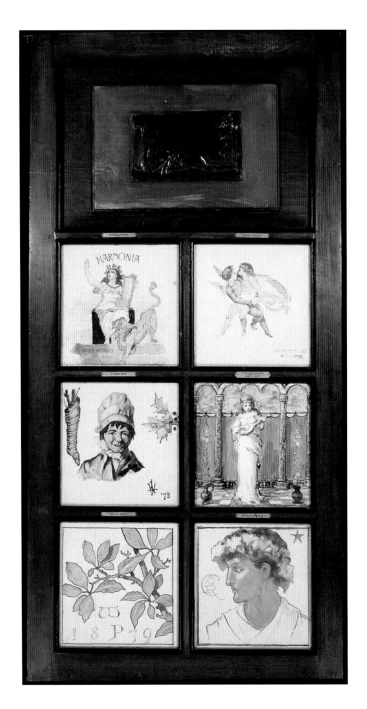

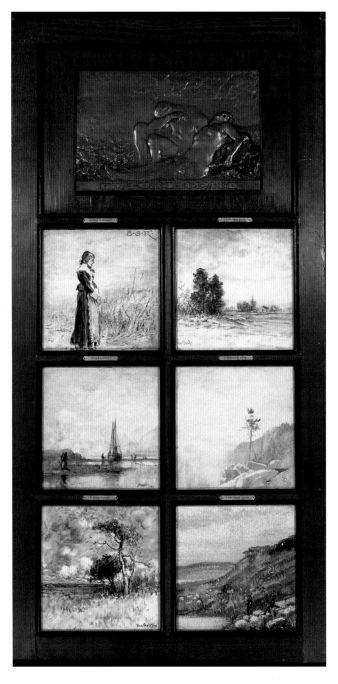

Twelve ceramic tiles by members of the Tile Club. Minton and Wedgwood, each 8 x 8 inches, mounted in a pair of wood doors with bronze plaques by an unknown sculptor and E. Saroldi.

LEFT DOOR, CLOCKWISE FROM TOP: Bronze by an unknown sculptor; tiles by Edward Strahan, undated; Frederick Dielman (begun by Edwin Austin Abbey), undated; Charles S. Reinhart, undated; Walter Paris, 1879; J. Alden Weir, 1878; Edward Strahan, 1879.

RIGHT DOOR, CLOCKWISE FROM TOP: Bronze by E. Saroldi, 1909; tiles by F. Hopkinson Smith, 1879; F. Hopkinson Smith, 1878; F. Hopkinson Smith, undated; R. Swain Gifford, 1898; Arthur Quartley, 1879; Charles S. Reinhart, undated.

Club, it was simply "a painter's gold-mine." "You see," said the Marine (Arthur Quartley), "some neighborhoods are very strongly marked with the artistic consciousness. They combine well. They set out their milk-pans to drain in beautiful compositions. They are all the time posing for effect. Easthampton [*sic*] is one of them." The consensus was that, among eastern Long Island villages, this one was the least changed since colonial times, existing, as the article put it, "like a vignette perpetuated in electrotype." Southampton, Bridgehampton, and Sag Harbor, already invaded by the railroad, were no longer unspoiled. Montauk, which the Tilers also visited, was a wild outpost at the farthest reaches of East Hampton Township, where guests were accommodated by the lighthouse keeper or at lonely cattle stations. There they found "noble amphitheaters of tree-tufted mountains, raked by roaring winds, [which] caught the changing light from a cloud-swept heaven; all was pure nature, fresh from creation."

The combination of the picturesque and the primitive made East Hampton and its surroundings enticing to landscape and genre painters alike. One of their number, Frances Ordway, described the area's appeal in terms of foreign precedents. She believed that artists found in East Hampton many of the elements they prized in European locales. "To [Edwin] Abbey," she wrote, "the gardens, the lanes, the shrubbery were pure English. The wide meadows stretching to the horizon, salt marshes, sand dunes, old windmills with their delicate white sails against the rushing clouds, brought Holland home to [Arthur B.] Frost. Bolton Jones found Brittany here; and Bruce Crane was carried away straight to 'Pont Aven' by the hay ricks, the poultry yards, the winding sheep, the returning herds lost in a maze of soft grey atmosphere so like their beloved Barbizon."

The parallel between East Hampton and Barbizon, a rural hamlet about forty miles southeast of Paris that had attracted artists since the 1820s, is revealing, for artists responded to both locations selectively, ignoring the aspects that did not suit their aesthetic and ideological purposes. The poverty that often characterized rural life was glossed over in favor of its bucolic appeal and preindustrial symbolism. At the same time, the surrounding countryside—whether Barbizon's forest or East Hampton's farmland and coastline—was coming under increasing pressure from the commercial development and tourism made possible by the railroad. The vehicle that embodied the Industrial Revolution's relentless motive power was, according to a French journalist in 1849, responsible for making Barbizon "seem little more than a suburb of Paris, and bringing (much to the regret of the many artists in the neighborhood) vast crowds of day-trippers to the place at the weekends." That description is just as relevant to East Hampton after 1895, when the Long Island Rail Road was extended from Bridgehampton through East

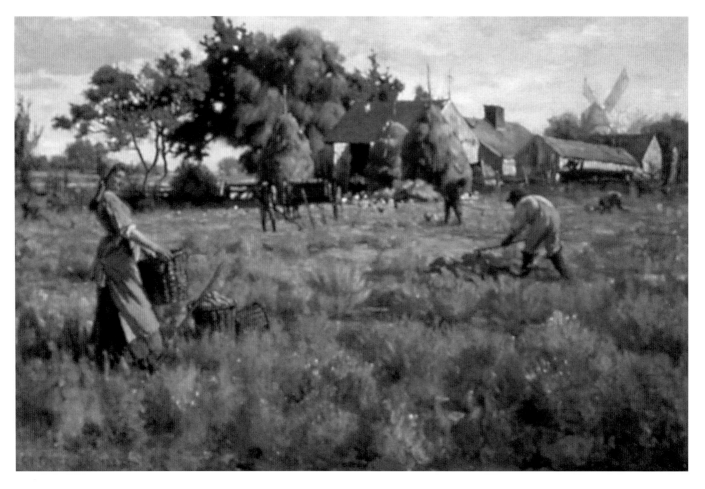

Hampton and Amagansett to Montauk, and the whole region became accessible to tourists from New York City and its eastern suburbs.

Already in 1883, *Lippincott's Magazine* had dubbed East Hampton the American Barbizon, where portable easels and sunshades punctuated the fields and farmyards, the Art Students League conducted a summer sketching class, and critiques were held in the former Clinton Academy building, then the village hall. Two years later, when *The Century Magazine* described East Hampton as "a true artist colony, and perhaps the most popular of adjacent sketching grounds for New York artists," the town had grown enough to support a weekly newspaper. In its very first issue, the fledgling *Star* (later renamed the *East Hampton Star*) noted the sale of a watercolor, *Village of Amagansett*, by William Trost Richards, and subsequent issues regularly reported on the community's growing cadre of artists. None were followed more avidly than the Moran family, headed by the renowned landscape painter Thomas Moran and his wife, Mary Nimmo, a noted etcher. Although not members of the Tile Club, the couple had heard from their friend Laffan about the East Hampton pilgrimage and paid their own visit to the village the same summer. They fell in love with

the place, and five years later, in 1884, erected the area's first purpose-built studio-residence. The house still stands at 229 Main Street, opposite what was then called Goose Pond, now Town Pond—where, after visiting Venice, the unconventional Morans installed a genuine Venetian gondola.

Famed for his dramatic Yellowstone panoramas, Thomas Moran was surprisingly responsive to the less imposing scale of the local landscape and its domestication. As art historian Phyllis Braff has observed, his conversion had a "timeliness with regard to changing American taste. By 1878 the avant-garde had moved away from grandiose settings toward landscapes suggesting a more personal, intimate response to nature." The Morans delighted in the area's "antique rural charm," so reminiscent of their native Britain, which they captured in atmospheric oils and exquisite etchings. The Moran clan included no fewer than sixteen painters, printmakers, and illustrators; whenever the family gathered at "The Studio," East Hampton had an instant art colony. Frequent guests included Thomas's brother, Edward, a marine painter, who came over from nearby

BELOW: Thomas Moran outside The Studio, ca. 1900.

BOTTOM: Miss Annie Huntting's boarding-house, Rowdy Hall, in Main Street, East Hampton, about 1890. The Presbyterian Church is at the right.

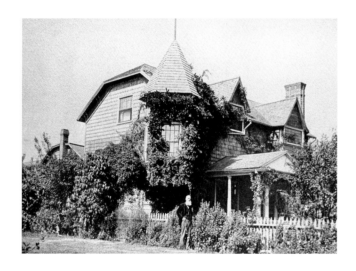

Greenport, and Edward's sons Percy and Leon, who put up at "Rowdy Hall," Annie Huntting's boardinghouse next door to the Presbyterian church. The God-fearing locals evidently regarded the establishment—where all-night poker games were known to attract some of the village's weaker-willed menfolk—with a certain degree of disapproval. In turn, they were baited on their way to Sunday morning services by the disrespectful boarders, self-described by Percy as "carefree young men just back from Paris and their art studies there," who would "open all the windows, put their feet on the window-sills and wave their beer mugs . . . and sing their most ribald French songs to the pious passersby."

In the summer of 1890, the *New York Evening Post*, reporting the art colony's social calendar, noted that C. M. Dewey was leading a sketching class of twenty-four students in Amagansett, that the Moran brothers were again comfortably in residence at Rowdy Hall, and that art exhibitions would be held across the street at Clinton Hall. The old Clinton Academy's upstairs rooms were often rented out as studio space, where informal

gatherings of artists were a regular feature of the summer colony. Another highlight of the social season might be a musical evening at the Morans', with Percy, Leon, and their cousin Paul (Thomas and Mary's son) on guitar, mandolin, and violin. The Studio was also the scene of *tableaux vivants*, with members of the Moran family posed in period costumes as "living pictures." In 1891, these entertainments were praised in the *Star* as tastefully executed "with the artistic skill that has already made the name of the Morans celebrated in this line."

Thomas and Mary enjoyed professional recognition throughout the 1890s, but tragedy struck in 1899 when Mary died of typhoid fever. The epidemic that swept eastern Long Island began with the return of the Rough Riders from the Spanish-American War. The troops, billeted at Camp Wikoff in Montauk, brought the disease from Cuba and spread it to the local populace. Thomas Moran continued to use the East Hampton studio until 1922, when he moved to California. His

Members of the Moran family and friends in costume for *tableaux vivants*, in the garden of The Studio, East Hampton, ca. late 1890s.

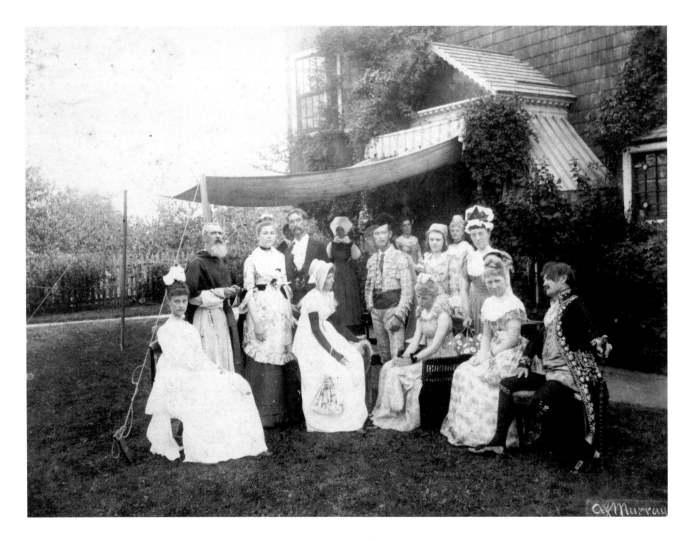

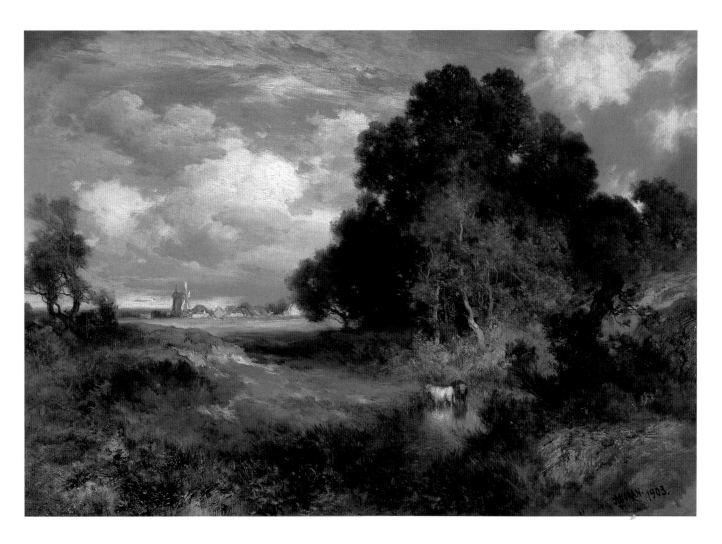

Thomas Moran,
A MIDSUMMER DAY,
EAST HAMPTON,
LONG ISLAND, 1903.
Oil on canvas,
14 x 20 inches.

daughter Ruth inherited it after his death in 1926. His grandnephew Edward, also an artist, lived across the street on James Lane. Both houses overlook the tranquil, willow-bordered Town Pond, a favorite motif of East Hampton's landscapists, and the South End Cemetery, site of the Moran family crypt.

Given East Hampton's high profile as an artists' destination, it is surprising that the town did not foster a formal school of outdoor painting. That distinction went to Southampton, fifteen miles to the west, where William Merritt Chase established the Shinnecock Summer School of Art in 1891. Although a Tile Club member, Chase had not been on the 1878 trip. His first visit to the area was in 1890, as a guest of Mrs. William Hoyt, a socially prominent amateur artist who summered in Southampton. Chase was already one of America's best-known painters, and his dynamic personality had made him a popular teacher. With its convenient rail access, Southampton was well established as a fashionable summer resort, and Mrs. Hoyt, who had been introduced to outdoor painting on her trips abroad, offered to help Chase set up a country branch of his New York City

Mary Nimmo Moran,
SUMMER, EAST-
HAMPTON, 1883.
Etching, 12 x 9³/₄ inches.

painting class. Plenty of attractive subject matter abided in this community, described in a contemporary account as "full of relics of the long buried past [and] teeming with associations and traditions of our young country's antiquity." Mrs. Hoyt and two of her friends, Mrs. Henry Kirke Porter and Samuel L. Parrish (who would soon make an even more lasting contribution to the village's cultural life by building the art museum that now bears his name), provided the financial support and the property on which the school was constructed. They also financed Chase's nearby studio-residence, designed by his friend and fellow Tile Club member, the eminent architect Stanford White. The spacious shingled

building where Chase and his family spent summers from 1892 to 1902 is featured in several of the artist's most famous Shinnecock canvases—luminous landscapes and sensitive figure studies that are now considered his finest works.

The philosophy of the Shinnecock school, which operated for twelve summers and attracted as many as a hundred students a season, was, according to the 1899 *American Art Annual*, "to afford both men and women facilities for studying art in the open air." The fashion for working *en plein air*, as opposed to making finished canvases in the studio from sketches done in the field, was taking hold with a generation of painters eager to emulate the success of the French Impressionists. Students, it seems, ranged throughout the dunes, into the farm fields, and along the country lanes—virtually everywhere within biking distance of the Art Village, the cluster of residential cottages that surrounded the school's main building, where classes were held in the evenings and on rainy days. Notwithstanding the seaside scenery, quaint settlements, and rustic natives, the primary attraction was the opportunity to receive instruction and criticism from the charismatic Chase. He emphasized spontaneity and advised his students to "play with your paint, be happy over it, sing at your work."

William Merritt Chase,
AT THE SEASIDE,
ca. 1892. Oil on canvas,
20 x 34 inches.

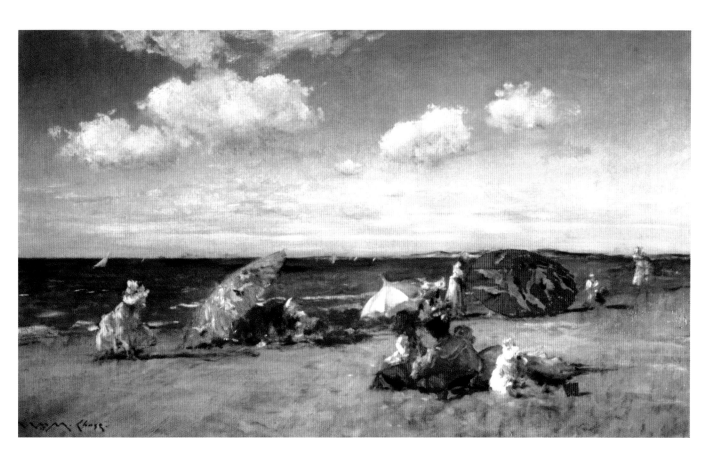

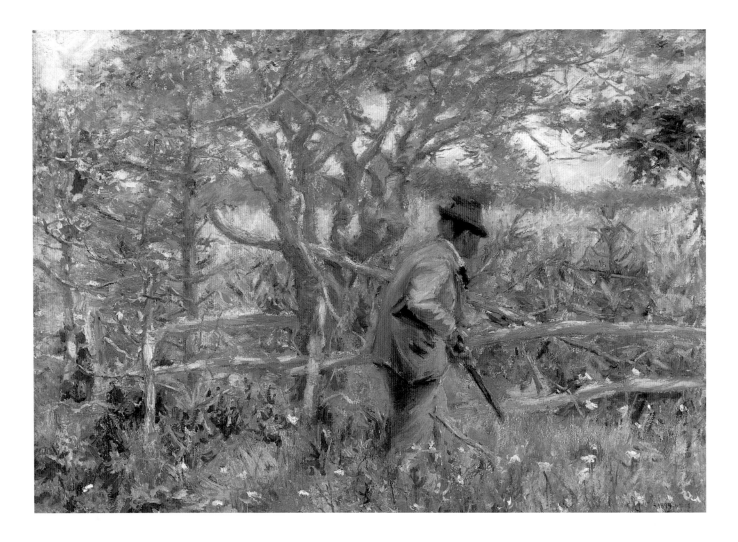

Reynolds Beal, CAPTAIN
HARLOW'S LOT,
SOUTHAMPTON, 1894.
Oil on canvas,
26 x 36 inches.

Chase was such a draw that his weekly critiques were open to the public. As described by Marietta M. Andrews in her 1927 book, *Memoirs of a Poor Relation*, "this was as good as a bull-fight to the cottagers and loungers from the hotels. . . . Carriages and motors were at the door, the 'nobility' with their lorgnettes ready, the students all sitting on little camp-stools before a large revolving easel. While Chase criticized the studies on one side, a servant filled the other side with more—thus it went round and round, until hundreds of daubs had met their fate." Many of those daubs were produced by novices who later made names for themselves in American art, including Rockwell Kent, Joseph Stella, the brothers Gifford and Reynolds Beal, Howard Chandler Christy, and Charles W. Hawthorne, who went on to found his own influential school of plein air painting at Provincetown.

One of Chase's students was Annie Burnham Cooper, a Sag Harbor native who later gained recognition as a poet and local historian as well as a painter specializing in scenic views of the region. She was born in 1864 and, according to

her diary, even as a teenager was determined to become an artist. Her father, who operated whaling vessels out of the port, evidently indulged her youthful ambition and paid for art classes locally and in New York City before she studied with Chase at Shinnecock. But for Cooper, art was more than just a suitable hobby for a well-bred young lady—she saw it as a route to financial independence and self-sufficiency. "May it not be possible that my Art is yet to help me fight the battle of life?" she wondered, later adding a frank statement that echoed the sentiments of many women of her generation: "I want to earn by my work." Although Cooper eventually shelved her professional aspirations in favor of marriage and motherhood, she did not entirely abandon the artistic dreams she expressed so vividly in her journal. She continued to paint, and her historical pamphlet titled *The Story of Sag Harbor*, published under her married name of Annie Cooper Boyd, was illustrated with her own drawings. At the time of her death in 1941, the *Sag Harbor Express* reported that "her paintings, largely of Long Island scenes, have been valued and carried away to all parts of the world."

Five years after Annie Cooper was born, Abraham and Eliza Draper Ward, free blacks living in Sag Harbor, gave birth to a daughter, Olivia. The Ward family

Annie Cooper Boyd, TOLL GATE, EAST HAMPTON TURNPIKE, ca. 1920. Watercolor on paper, 3 x 5 inches.

Toll-Gate To Sag Harbor - from Easthampton - L.I.

had been free since 1810, the Drapers since 1830; both Abraham and Eliza were also part Montauk. Their little girl was to become Olivia Ward Bush-Banks, a poet, playwright, and journalist. Eliza died when Olivia was just nine months old, and her father placed her in the care of her mother's sister in Rhode Island. This aunt kept their Montauk Indian and African-American heritage alive in the child and, as biographer Bernice Guillaume notes, from this "ethnic combination . . . emerged an extraordinary woman and writer."

Throughout her life—in Rhode Island, Chicago, and New York—Bush-Banks revealed her pride in her dual heritage. Although not a resident of Long Island, at one time she served as tribal historian to the Montauks and, as an adult, she regularly attended tribal powwows and other gatherings. Bush-Banks's play *Indian Trails; or, Trail of the Montauk* explored the Montauks' extinct language and the survival of their culture. Her poem "Morning on Shinnecock" expresses the nostalgia, yearning, and apprehension evoked by her relationship to eastern Long Island's earliest residents.

Bush-Banks also affirmed her African-American roots—in poems dedicated to Frederick Douglass and Charles Dunbar, for example, and in the essay "Hope," published in the journal *Driftwood* in 1914. In it she writes eloquently on the racial issue in America:

> If in the intensity of his soul, the artist of today desires to paint a true picture of the present attitude of the American mind toward a part of its citizenship, he might portray upon his canvass the following scene—an American citizen of darker hue, with manly bearing, standing, with outstretched hands before the closed door of a miniature institution known as "Progressive Civilization," and behind him, a lawless mob. Beneath this he might well write the convincing words:
>
> "Predjudice [*sic*] and Lynch Law—The Curse of the Twentieth Century."
>
> But, happily, amid the wreckage, despite the turbulence, the floating spar of Hope is seen, making its way toward Right and Justice.

BY THE TURN OF THE TWENTIETH CENTURY, both East Hampton and Southampton had settled comfortably into their roles as artists' retreats. Although the Shinnecock School closed after the 1902 season and William Merritt Chase began leading summer art tours to Europe, many of his former students had put down roots in the region. Friends who had visited the Morans were buying land and building their own studio-cottages. Several of the recent arrivals, establishment by birth but bohemian by inclination, had a foot in each camp. The

Morning on Shinnecock

The rising sun had crowned the hills,
And added beauty to the plain;
O grand and wondrous spectacle!
That only nature could explain.

I stood within a leafy grove,
And gazed around in blissful awe;
The sky appeared one mass of blue,
That seemed to spread from sea to shore.

Far as the human eye could see,
Were stretched the fields of waving corn.
Soft on my ear the warbling birds
Were her[al]ding the birth of morn.

While here and there a cottage quaint
Seemed to repose in quiet ease
Amid the trees, whose leaflets waved
And fluttered in the passing breeze.

O morning hour! so dear thy joy,
And how I longed for thee to last;
But e'en thy fading into day
Brought me an echo of the past.

'Twas this, —how fair my life began;
How pleasant was its hour of dawn;
But, merging into sorrow's day,
Then beauty faded with the morn.

—Olivia Ward Bush-Banks, 1899

Olivia Ward Bush-Banks, poet and occasional historian of the Montauk Indians, ca. 1900s.

painters Francis and Richard Newton, for example, were sons of the Rev. Richard Heber Newton, a well-to-do minister who is credited with building East Hampton's first dune house in 1898. The Newton brothers founded the Suffolk Hounds, a foxhunting society, and were charter members of the exclusive Maidstone Club, where Thomas Moran's name is also on the founders' plaque. Muralist Albert Herter belonged to the family that made Herter Brothers furniture and Herter Looms tapestries. When he married the pastel painter Adele McGinnis in 1893, his mother's wedding present to them was a cottage and seventy-five acres of land on Georgica Pond. In 1899, the couple commissioned the society architect Grosvenor Atterbury, who had just completed Samuel L. Parrish's Southampton Art Museum, to design The Creeks, an Italianate villa with his-and-hers studios, extensive gardens, and one of the most idyllic locations in the Hamptons. Like Chase, these artists were as comfortable in drawing rooms and garden parties as they were in the studio.

The Maidstone Club, ca. 1930s.

One of the most distinguished members of the social-cum-artistic set was the American Impressionist painter Frederick Childe Hassam. Proud of his Puritan heritage—his Arab-sounding surname is actually a variant of the English name Horsham—he often painted in New England locales, including Old Lyme, Gloucester, and the Isles of Shoals. In the summer of 1898, he and his wife visited an old friend, Gaines Ruger Donoho, a landscape painter who had bought a cottage on Egypt Lane in East Hampton. The Hassams returned frequently during the following two decades, and in 1919 made the village their permanent summer home. Over the next fifteen years, Hassam produced innumerable paintings, drawings, and etchings of local subjects, including the area's distinctive, English-style smock windmills; Home, Sweet Home; and other landmarks. Main Street, with its avenue of stately elms, was a favorite motif. A dedicated golfer, Hassam often pictured the Maidstone links, with their curious natural sand traps.

The rural character of the village center had long since given way to residential development, and many of Hassam's works reflect the increasing domestication. Recalling his attraction to Willow Bend, the eighteenth-century shingled house he had purchased from Donoho's widow, Hassam registered his protest against any attempt to clean up the wild undergrowth along Egypt Lane. "East Hampton could very easily be made into a combed and manicured suburb—a New Rochelle—but it must not happen!" he advised an *East Hampton Star* reporter in

Charles de Kay, editor, poet, and critic, ca. 1900.

1923. Nevertheless, there was already little doubt that gentrification had worked to the artists' disadvantage, and had discouraged a new generation from perpetuating East Hampton's artistic tradition.

In his essays, the novelist, translator, and critic Charles de Kay also sounded the alarms of change. Once called by an admirer "the master of more branches of Knowledge than any man I have ever met—art, science, philosophy, Oriental lore, to general literature," de Kay ornamented salons in New York and abroad, counting among his acquaintances and friends Henry James, Robert Browning, and James McNeill Whistler. In the 1870s, when he was just beginning to make his way in social and literary circles, he was known as the "Charmer of New York." At various times between 1876 and 1917 he served as literary or art editor at the *New York Times*, the *New York Evening Post*, and *Art World* and was a member of the Institute of Arts and Letters.

"East Hampton the Restful," his earliest article on the subject, appeared in 1898. It was a wry and amusing look at the manners of the popular resort. "People have so far avoided the absurdity of repeating in Summer the same things they do in Winter," he wrote.

"The law as to the sale of liquor has been enforced; the one man in the township who is charged with selling in secret has failed and his store is closed." De Kay also wondered how long East Hampton would retain its soothing atmosphere. Though it was still a place where one could "bathe without caring for looks or asking what is the correct thing in bathing suits," he feared that if "very costly country places" were built, "those who know and love East Hampton will regretfully turn their backs and seek some other place where there is a chance for rest and pensive sojourn among country sounds and picturesque views of shore and sea." There was another threat: while the settlers of two centuries earlier knew the "severity of nature" and did not plant their homes close to the sea, city folks "cannot get close enough."

Despite his perception of its inevitable growth and change, de Kay loved East Hampton. His 1903 essay, "Summer Homes at East Hampton," was a paean to unpretentious cottages. He painted a loving portrait of the landscape: "A line of wooded hills on the one hand, a low undulation of dunes on the other; here a glimpse of lake or pond, there the blue of ocean served up between two sand hills, as in a bowl; here a wedge of wind-clipped trees hiding a village street, and yonder a long vista of arable lands, pastures, and salt marshes." Applauding the summer visitors who did not build the costly homes they could have afforded but instead conformed to the local spirit of simple living, he wrote, "The only fear that seems to haunt the summer folk in the old camping ground of the Montauks is a speculation whether the time may come for the advent of those who build great places and try to out-do their neighbors in luxury, thus gradually destroying the informal, easy-going life by the sea which still puts East Hampton apart from many other less fortunate watering places."

The artist population of eastern Long Island gradually declined through the first decades of the new century. On a chance visit to Sag Harbor in 1922, the painter James Britton found the port to be a "sleepy little village" where nothing much was going on, especially for artists. As it happens, solitude and relief from "the strutting exhibitioners" of New York's art world were precisely what he was searching for. In those days, he wrote in his unpublished autobiography,

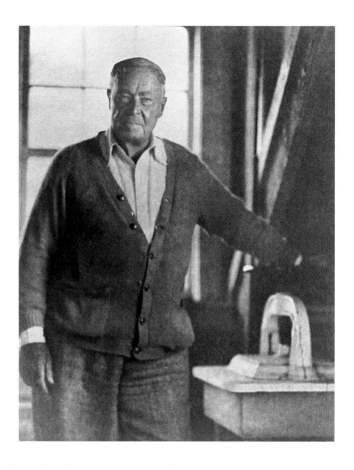

ABOVE: Frederick Childe Hassam in his studio at Willow Bend, East Hampton, ca. 1930.

OPPOSITE: Frederick Childe Hassam, OLD HOUSE AND GARDEN, EAST HAMPTON, LONG ISLAND, 1898. Oil on canvas, 24¼ x 20 inches.

Southampton was the "fashionable watering-place for New York's socially elect . . . certain others went to East Hampton, and still others to Hampton Bays. No one went to Sag Harbor. That was as it should be. Very often I rolled in on the little steam train, in the dark, the sole passenger making the change from the New York train at Bridgehampton." Passenger traffic all but ceased during the next decade, and in 1939 the Sag Harbor spur line was closed altogether.

James Britton, STUDIO INTERIOR, SAG HARBOR, 1925. Oil on canvas, 24 x 36 inches.

IN THE 1920s, five New York City writers—Ring Lardner, Grantland Rice, Irwin S. Cobb, Percy Hammond, and John Wheeler—settled into the best areas of East Hampton. Wheeler and Rice were journalists; Cobb, a humorist known as the "Sage of Paducah"; Hammond, a drama critic for the *New York Herald Tribune*; and Lardner, a journalist who had books, films, nonfiction, plays, songs, comics, and short stories to his credit. The Hammonds moved an old house to Hither Lane. The Cobbs bought the cottage next door. The Wheelers moved into Lily Pond Lane. The Lardners and the Rices, the closest of the friends, purchased four-acre oceanfront lots and built their houses side by side. Lardner and Rice and their wives made an affectionate foursome. Still, it was, as

the critic Jonathan Yardley suggested, "a thoroughly peculiar friendship. Rice was as ebullient as Ring was reticent, as sentimental as Ring was skeptical, as corny and obvious as Ring was subdued and subtle." While their writing styles were also markedly different, he continued, "the two men had a lively mutual interest in sports, gambling, and strong drink."

The Lardners and the Rices moved to East Hampton in search of the cleanest air possible—for reasons of Lardner's health—and for a quiet country life.

Ring Lardner (LEFT) and songwriter and producer Gene Buck, late 1920s.

Despite de Kay's fears a generation earlier, both were still in ready supply. From the porch of his expansive cottage, Rice wrote, "we could stare straight out and into the bull rings of Lisbon . . . or perhaps it was the clearness of the gin cocktails. At any rate, nothing but gulls, whales, and water separated us from Portugal and Spain." On the lawn that separated the two houses, Rice created a reasonable facsimile of a nine-hole golf course that also accommodated croquet, archery, and horseshoes. On summer Sundays he hosted not only Lardner, Cobb, Hammond, and Wheeler but scores of others from the New York sports and journalism worlds.

Lardner, Rice, and Cobb used their second-home experiences as fodder for their journalism. Lardner's "High Rollers," which appeared in *Hearst's International Cosmopolitan* in June 1929, was headed as being a "wee bit autobiographical" and revolved around friendly card games spiraling out of control.

> It soon became an understood thing that the four families—the Parkers, Harts, Bowens and Finches—would spend their Friday, Saturday, and Sunday evenings playing contract, at some house other than the Finches', which was too small. The men always played together at one table and the women at another.
>
> Walter [Finch] announced that he couldn't go higher than five cents a point; in fact, that was much higher than he ever had gone before. The other men said that was all right, but they were playing among themselves for ten, which Walter thought at first meant ten cents, but soon discovered was a hundred times that much. He got a shock one night

when the totals were announced and it was found that [Dick] Parker was three thousand points up on Hart. Just a matter of thirty thousand dollars.

"I'll play you a cold hand for it, Dick," suggested the loser.

"All right; just one," said Parker.

Two poker hands were dealt and Parker won with two pair against four clubs and a spade.

"Another one?" asked Hart.

"Not tonight," said Parker.

"O.K. That's sixty thousand," said Hart, and set about getting his wife started for home.

The twenties in East Hampton were a continual party for the Lardners, the Rices, and their friends. But the drinking that began when Ring Lardner was a teenager eventually took its toll. Lardner died on September 25, 1933, at the age of forty-eight. Rice was deeply affected by his friend's death and the subsequent loss of others from the East Hampton group. In his memoir, *The Tumult and the Shouting*, he speaks with nostalgia of the old days: "You could sit down and write a long book about such people as Lardner, Crowninshield, Hammond, Ross, Cobb, and others with whom we spent so many never-to-be-forgotten afternoons in other days and other years. They live with me today as they did years ago. . . . There have been many other friends, but these have contributed more to the happiness of my wife and me over past years than perhaps any others. For they came to us when the sun was just above the meridian, before sunset was due."

These joyous times had been spoiled before Lardner's death. The stock market crash of October 1929 signaled an end to the country's flamboyant economic boom, and it brought hard times to the five writers.

While eastern Long Island's economic mainstays of agriculture, fishing, and tourism were hit hard by the Depression, there were still wealthy people who could afford to summer in the Hamptons. Among them was Mrs. Lorenzo E. Woodhouse, East Hampton's lady bountiful. The Woodhouses had built a village estate, The Fens, in 1899, and thereafter Mrs. Woodhouse devoted considerable time, energy, and money to neighborhood preservation and improvement projects. She financed the restoration of Clinton Academy, though the renovation destroyed the village's assembly hall and meeting rooms, which were also used as artists' studios and exhibition galleries. This prompted Mrs. Woodhouse to

Frederick Childe Hassam,
THE GUILD HALL,
EAST HAMPTON, 1931.
Etching, 6³/₈ x 8¹/₄
inches.

propose a community cultural center, including a small theater. Nelson C. Osborne, a descendant of one of the town's oldest families, and the sculptor Maud Jewett encouraged her to provide an art gallery where the scope and importance of artists' activity in the region could be adequately represented. Mrs. Woodhouse conceived of a headquarters for an association of like-minded citizens devoted to artistic and educational pursuits, naming it Guild Hall. She committed the new center to high standards of quality in the arts. Its construction would also provide sorely needed work for the town's many unemployed builders.

On August 19, 1931, natives and summer folk alike crowded into Guild Hall for opening ceremonies. There was praise for the building's architect, Aymar Embury II, and his wife, landscape architect Ruth Dean, who designed the gardens, and a testimonial to Mrs. Woodhouse, who had donated the land and

$100,000 to the construction fund. Childe Hassam dedicated the main gallery to the memory of Thomas Moran, whom he credited with establishing the village as an artists' retreat. The inaugural exhibition was a tribute to the Tile Club and their contemporaries, in recognition of the role they had played in "discovering" East Hampton. But most of the so-called discoverers were long dead, and the economic conditions of the Depression decade did not favor a renaissance. Although Hilton Leech's Amagansett School of Art, established in 1933, did much to sustain creative activity in the area, in those years it was more transient than permanent.

In August 1935, when the art colony held its first exchange exhibition with another similar community, the choice was genteel Newport, Rhode Island; not

William J. Whittemore,
AUTUMN IN OLD EAST
HAMPTON, 1901.
Oil on canvas,
28 x 36¼ inches.

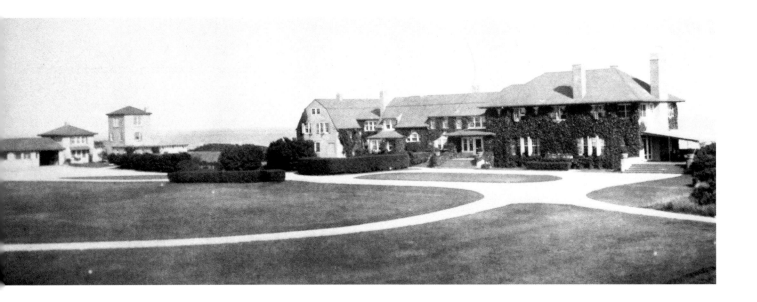

bohemian Provincetown, Massachusetts; or Woodstock, New York. Only six painters—none of them financially insecure—represented East Hampton: Francis and Richard Newton, Hamilton King, Helen and William J. Whittemore, and Adele Herter. These were not the only artists in residence at the time, but there were only a handful more. The Newport Art Club that year awarded Hassam its John Elliott Memorial Prize "for the greatest artistic imagination." His ill health may have prevented his inclusion in the exhibition; he died twelve days after its opening. Realizing that death was near, Hassam had hired an ambulance to take him from New York City to East Hampton, where he ended his days in the village he loved.

O N SEPTEMBER 21, 1938, a devastating hurricane battered the entire Northeastern seaboard. The eastern coast of Long Island was especially hard hit. Among the hundreds of buildings damaged or destroyed was Swan Cove, the East Hampton home of Sara and Gerald Murphy, whose personalities had been mined by F. Scott Fitzgerald to create Nicole and Dick Diver in *Tender Is the Night.* The storm also suggested a larger cataclysm to Katy Dos Passos, wife of novelist John Dos Passos. She wondered in a letter to Sara Murphy on October 8: "Do you think these convulsions of nature are accompanying political disturbances like they used to in Sartonius . . . Well, I don't know—but it's funny we have a hurricane just while Hitler is starting to march." The parallel was apt. On that very afternoon Czechoslovakia fell, and less than a year later Hitler invaded Poland. The Second World War had begun.

THE MURPHYS

In *Everybody Was So Young,* her 1998 biography of Gerald and Sara Murphy, Amanda Vaill describes the East Hampton social scene early in the twentieth century, when the wealthy Wiborg family entertained lavishly at their estate, Dunes: "There were golf games and amateur theatricals at the Maidstone Club, horse shows and dog shows in neighbors' paddocks, parties on friends' porches and sloping lawns." It was at one of these events that Sara Wiborg met Gerald Murphy, five years her junior. Still in prep school, Murphy was being groomed for his father's company, Mark Cross, but daydreamed of travel and adventure.

For the romantic Gerald and sophisticated, fun-loving Sara, their 1916 marriage was an antidote to the stifling conventions of their families' haute-bourgeois milieu. He urged her to "think of a relationship that not only does not bind, but actually lets loose the imagination!" Like other daring young moderns, well-heeled and impoverished alike, they spent the 1920s in France, where they socialized with the Parisian avant-garde and American expatriates of the so-called Lost Generation. Gerald briefly pursued a career as an artist, while Sara beguiled Picasso, who painted and sketched her as the mysterious "Woman in White." At Villa America, their Cap d'Antibes retreat, they hosted a virtual open house for their artist and writer friends. That idyll ended in 1929, when their son Patrick contracted tuberculosis. Four years later they were back in the United States, desperately but unsuccessfully seeking a cure. Patrick died in 1937, soon after his brother Baoth succumbed to meningitis.

Despite these tragic losses—as Ernest Hemingway put it, the Murphys "lived to have all of their bad luck finally; to the very worst end"—their legendary joie de vivre never deserted them. At Sara's funeral in 1975, Archibald MacLeish remarked: "Person after person—English, French, American, everybody—met them and came away saying that these people were really mastering the art of living."

Swan Cove, a renovated farmhouse on the Wiborg estate, was the country retreat of Gerald and Sara Murphy.

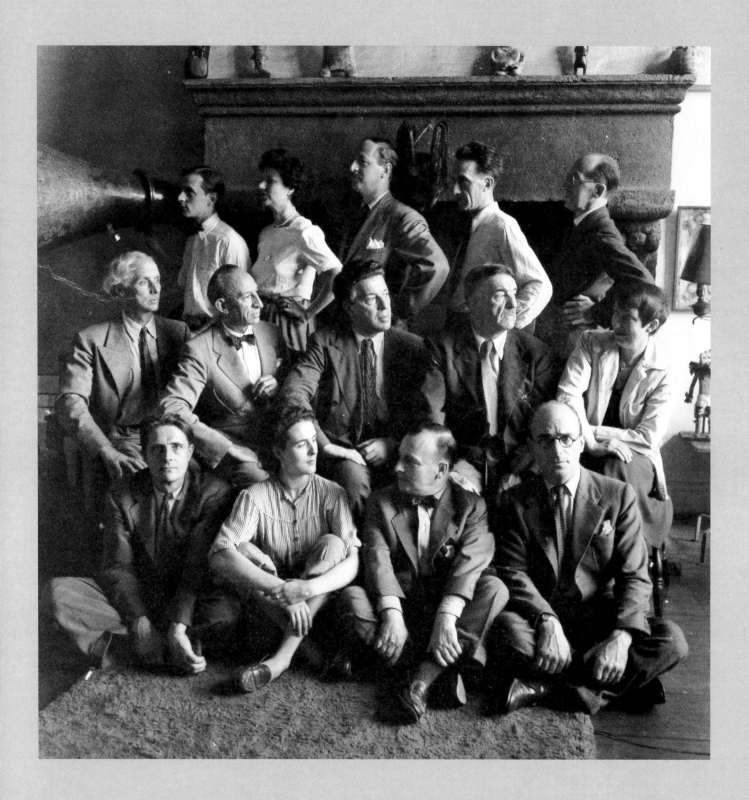

Old Guard to Vanguard

WORLD WAR II TO 1960

TO READ THE advertisements in the *Southampton Press* for December 1, 1939, gives no inkling that Hitler's forces had invaded Poland three months earlier. One could have a complete dinner out for as little as 65 cents, or dine at home on prime rib roast, at 29 cents a pound. *Mr. Smith Goes to Washington* was playing at the local theater. As normal as most things appeared, though, the East End was seeing glimmers of conflict on the horizon and was in fact home to a rankling debate about the appropriate international role of the United States. An editorial advised that Americans should keep out of the war and cautioned readers to stop thinking about Europe and to concentrate instead on domestic problems. If Washington continued to indulge in extravagant spending and high taxes, the writer believed, there was more danger of dictatorship here than in Europe. However, others were not so isolationist: the paper that day also included a story on the Polish Relief Committee, with a long list of local contributors.

The war affected the East End in a way the editorialist never could have imagined. With the outbreak of hostilities in Europe, New York City became a haven for artists, writers, scientists, and intellectuals fleeing Nazi persecution. Whether artistically radical, politically left-wing, or non-"Aryan," those identified by the Fascists as degenerate or undesirable were forced to flee or perish. Among the many who found refuge in America was a large contingent of Surrealists, including poet André Breton, Paris-based printmaker Stanley William Hayter, and painters Max Ernst, Marcel Duchamp, Fernand Léger, and Jean Hélion. (Many of these émigrés had been saved by the American Varian Fry, who

had housed them at Villa Air-Bel in Marseilles until discovery by the Nazis made an exodus to New York necessary.) Expatriate Americans and Latin Americans who had been living in Europe's cultural capitals were also on the run from the Nazis, among them the painters Roberto Matta, Wifredo Lam, and John Ferren, and the eccentric art collector and patron Peggy Guggenheim. As the cultural capital of the United States, New York City was the obvious place for émigrés and exiles to call home, at least temporarily.

This influx had far-reaching consequences, for it helped cement New York's role as the center of artistic and literary modernism in the second half of the twentieth century. But it was also decisive in reestablishing eastern Long Island as a mecca for artists and writers. The annual summer migration from the stifling city to idyllic country retreats was a routine the European exiles had no intention of forgoing, especially when patrons were willing to play host. Among the first to take advantage of Hamptons hospitality were Léger and his traveling

Lucia, Maria Motherwell, Dorothea Tanning, and Max Ernst as nymphs (and satyr), Amagansett, 1945.

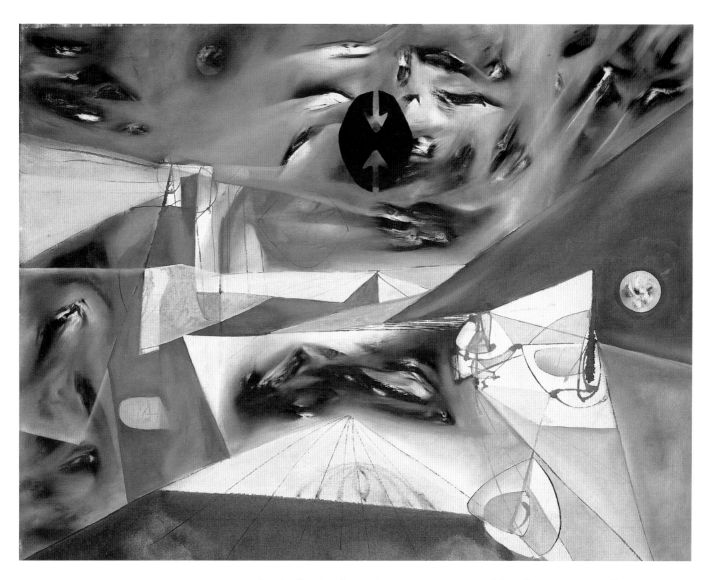

Roberto Matta,
GENESIS, 1942. Oil on
canvas, 28 x 36 inches.

companion, Lucia Christofanetti, an artist who used her first name profession-
ally and was associated with the Surrealists in Paris. The couple left Europe in
September 1938 under the auspices of Gerald and Sara Murphy. After sitting out
the hurricane in New York Harbor aboard the *Normandie*, they soon joined their
benefactors in East Hampton. The Murphys had plenty of room for guests in
the various outbuildings of Sara's family's sprawling estate, Dunes, adjacent
to the Maidstone Club, where East Hampton's elite golfed, swam, and dined.
Just as the couple's celebrated Riviera retreat, Villa America, had welcomed the
writers and artists who made up Hemingway's "moveable feast," their home in
East Hampton became a haven for visiting expatriates.

Léger and Lucia were given the use of a cottage at Dunes, and Lucia was so
taken with the area that she eventually settled in nearby Amagansett. Her enthu-
siasm attracted other expatriates, as well as their American admirers. Jimmy

Ernst, Max's son, recalled a visit to Lucia's Amagansett rental—which she shared with Max and his American lover, artist Dorothea Tanning—in the summer of 1945, when Breton, Ernst, Duchamp, Hélion, and Léger socialized, played chess, and argued Surrealist theory with American artists David Hare and Robert Motherwell. Meals were as improvisational as their Surrealist parlor games, sometimes incorporating dandelion greens, wild mushrooms, and junk fish left on the beach by haul seiners.

For trips to the beach, the ladies of the group improvised Continental-style string swimsuits that raised eyebrows among the locals. Not only were the costumes exotic by neighborhood standards, but the cast of characters was decidedly polyglot and therefore doubly suspect. In addition to the French contingent, the group included the German Ernst and Italian Enrico Donati (both ostensibly enemy aliens); Japanese-American sculptor Isamu Noguchi; Romanian-born architect Frederick Kiesler; Sonia Sekula, who was from Switzerland; and the Chilean Matta; all of whom visited Lucia, a native of Lebanon.

Hampton Bays also attracted a number of expatriate artists during the war years. David Burliuk, a leader of the Russian Cubist-Futurist avant-garde who had come to New York in the 1920s, evidently chose the village for strategic reasons. When the war broke out he decided to quit New York City, fearing an

Sara Murphy, Fernand Léger, and Ada MacLeish, 1940s.

THE SUBMARINE

from "The Spies Who Came in from the Sea," by W.A. Swanberg

Few Americans remember even hazily what they were doing on the night of June 13, 1942. John C. Cullen remembers exactly what he was doing. He remembers with special vividness his activities at around twenty-five minutes past midnight. He was patrolling the lonely Atlantic beach near Amagansett, Long Island, 105 miles east of New York City. He did this every night—a six-mile hike. At that moment he was coming out of a thick patch of fog to run head-on into what seemed to be a Grade B movie thriller, but which turned out to be real life, with intimations of real death.

Cullen was twenty-one, a rookie coastguardsman, unarmed. America, at war with the Axis powers more than three thousand miles away, was yet worried enough about invasion, sabotage, and sneak attacks that houses were blacked out and coastlines were watched. Many good citizens thought this an excess of caution. Cullen himself says now that the last thing he expected to encounter was a party of invading Nazis just landed from a German submarine. . . .

A man emerged from the mist—not too surprising, for some fishermen stayed out all hours in the summer. Cullen shone his torch on the stranger's face. "Who are you?" he asked.

(The stranger was George Davis, a German-American recruited by Nazi intelligence who, on this foggy morning, was one of four German agents dropped off by submarine. Although their mission was to create mayhem in America with incendiary devices, they turned themselves in to the FBI within a few days.)

onslaught like the Bolsheviks' siege of Moscow. In 1940, he and his wife bought a small house in Hampton Bays and moved there permanently the following year, when the United States entered the war. Ironically, eastern Long Island was in fact quite vulnerable to enemy attack, and the Coast Guard regularly patrolled the shore on the lookout for submarines—one of which evaded detection and landed a party of German would-be saboteurs on the Amagansett beach in 1942.

André Breton also spent time in Hampton Bays, though under less than convivial circumstances. Not long after he and his wife, painter Jacqueline Lamba, arrived in America, she left him for sculptor David Hare, taking their young daughter to live with her new lover. Breton was forced to accept the situation to maintain contact with his child. But he also had professional reasons: Hare edited Breton's Surrealist magazine, *VVV*. In 1943, the adulterous couple rented a summer cottage in Hampton Bays and invited Breton to visit. The awkward circumstances seem to have stimulated Breton's creative juices as much as his bile. While Hare and Lamba scandalized the neighbors by cavorting nude on the beach, he sat in the shade, fully dressed, composing such poems as "Les États généraux" and "War," which was published in the perhaps symbolically titled collection, *Young Cherry Trees Secured Against Hares*.

THE RATTRAYS

Jeannette Edwards Rattray, who with her husband, Arnold, owned the *East Hampton Star*, was an important interpreter of local experience during the war. In her weekly column, "Looking Them Over," Rattray, known to her friends as Nettie, linked the world of the East End to the larger events of those years. She recorded, for example, that Robert Sherwood had spent the summer of 1940 on Pudding Hill Lane, working diligently on the book version of *There Shall Be No Night*, his play about Finland's resistance to the invading Nazis. Her five-volume scrapbook of clippings from the paper affords a richly detailed picture of the war's effect on the area. The clippings include lengthy letters from East Enders living abroad and news of the invasion of Holland, Belgium, and Luxembourg and of the threat to Paris. One letter describes the December 1941 attack on London; another, dated August 1942, the fall of Singapore.

Apart from her contributions to the *Star*, the subjects of Rattray's writing were the sea and East Hampton itself. Descended from whalers, Rattray collaborated with her father to write *Whale Off!*, the story of how her grandfather and uncle captured "the last right whale on the Eastern seaboard." Lloyd Becker called two of her other maritime works, *Ship Ashore!* and *The Perils of the Port of New York*, "essential studies of Long Island maritime history." Her *East Hampton History* is an invaluable synthesis of earlier accounts, town records, and memoirs. And in another book, *Up and Down Main Street*, Rattray tells the lore of every old house and family. In her *Star* column, she once wrote that "we must not let East Hampton change too rapidly. We who have known it always appreciate its permanence all the more."

Jeannette Rattray's son, Everett, edited the *Star* from 1958 until 1980. Though he also wrote several books, it was as a newspaper editor that Everett attained his highest level of achievement. In an obituary, the author John N. Cole wrote that one of Rattray's great qualities as a newspaperman was his tolerance. "The *Star* was never snide; the *Star* never ridiculed; the *Star* absorbed celebrity vistas, nude bathing, homosexual romps, group tenants, traffic jams, poodle parlors, and television film crews with Everett's ever-present equanimity." After Everett's death, the paper was edited by his wife, Helen Seldon Rattray, whose weekly column, "Connections," carries on the Rattray tradition of lively commentary and personal insight. In 2001 their son, David, became the paper's editor, extending to the third generation the family's role as chroniclers of East End life.

War

I watch the Beast as it licks itself

The better to confound itself with all that surrounds it

Its storm-colored eyes

Are unexpectedly the pond dragging to itself the filthy linen the rubbish

The one that always stops man

The pond with its little Place de l'Opera in its belly

Because phosphorescence is the key to the eyes of the Beast

That licks itself

And its tongue

Thrust one never knows beforehand in what direction

Is a crossroad of braziers. . . .

—André Breton, 1943

One of the most productive and interesting of Jeannette Rattray's contemporaries—see "The Rattrays," opposite—was the poet John Hall Wheelock, a son-in-law of Charles de Kay. Wheelock spent eighty-six of his ninety-one summers in an East Hampton house his father had built. At the age of eighty-nine, he noted in an autobiographical essay written in the third person: "While his mother introduced him to the works of the principal poets, the labyrinthine paths, laid out by his father through an ever-deepening woodland, served as a perfect 'poet's walk.' . . . Here, as a boy of six, he scribbled his first verses, a feeble imitation of Sir Walter Scott." In the course of his long career, Wheelock produced eleven volumes of verse, a collection of criticism, and, as an editor at Scribner's from 1910 to 1956, published the work of numerous young poets. Those he discovered and first published include James Dickey, May Swenson, and Louis Simpson.

Wheelock wrote no poetry during his last fifteen years at Scribner's, taking up that vocation again only after he retired. Much of his work is intimately related to his East Hampton home, the area's "birds and insects, its woodlands, dunes, and beaches," and his formative experiences there. "Bonac," published soon after he retired, is a paean to the "enchanted country" he had learned to love. (The poem's title refers to the area around Accabonac Creek in Springs, where the inhabitants are known as Bonackers, a sobriquet now applied broadly to East Hampton natives.) "Afternoon: Amagansett Beach," published at the same time, describes in perceptive detail the place he had come to know so well.

TOP: Jeannette Rattray in Havana.

BOTTOM: Everett Rattray.

Afternoon: Amagansett Beach

The broad beach,
Sea-wind and the sea's irregular rhythm,
Great dunes with their pale grass,
 and on the beach
Driftwood, tangle of bones, an occasional shell,
Now coarse, now carven and delicate—
 whorls of time
Stranded in space, deaf ears listening
To lost time, old oceanic secrets. . . .

— John Hall Wheelock, 1956

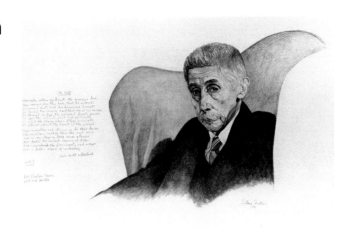

Victoria Fensterer, JOHN
HALL WHEELOCK, 1978.
Graphite on paper.

IN THIS POETIC SETTING, remote from world pressures, the European refugees were unexpectedly tolerant of the young Americans who fraternized with them. The Surrealists were notoriously aloof in New York City, where their superior airs were reinforced by a reluctance, and often an inability, to speak English. But in the relaxed atmosphere of country summers, with Francophones like the Murphys and Robert Motherwell and the English-speaking Marcel Duchamp and Roberto Matta as go-betweens, social tensions were eased and professional guards lowered if not dropped. The pivotal bilingual intermediary was Stanley William Hayter, a native of England, whose Paris printmaking studio Atelier 17 had been a hotbed of experimentation before the outbreak of war forced it to close.

Hayter transferred his workshop to New York in 1940. Four years later, he and his wife, American sculptor Helen Phillips, first visited eastern Long Island. By then the expatriate community had achieved a measure of notoriety. "A pair of women, all dressed up, stopped me on Amagansett Main Street," Phillips later recalled, "and said, 'We're from Southampton. Can you tell us where we'll find the Surrealists?'" Like the quaint windmills and shingled cottages, the artists themselves had become tourist attractions. But unlike the previous generation of art colonists, who looked outward to the coastal scenery and charming villages for their subject matter, the new group sought creative inspiration in the unconscious mind. And for them, economics and convenience took precedence in the choice of summer retreats. The Hamptons had obvious advantages over the established bohemian outposts of Provincetown on Cape Cod and Woodstock in upstate New York. Rentals outside the traditional resort sections were cheap, and

the area was readily accessible by rail and road—although wartime gas rationing made the train the more practical option. "None of us had much money, which is why we were there," Phillips said. "That and Provincetown's being too far from New York."

In the summer of 1945, the Hayters rented a shack at Louse Point in Springs, a hamlet of some three hundred souls a few miles outside East Hampton village. The primitive structure, without indoor plumbing or electricity, proved to be too remote for Hayter, who had to bike to the train station for his regular trips into the city, where Atelier 17 demanded his supervision. Hayter offered the use of the shack to his assistant, Reuben Kadish, who invited his friends Jackson Pollock and Lee Krasner, who were then living together, to share the place with him and his wife. Thus it happened that, by chance, Pollock and Krasner found themselves in Springs that August.

The Kadishes remembered the vacation as a carefree time, the days filled with bike rides, clamming, and good-natured horseplay, although Krasner was worried, as always, that Pollock's drinking would get out of hand. But compared to the city, where liquor and like-minded companions were plentiful, the country offered a respite from the social and professional pressures that literally drove Pollock to drink and caused Krasner such anxiety. The couple speculated about subletting their Greenwich Village apartment and finding a cheap winter rental out east, where they could concentrate on painting. They did a little house-hunting with the Kadishes in Amagansett, but it wasn't until they returned to the city after Labor Day that Pollock suddenly decided their pipe dream should become a reality. Their friends, writers Harold Rosenberg and May Natalie Tabak, had bought an old house on Neck Path in Springs, a neighborhood that had previously attracted few people "from away." If the Rosenbergs could manage it, Pollock and Krasner reasoned, so could they. They found a run-down property on Fireplace Road, and undeterred by a total lack of funds, Pollock decided to buy the place and settle down.

Bankrolled by a loan from Peggy Guggenheim, who had become his patron and ardent promoter, Pollock engineered the purchase and moved to Springs in November 1945. He and Krasner had married the previous month—a decision prompted, at least in part, by Krasner's belief that the local community would not welcome an unmarried couple. Their presence not only revitalized the moribund East Hampton art colony, it also changed its orientation from Barbizon-style landscape and genre painting to New York School abstraction. But no matter how abstracted, their imagery was shaped by phenomena—the night sky, wind, sea life, and the tangle of undergrowth—that they experienced as they relaxed on their porch, walked through the woods, or strolled along the beach. Soon after leaving

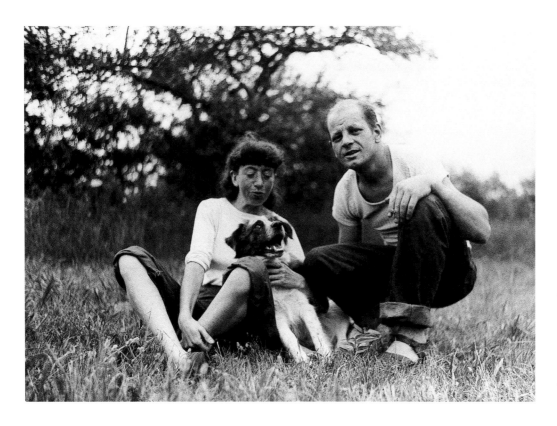

the city, Pollock painted his *Sounds in the Grass* series—all-over abstractions alluding to nature as an inspiration, if not a literal subject. Even in his nonobjective compositions, most identified only by number, he sometimes allowed titles like *Comet*, *Enchanted Forest*, and *Ocean Greyness* to invite analogies to nature. Krasner's work contains numerous references to the seasons and plant life, and the natural cycle of renewal that represents an apt metaphor for her creative development before, during, and after her relationship with Pollock.

As the Morans had been sixty years earlier, the Pollocks became a magnet for their contemporaries. They quickly began acting as unofficial real estate agents for colleagues such as David Porter, Conrad Marca-Relli, John Little, and Wilfrid Zogbaum, who later sold parcels of his land to John Ferren and Willem de Kooning. They were also responsible for notifying Alfonso Ossorio that The Creeks—the spectacular estate built for Albert and Adele Herter in nearby Georgica—was on the market. Ossorio, whose wealth (from a Philippine sugar fortune) and overt homosexuality set him apart from the other artists in Pollock's circle, had become a close friend and staunch supporter after buying one of Pollock's paintings in 1948. Four years later, The Creeks became his permanent home. Like the Murphys, Ossorio had plenty of room for guests. Among the artists who lived and worked in studios at The Creeks during the 1950s were

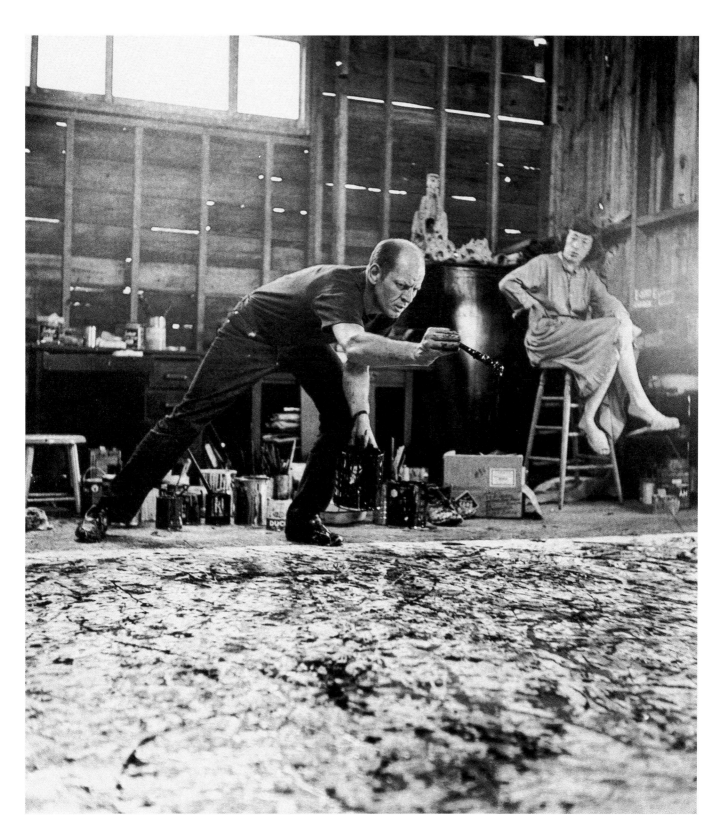

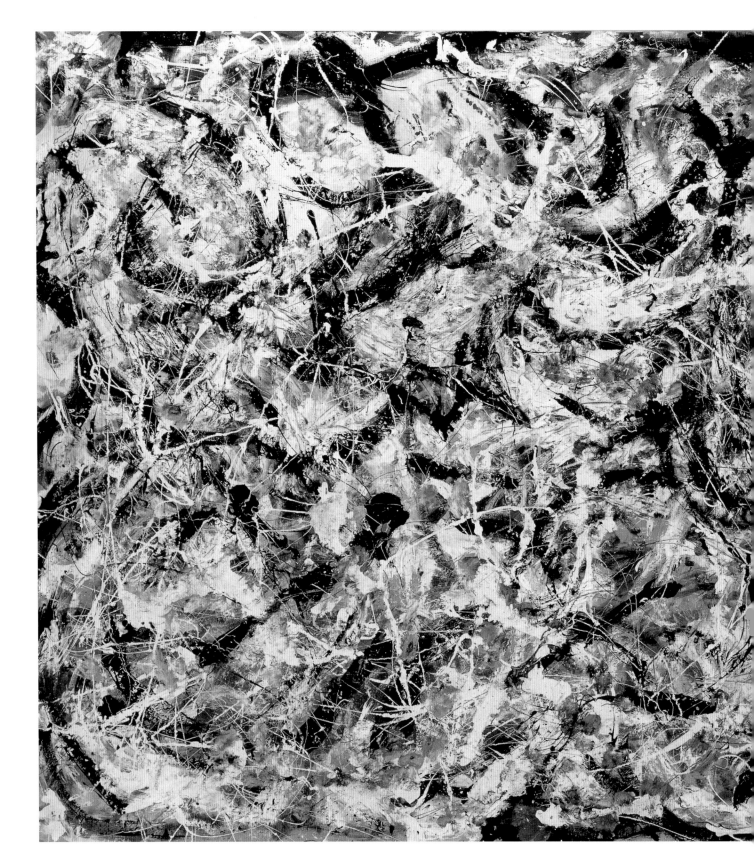

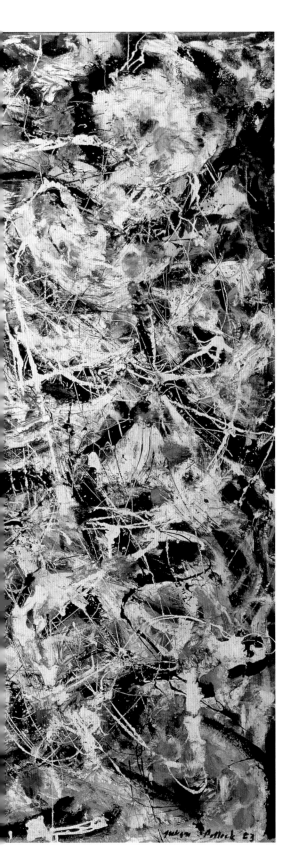

Clyfford Still, Grace Hartigan, George Spaventa, Joseph Glasco, and Syd Solomon, who later settled in Sagaponack. Paul Brach and Miriam Schapiro bought a barn on the former Herter property and converted it to his-and-hers studios in 1954.

Considering its longstanding reputation as a sedate, upscale neighborhood, Georgica attracted a surprising number of offbeat residents in the early 1950s, including the young poets John Ashbery and Kenneth Koch, who shared a summer rental with painters Larry Rivers, Nell Blaine, and Jane Freilicher. Just down the road, New York art dealer Leo Castelli's Georgica retreat became the temporary workplace of Elaine and Willem de Kooning, who improvised studios on the porches. The de Koonings first visited the area in 1948 as house guests of the Pollocks, and they became seasonal regulars in the following years. In the summer of 1954 the couple, together with fellow artists Ludwig Sander, Franz Kline, and Kline's companion, Nancy Ward, pooled $600 and rented the Red House, a rambling Victorian pile in Bridgehampton. There they hosted a perpetual house party,

Jackson Pollock, GREYED RAINBOW, 1953. Oil on canvas, 72 x 96 inches.

BELOW: Lee Krasner, Robert Motherwell, and Willem de Kooning at Guild Hall, 1952.

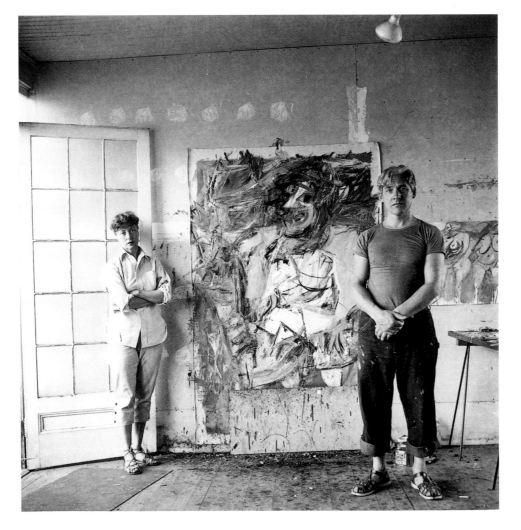

improbably (and ineffectively) chaperoned by de Kooning's mother, who was visiting from the Netherlands. The season's most celebrated social event was their August croquet tournament, for which the bushes were decorated with hand-painted paper flowers and the outhouse's three-hole toilet seat was marbleized just freely enough to suggest an irreverent paraphrase of Pollock.

In later years, both de Kooning and Kline gravitated to Springs, where they joined Ibram Lassaw, Perle Fine, Ludwig Sander, Nicolas Carone, and Constantino Nivola in the growing contingent of artist residents. The Nivola property was particularly notable for its extensive sculpture gardens and a pair of biomorphic murals painted by Le Corbusier during the French architect's 1950 visit. James Brooks and Balcomb Greene preferred the far-flung solitude of Montauk, where in 1946 Greene and his painter wife, Gertrude, built themselves an austere cinderblock outpost. Perched on a cliff overlooking the ocean, the house and

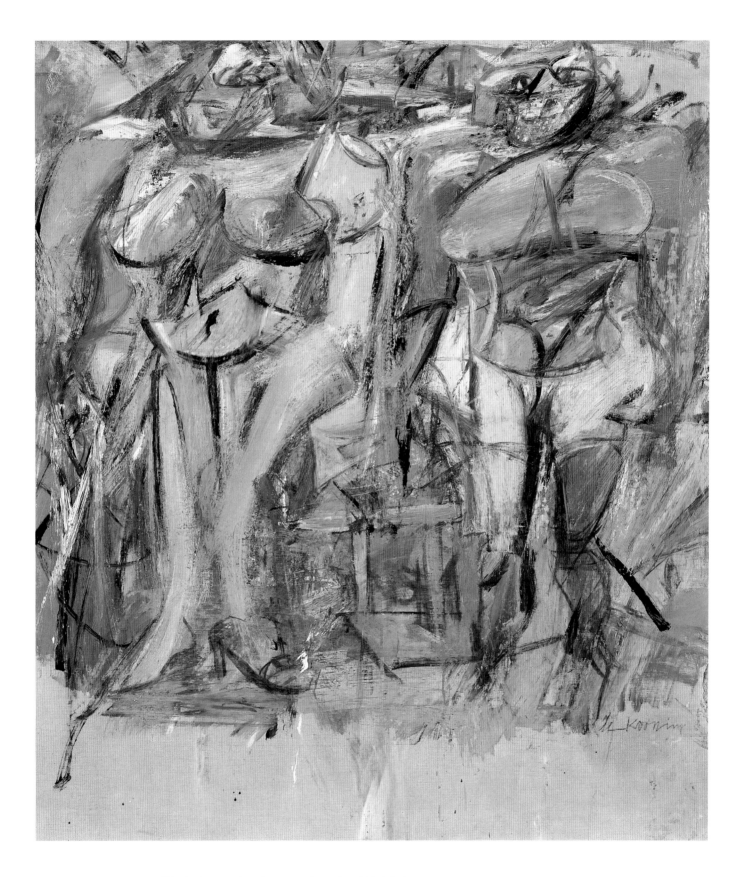

studio provided Greene with uninterrupted views of the rocky, mist-shrouded coastline that inspired his paintings. Montauk's offshore tides and currents may have informed Brooks's sinuous abstractions as well, but after a hurricane nearly swept his cottage out to sea, he and his wife, the painter Charlotte Park, had the building moved to Springs.

Robert Motherwell, who originally envisioned an art colony in Springs, opted to settle in Georgica, where he offended establishment sensibilities by commissioning experimental French architect Pierre Chareau to design a house and studio made of war-surplus Quonset huts, erected in 1946. Although not as wealthy as Ossorio, Motherwell had enough money to build from scratch, while

most of the artists contented themselves with renovations, bargain rentals, or borrowed work spaces. Not long after Motherwell moved in, his neighbor, the writer James Tanner, was approached by a local dowager. She'd heard that he needed a studio, and offered him the use of her garden shed. Tanner assured her that his cottage had all the work space he needed, and suggested that perhaps it was Motherwell's current house guest, an English ceramist, who was looking for a studio. "'And what do you do?' she asked me suddenly," Tanner recalled. "'Do you paint, too?' 'No, I'm a writer.' This time she beamed. 'We used to have you people here,' she said. 'It's so nice to have you back.'"

Robert Motherwell inside his adapted Quonset hut residence in Georgica, 1950. Photograph by Hans Namuth.

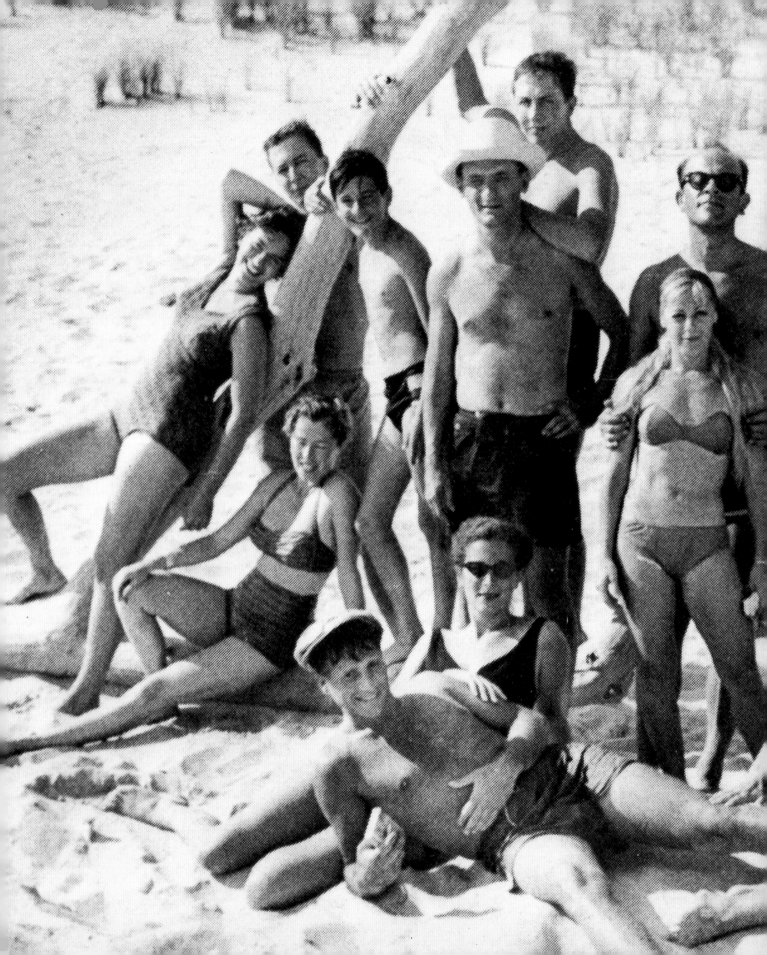

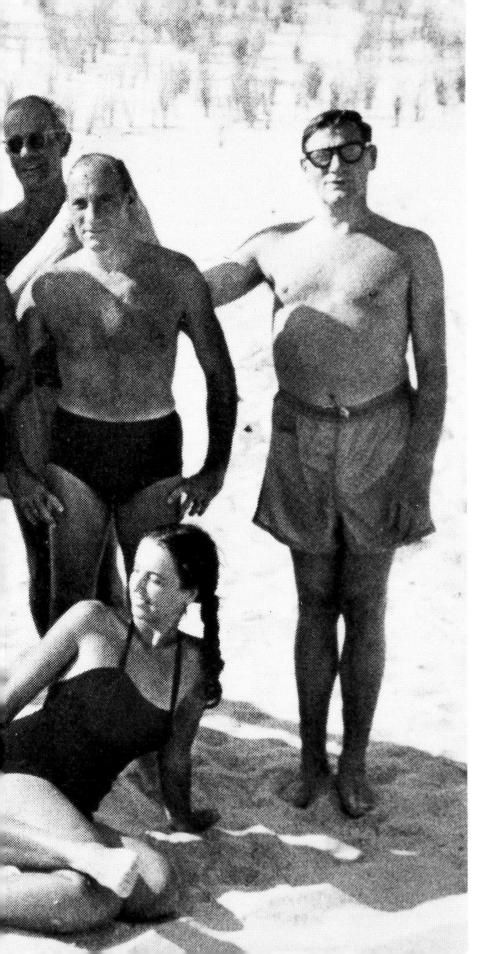

Artists on the beach, Water Mill, 1959.
FRONT ROW: Joe Hazan, Maxine Groff-sky (in sunglasses), Jane Freilicher.
MIDDLE ROW: Grace Hartigan (leaning against tree), Mary Abbott (sitting on tree), Stephen Rivers, Larry Rivers, Herbert Machiz, Sondra Lee (in front of Machiz), Tibor de Nagy, John Myers. BACK ROW: Jasper Johns (peaking out behind tree), Robert Rauschenberg (behind Larry Rivers), Roland Pease. Photograph by John Jonas Gruen.

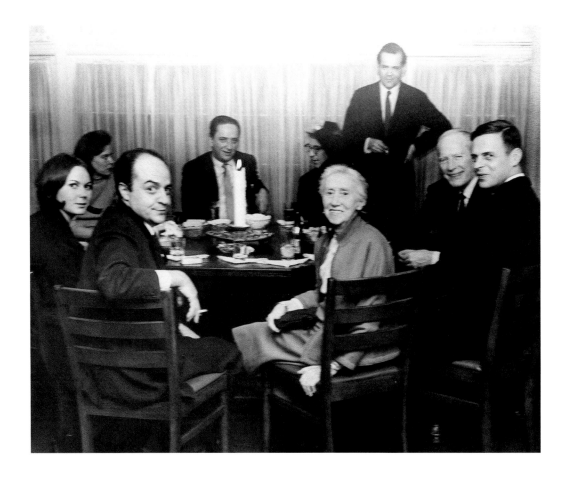

THE CREATIVE MIGRATION TO THE EAST END after World War II later brought a group of writers—Peter Matthiessen, Patsy Southgate, and George Plimpton—returning from a postwar expatriate sojourn in Paris. Talented and well educated, they had taken to the bohemian life that the City of Light afforded. In 1951, Matthiessen and Harold Humes had launched a literary magazine named after their adopted city, the *Paris Review*, with Plimpton as editor, Matthiessen as fiction editor, and Southgate, Matthiessen's wife, as contributing editor and translator.

When the triumvirate returned to the United States shortly thereafter, bringing the *Paris Review* with them, they put down roots in the area that seemed most congenial for their Europeanized imaginations—the inexpensive farming communities of the East End. While Plimpton continued to edit his influential journal and to write, Matthiessen worked as a charter fisherman for three years before beginning a life of travel, exploration, and advocacy for the environment and human rights that produced dozens of notable works, including *At Play in the Fields of the Lord, The Snow Leopard,* and *In the Spirit of Crazy Horse.* In his 1985 book, *Men's Lives,* he recounts the moment he decided to quit fishing:

The PARIS REVIEW crowd, including George Plimpton (right), Peter Matthiessen (scratching his head), George Brown, Robert Scher, Marianne Moore, and John Marquand.

Peter Matthiessen and Patsy Southgate, with their children Lucas and Sara, ca. 1955.

In August of 1956 I was approached by Lewis Lester, who . . . was putting together a new crew. "Got most of 'em, I guess," Lewis said, "but I'm still looking for a good, experienced man." I shook my head; my days as a commercial fisherman were over. My marriage had disintegrated, my old fishing partners were scattering, and my friend Jackson, driving drunk, had destroyed himself and a young woman passenger when he lost control on the Springs-Fireplace Road. I had lost all heart for charter fishing . . .

It was time to move on, but Lewis's words sent me on my way feeling much better. I would never be a Bonacker, not if I lived here for a century, but apparently was accepted as a fisherman. The three years spent with the commercial men were among the most rewarding of my life, and those hard seasons on the water had not been wasted.

The Hamptons continued to draw serious writers attracted to its tranquility and beauty. Later, however, they came less to be with one another than to escape. Sag Harbor's appeal as a quiet place to work is what drew John Steinbeck in 1953, when he rented a house to work on his novel *Sweet Thursday*. (He purchased the house a year later.) Steinbeck loved that house, which reminded him of his family's summer home in Pacific Grove, California. He and his wife Elaine lived there for longer and longer periods each year until his death in 1968. He also loved the quaint village of Sag Harbor, a relationship that was mutual. Other residents understood his wish for privacy and protected him from tourists. The owner of the local grocery store, Schiavoni's, once paid him this compliment: "He should have been born here and shouldn't have been famous."

While *Sweet Thursday* continued the stories of Steinbeck's California Cannery Row characters, some of his later work reflected the influence of his new retreat. In *The Winter of Our Discontent*, Steinbeck used Sag Harbor as well as his family and acquaintances to render the Hawley family and their life in New England. The much-praised story of a man's moral and emotional decline is set in the spring and summer; Steinbeck's description of the threat of bad weather on a summer holiday weekend is immediately recognizable to anyone who has spent time in the Hamptons:

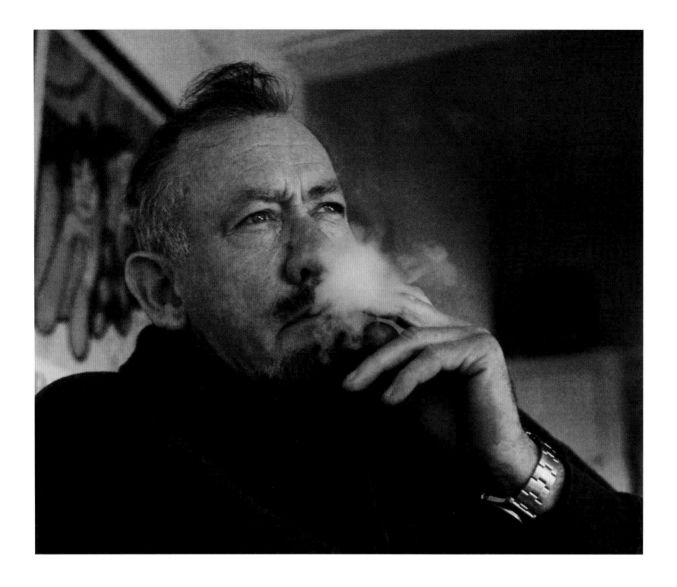

It was a day as different from other days as dogs are from cats and both of them from chrysanthemums or tidal waves or scarlet fever. It is the law in many states, certainly in ours, that it must rain on long holiday weekends, else how could the multitudes get drenched and miserable? The July sun fought off a multitude of little feathered clouds and drove them scuttling, but thunderheads looked over the western rim, the strong-arm rain-bearers from the Hudson River Valley, armed with lightning and already mumbling to themselves. If the law was properly obeyed, they would hold back until a maximum number of ant-happy humans were on the highways and the beaches, summer-dressed and summer-green.

John Steinbeck at his home in Sag Harbor, 1963.

In 1960, after he finished *The Winter of Our Discontent*, Steinbeck took off on a cross-country trip with his French poodle, Charley. His account of the journey, published as *Travels with Charley: In Search of America*, opens with the real-life Sag Harbor. Though the village is just his starting point, in one of its residents he sees his own lifelong urge to wander. As he prepared to leave, Steinbeck wrote, "One small boy about thirteen years old . . . said, 'If you take me with you, why, I'll do anything. I'll cook, I'll wash all the dishes, and do all the work and take care of you. . . . I'll do anything,' he said. And I believe he would. He had the dream I've had all my life, and there is no cure."

Two years later, Steinbeck was invited by President Kennedy to visit the Soviet Union as a participant in the Cultural Exchange Program. In a letter to the American cultural attaché in Moscow, Steinbeck expressed a reservation: How was he to explain the racial violence in Birmingham? He also asked if Edward Albee, whom he considered "our newest and perhaps most promising young playwright," might accompany him. The two had been friends since Terrence McNally had introduced them the year before, and Steinbeck believed Albee would have a deep impact on the younger Russians.

Despite Steinbeck's frail health, the trip was a success. He and Albee—one a celebrity, the other unknown—met Russian writers, gave talks and interviews, attended a variety of events, and traveled. Although the journey ended tragically—in Leningrad, they learned that President Kennedy had been assassinated—it cemented the writers' relationship. Later, during Steinbeck's last years, when he declined to see most visitors, Albee was always welcome. Albee, in turn, dedicated his Pulitzer Prize–winning play *A Delicate Balance* (1966) to his friend. Steinbeck spent his final days in Sag Harbor, returning to his New York apartment only to be near his doctor. At his funeral, Albee was one of the pallbearers.

John Steinbeck, Edward Albee, and a State Department officer after their trip to Moscow, 1963.

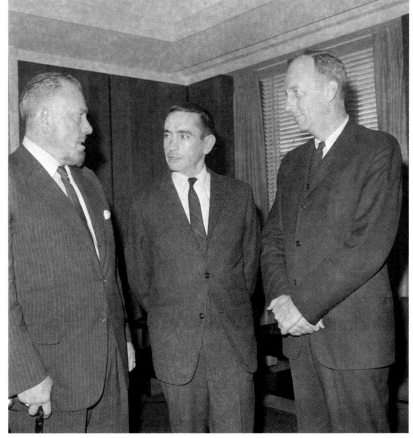

Albee had discovered the East End while preparing the Broadway production of *Who's Afraid of Virginia Woolf?* in 1962. "I had come to Montauk to visit actress Uta Hagen, who was thinking about playing the role of Martha on Broadway," Albee recalled. "I drove along a ridge by the ocean, and the area was deserted—no hotels, no motels. It is the only place on Long Island where there are heights, beside sand dunes, on the south shore and on the ocean side. I fell in love with the area." In a singular gesture of generosity, he invited others to share his discovery and its potential for creative inspiration. Following the critical and financial success of *Who's Afraid of Virginia Woolf?* he purchased what had once been a stable for the Montauk Manor Hotel and established the William Flanagan Memorial Creative Persons Center—named in honor of a deceased friend. Familiarly known as the Barn, it has served as a seasonal retreat for artists and writers and for many years has offered one-month residencies. The dedication Albee shows to young artists and writers may very well date to that Russian visit with Steinbeck, when he was given encouragement and where his sympathies were aroused for the plight of the writers he met. Since then, he has been a committed advocate for human rights and freedom of expression.

SPRINGS HAD EARLIER WELCOMED a most unlikely literary couple, *New Yorker* writer A. J. Liebling and Jean Stafford, a journalist and master of the short story. During an earlier marriage Liebling had bought a house in Springs, not far from where Jackson Pollock and Lee Krasner lived; he and Stafford began using the house soon after their marriage in 1959. Liebling loved both the house and the thirty-one acres it sat on. "One of his favorite self-indulgences was to lie on his back in the field behind the house savoring his property," wrote David Roberts in *Jean Stafford: A Biography*.

Liebling was a large man; when he and Stafford met in 1956, he weighed 243 pounds. "To eat and overeat," notes his biographer Raymond Sokolov, "was a badge of freedom. His belly was the outward and visible sign of an inward and manly grace." Significantly, or ironically, his last book was *Between Meals: An Appetite for Paris*, "a memoir of a great eater's best times in Paris before the war." In it he demonstrates the winning combination of irony, humor, and sheer good writing that had made him the classic *New Yorker* reporter, both as a World War II foreign correspondent and later as a press critic and boxing writer.

After Liebling's death in 1963 at the age of fifty-nine, Stafford made the house on Springs-Fireplace Road her permanent residence. By then, her literary career was on permanent hold. She had landed on the national scene in 1944 with the publication of her first novel, *Boston Adventure*, and over the next two

A. J. Liebling and Jean Stafford in their backyard, late 1950s.

decades became known for her remarkable short stories. But in 1956 she developed writer's block. Although she continued working as a journalist, she wrote almost no fiction after marrying Liebling. (Still, her *Collected Stories* earned her the Pulitzer Prize in 1970.) As the years went on, Stafford was drinking more than she was writing. She stayed inside the house most of the time; her few friends included *New Yorker* colleagues Howard Moss, Berton Roueché, and Saul Steinberg as well as Saul Bellow and Jeannette Rattray. She also cultivated friendships with a number of her neighbors, especially those she felt were real Bonackers.

Despite her struggles with depression and alcohol, Stafford participated in East Hampton's community life throughout the 1970s. She lectured at Guild Hall, she wrote letters to the *Star*, and she spoke at a commencement at Southampton College. But Stafford was also becoming more and more difficult.

She believed that the most caring person in her life at this time was Josephine Monsell, her faithful, cheerful, and uncritical cleaning lady—and a pure Bonacker. When Stafford died, in March of 1979, she left her entire estate to Mrs. Monsell.

WHEN ALEXANDER BROOK and his wife, Gina Knee, moved to Sag Harbor in 1948, he was already a well-known painter of portraits and genre scenes, and she enjoyed some renown as a Modernist. "He was one of the darlings of the art world," according to Brook's friend Raphael Soyer. "He was outgoing, flamboyant, picturesque." The couple acquired Point House, overlooking the harbor in North Haven, and a wonderful carriage house with studio space for them both. When the property next door went on the market, Brook persuaded the Precisionist painter Niles Spencer to buy it and move an old cottage to the plot. He also scouted houses in the village for two other longtime friends, Henry Billings and Allen Ullman, both illustrators and muralists. But with the advent of Abstract Expressionism, their work seemed old hat. Although he and Knee befriended members of the insurgency—and Knee, whose painting style was semi-abstract, was active in promoting them locally—mainstream artists like Brook and his circle were increasingly left behind in the race for recognition.

Sag Harbor's most unorthodox art colonist of the fifties was Val Telberg, a photomontagist and avant-garde filmmaker in the Surrealist tradition, who bought a house on Bay Street in 1956. A native of Russia, Telberg came to the United States as a teenager and trained as a chemist. In the 1940s, however, he became fascinated by experimental photography and soon gained wide recognition for his poetic visual reveries, printed from negative fragments organized into endless variations, each one unique. Anaïs Nin used his montages to illustrate *House of Incest* and *A Season in Hell*, published in the 1950s. Although urban vignettes and nude figure studies dominate Telberg's repertoire of motifs, many of his most haunting images were made at Trout Pond in Noyac, just outside Sag Harbor, where he captured the antics of spritelike children swinging on ropes and diving off overhanging trees.

In 1958 James Tanner dubbed the Hamptons the "solid gold melting pot" where "the old social barriers have begun to waver if not to crumble." Yet Patsy Southgate was skeptical. Even after more than a decade of détente, she perceived the relationship of Old Guard to vanguard as an "uneasy juxtaposition, with very little contact and hardly anything in common." When the eccentric artists and the straitlaced social set (several of whom were avid collectors of the challenging new art) mingled at exhibition openings, the recent arrivals were regarded with a

Val Telberg,
CATACLYSM II,
ca. 1950. Photomontage,
9³/₄ x 11⁷/₈ inches.

mixture of fascination and fore-
boding. Guild Hall's director, Enez Whipple,
enjoyed describing an encounter at one such event between a
genteel volunteer hostess and Jackson Pollock. "Oh, Mr. Pollock," the woman
gushed politely, "I do admire your work." To which the irascible Pollock, who was
showing one of his most perplexing abstract paintings, replied, "Bullshit!"

Conservative artists found the work of Pollock, de Kooning, and their ilk
alarming. The spiritual heirs of Hassam and the Herters were shocked and dis-
mayed by the abstractions—described by the *East Hampton Star*'s art reviewer as
"sordid and scrambled"—that hogged more and more wall space at the annual
invitational shows. The conflict was dubbed the Art Wars by novelist Gerald
Sykes, whose wife, Buffie Johnson, was among the action painting contingent of
Abstract Expressionists. Writing in 1957, Sykes pointed out that while the aes-
thetic battle was still raging, "so far at least, all the bloodshed has been verbal.

There will be violence, but it will exhaust itself in a few well-worn phrases, such as every museum guard knows by heart."

The situation was only marginally less fractious in Southampton, where it was artists' and writers' lifestyles, rather than their painting or poetry styles, that affronted the establishment. Fairfield Porter, scion of a respectable, well-to-do Midwestern family, had moved in 1949 from Manhattan to a somewhat ramshackle but spacious house on South Main Street, believing that it was a good place to raise his children. But while his canvases were inoffensive landscapes and portraits, his household was far from conventional. As soon as the Porters settled in, the welcome mat went out to their decidedly oddball circle of artist and writer friends, including the New York School poets Frank O'Hara, John Ashbery, Kenneth Koch, and the mentally unstable James Schuyler, who was virtually adopted by Porter and his wife, Anne, herself a poet.

JACKSON POLLOCK
1912–1956

"None of the art magazines are worth anything. . . . I hate to admit it, but I prefer the approach of *Time*. I'd rather have one of my pictures reproduced in *Collier's* or the *Saturday Evening Post* than in any of the art magazines. At least you know where you stand. They don't pretend to like our work."

Jackson Pollock, June 1956

"Died. Jackson Pollock, 44, bearded shock trooper of modern painting, who spread his canvases on the floor, dribbled paint, sand and broken glass on them, smeared and scratched them, named them with numbers, and became one of the art world's hottest sellers by 1949; at the wheel of his convertible in a side-road crackup near East Hampton, N.Y."

Time, *August 20, 1956*

Fairfield Porter and Jane Freilicher. Photograph by John Jonas Gruen.

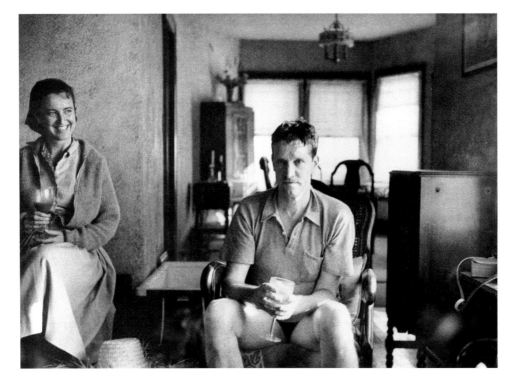

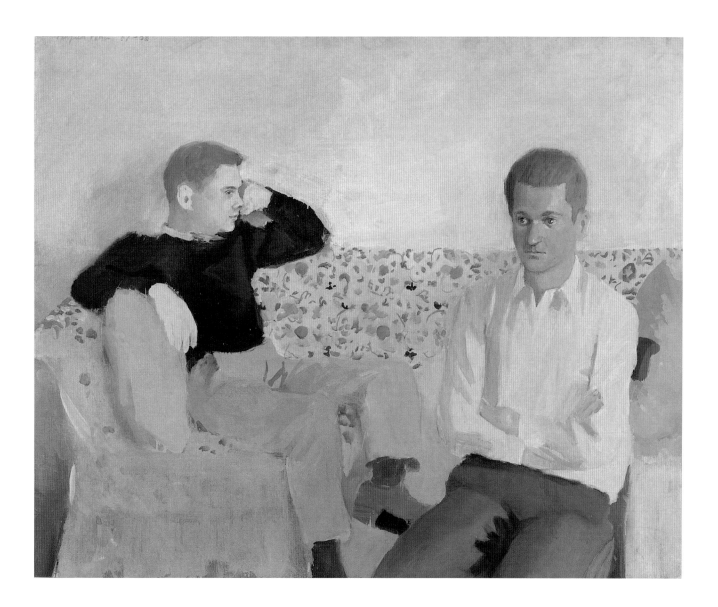

Their friend Larry Rivers's nude portraits of his elderly mother-in-law and O'Hara, his sometime lover, predictably horrified the traditionalists. Rivers initially came to the Porters' to recover from a suicidal depression; indeed, so many of their city friends used their house as an informal sanatorium that Anne described it as their "rest home for broken-down New Yorkers."

In some respects, the Porters were to Southampton what the Pollocks were to East Hampton: a magnetic influence that attracted others and revitalized the creative community that had languished after the original colony petered out. Several of those who first came at the Porters' behest later bought homes in the area, among them Rivers; Jane Freilicher; Robert Dash and John Button; the writer and composer John Gruen and his wife, painter Jane Wilson; and poets Barbara Guest and Kenneth Koch. But unlike East Hampton, Southampton drew

a group of younger figurative artists in open rebellion against the primacy of Abstract Expressionism. "If you weren't doing that," Freilicher once remarked, "you were put in the position of being either a reactionary or sort of out of the mainstream—a renegade, not devoting yourself to the True Faith." However much she and her contemporaries admired the action painters' achievements, they wanted to avoid the trap of becoming second-generation followers. They found their own direction in a synthesis of painterly panache and recognizable subject matter, and saw precedents in the work of Porter and his friend Willem de Kooning, who seemed equally at home with abstraction and representation and was respected by both camps.

Jane Freilicher and Jane Wilson both found perpetual inspiration in the coastal landscape just east of Southampton, with its flat fields, tidal inlets, and grassy marshes. Freilicher often juxtaposes the interior fixtures of her Water Mill studio with the distant view through the window. In Wilson's work, the landscape's flatness provides a conveniently neutral horizon for compositions that emphasize transient phenomena like time, atmosphere, and weather. "Light has a physical presence, but at the same time it's fused into this magnetic experience of sky which is totally elusive," she said recently. "I love how the sky is constantly changing, how it's so complicated. Changing color, changing humidity, changing light, changing winds, changing temperature."

The Porters' home offered O'Hara, Ashbery, and the other New York poets not only a place to relax, but also proximity to an extended family of artists and writers. A visitor to the figurative painter Porter would also have access to the *Paris Review* set as well as the Pollock/Krasner circle of Abstract Expressionists in Springs and Georgica. Contacts and friendships flourished among the avant-garde, and the resulting cross-fertilization can be detected in their poems: in references to color, in surreal images, in the artistic use of elements of everyday life, and in language divorced from sentimentality and moralizing. The artists found a renewed interest in surreal images, in the iconography of everyday life, and the use of text as a visual motif.

When Ashbery and O'Hara first came to New York after Harvard, they took jobs that kept them close to their interests. Ashbery went into publishing, while O'Hara worked at the Museum of Modern Art and began to write influential art criticism. About this time he became a close friend of Larry Rivers, for whom he modeled and with whom he collaborated on *Stones*, a series of lithographed poem-drawings.

To Larry Rivers

You are worried that you don't write?
Don't be. It's the tribute of the air that
your paintings don't just let go
of you. And what poet ever sat down
in front of a Titian, pulled out
his versifying tablet and began
to drone? Don't complain, my dear,
You do what I can only name.

—Frank O'Hara, n.d.

By all accounts Frank O'Hara was enormously energetic, attractive, and popular. But in the summer of 1966, at the age of forty, a freak accident on Fire Island ended his promising life. Shortly before three A.M. on a July morning, O'Hara and a friend were returning to their host's home in a beach taxi along with several other passengers. The taxi broke down, depositing the group on the beach. A dune buggy, blinded by the headlights of the disabled vehicle, swerved to avoid hitting the group. At that moment O'Hara stepped out from behind the taxi. It struck him hard, and he died the next day.

O'Hara's death devastated his friends. To them, an era seemed to end the day he was buried, in Green River Cemetery, in Springs. Pollock, killed ten years earlier, lay just a few yards away. Descriptions of O'Hara's funeral depict a heartrending scene, where dozens of his friends felt their grief like a physical injury. Enraged by the absurdity of the accident, Larry Rivers delivered an angry, passionate eulogy. Later, Allen Ginsberg, James Schuyler, David Shapiro, and a dozen of his other friends wrote elegies to him. Patsy Southgate's was especially affecting.

O'Hara's friend Peter Schjeldahl, a poet and art critic for the *New Yorker*, later called his poetry a "a form of uncommon common speech, urbane and at the same time passionately attached to the everyday." This contribution would survive him, "but the social and artistic scene of which he was a roving center now seems as distant as that of Paris in the twenties."

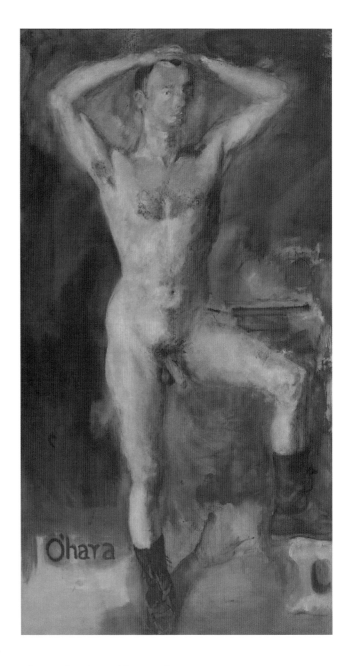

Larry Rivers, FRANK O'HARA, 1954. Oil on canvas, 97 x 53 inches.

Nobody Operates like an IBM Machine: For Frank O'Hara

You said:
"I love your house because my poems are
always on the coffee table!"
"I always have such fun with you!"
"Oh really, don't be an ass!"
"Just pull yourself together and sweep in!"
"Now stop it!"

An endless series of exclamation points
has ended.

Your voice
ran across the lawn wearing nothing but
a towel
in the good old summertime.
You always sounded so positive!
What freedom!
I'll get a flag! (I must!)

I loved your house too
with Grace Church looking in the window
and your imposingly empty ice-box;

all that work piled on the table
and lavished love on the walls and
everywhere.
You would say, yacking away, shaving at the
kitchen sink (the sink)
that we were going to be late again, for shit's
sake, but
"You look perfectly gorgeous,
my dear, would you mind feeding the cats?"
in those arrogant days
before your grave.

You said, during the intermissions, on the
phones, at the lunches,
in the cabs:
"If you want to do it, just do it! What else is
there?"
"My heart your heart" you wrote.
It all added up.
How flawless you were!

—Patsy Southgate, 1966

ALTHOUGH THE PARRISH ART MUSEUM AND GUILD HALL regularly included vanguard artists in their invitationals, both museums' exhibition schedules were devoted mainly to shows of traditional painting and sculpture. And while many of the area's former unknowns had become modern masters represented by prestigious Manhattan galleries—where collectors with houses in the Hamptons bought their work—the Hamptons lacked a commercial outlet for modern art.

Appropriately, perhaps, given the confluence of avant-garde writers and artists in those years, bookstores tried to fill this gap. Encouraged by Porter, Rivers, Ashbery, and O'Hara, Robert Keene began showing contemporary art at his

Southampton bookshop in the summer of 1956. The first show, which Keene summed up as "a sensation," was of Rivers's work. In East Hampton, ad hoc exhibitions had been held in 1954 and 1955 at Carol and Don Braider's Books and Music Inc., where paintings by de Kooning, Kline, Ossorio, Krasner, Joan Mitchell, and other local avant-gardists hung in a carport wedged between the store and a shed. "Although security was nonexistent," the *Star* reported much later, "there was no thief around who was smart enough."

The Braiders' shows ended after two years, when their shop moved. This new dearth of gallery space so troubled painters John Little and Elizabeth Parker that in 1957 they partnered with Alfonso Ossorio and opened the Signa Gallery on Main Street in East Hampton—the area's first commercial gallery devoted exclusively to advanced art. Ignoring the Old Guard's hostility, the trio renovated the former Maidstone Market as a loft-style exhibition space, blocked off the large storefront windows to tantalize prospective customers, and mounted shows that, in James Tanner's estimation, "would have done honor to New York's Museum of Modern Art." Marcel Duchamp was among the art-world notables in the opening night crowd. The gallery's receptions became popular social events where artists could cultivate potential collectors.

In keeping with Ossorio's philosophy that Modernism was an international language, Signa also exhibited European and Asian art, often lent by prominent New York dealers. But the gallery attracted more browsers than buyers. Sculptor David Slivka almost made a sale at his final show of the 1957 season. Marilyn Monroe, who was summering in Amagansett with her husband, playwright Arthur Miller, took a fancy to his stone carving, a seedlike abstraction titled "Maternity." Monroe believed she was pregnant, and the subject reflected her current preoccupation. The deal fell through, however, when her pregnancy proved to be wishful thinking.

Alfonso Ossorio, ACT OF FAITH, 1956. Oil on canvas, 77 x 38 inches.

Signa failed to develop a new audience or a market for modern art in the Hamptons. According to Ossorio, most sales were to established collectors, like Dorothy Norman, Ben Heller, and Evan Frankel, who needed no persuasion. After four years, having decided that the gallery took too much time and energy away from their art, the partners dissolved it and returned to their studios. Looking back on the experience, Ossorio believed that the effort was worthwhile, but that Signa did not really live up to its name, which suggested a signpost pointing the way ahead. Instead, the gallery reflected the advances made during the previous decade. "By 1959, 1960," he concluded, "what we should have done was show the first of Andy Warhol's tomato soup cans, Jasper Johns's drawings of numerals. He and Bob Rauschenberg spent a summer here, but we never moved in that direction." Why this lack of foresight? Ossorio ruefully admitted that, just like his conservative predecessors who were indifferent or hostile to Abstract Expressionism, he and his peers had little appreciation for the new wave that was challenging their hegemony: Pop art.

John Hawkins, Alfonso Ossorio, Elizabeth Parker, and John Little at Signa Gallery, 1960.

Pop Go the Hamptons

THE 1960s AND 1970s

I N THE SUMMER OF 1964, when a *Time* magazine reporter asked painter Jim Dine why he liked the Hamptons, Dine did not mention the radiant light or rural tranquility that are reputed to be the region's most appealing features for artists. Having just bought a house in Georgica, Dine singled out the local hardware stores, stocked with farm tools and fishermen's supplies, as the prime attraction. "I've bought more than twenty axes to put in my new assemblages," he reported. "If I'd bought them in Manhattan, the store clerks would have turned me in as an ax murderer."

If the Abstract Expressionists had turned inward for inspiration rather than to the landscape, Dine and his Pop art *confrères* were even less attached to a specific locale. True, they looked to their surroundings, as the plein air painters had done two generations earlier; but what they saw, and wanted to reflect in their art, was a mass-market culture driven by advertising. Nothing about it was unique to the Hamptons—indeed, that was the point. It was universal. Dine's axes were recognizably "standard," like Andy Warhol's soup cans, James Rosenquist's quotations from billboards, and Roy Lichtenstein's cartoon-derived imagery.

All of these Pop artists had come to the East End—Warhol to Montauk, Dine and Rosenquist to East Hampton, and Lichtenstein to Southampton—looking for a retreat, remote from the urban art world's pressures but not isolated from its sphere of influence. The art colony infrastructure they found, and gradually took over, included the dealers, collectors, critics, and museum professionals on whom their reputations depended. "If you say to a cocktail party of brokers out

Roy Lichtenstein, LANDSCAPE, 1974. Detail; see page 108.

Jim Dine, LONG ISLAND LAND-
SCAPE, 1963. Oil and collage on
canvas, 96 x 162½ inches.

OVERLEAF: Artists on the beach,
1962. Standing, left to right:
Al Held, Buffie Johnson, Lester
Johnson, Howard Kanovitz,
Michael Goldberg, Syd Solomon,
Frederich Keisler, Norman Bluhm,
unknown, Perle Fine. Sitting, left
to right: Unknown, Lee Krasner,
Balcomb Greene, Sylvia Stone,
John Little, Elenor Hempstead,
David Porter, Rae Ferren,
James Brooks, Arline Wingate,
Tania, Louis Shanker, Adolph
Gottlieb, Lucia Wilcox, John
Ferren, Theodore Stamos,
Elizabeth Parker, Jane Wilson,
Jane Freilicher, Robert Dash.
Photograph by Hans Namuth.

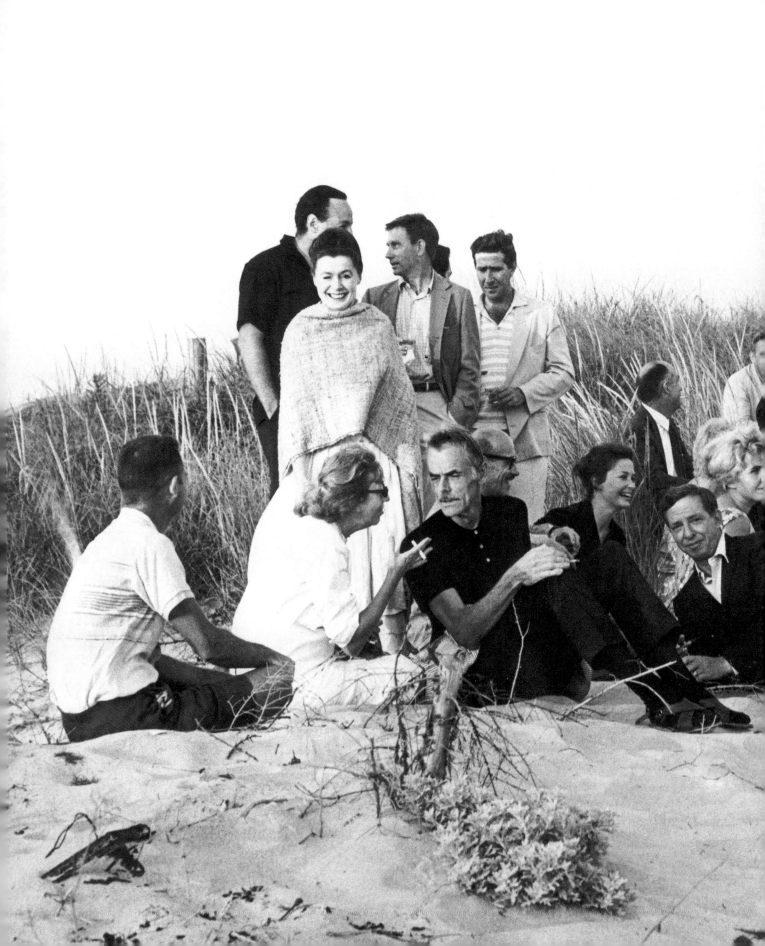

here, 'I'm a painter,' they understand," Adolph Gottlieb advised *Time*. "They are interested in art."

Roy Lichtenstein, LANDSCAPE, 1974. Oil on canvas, 30 x 36 inches.

By the time the Pop generation arrived, these connections were so well established that no one questioned the judgment of an artist who settled in year-round. As Lichtenstein remarked, he and his wife Dorothy "came for several summers and one fall we just didn't leave." Comfortably ensconced on Gin Lane, in Southampton's estate section, Lichtenstein insisted that, unlike Pollock, he had not fled the city out of discontent. More in the tradition of Chase, Hassam, and the Herters, he was already famous and affluent by the time he bought his house in 1971. His signature style was fully developed, and its later evolution

seemed unrelated to his locale. "I'm sure being in Southampton has influenced my work," he said, "but I have no idea how. I could paint anywhere."

Willem de Kooning, too, had decided to quit the city, and bought his brother-in-law's Springs house in 1961. But his reason for moving was directly related to his work. "I wanted to get in touch with nature," he told his neighbor Harold Rosenberg some years later, "not painting scenes from nature, but to get a feeling of that light was very appealing to me, here particularly. I was always very much interested in water." His little house and garage work space on Accabonac Road soon proved inadequate, but by then de Kooning was successful enough to afford a purpose-built studio residence. Over the next several years, on land bought from sculptor Wilfrid Zogbaum, he wrestled with the problems of designing and constructing his ideal working environment—a huge, hangarlike structure which, like his paintings, he constantly rethought, revised, and seemed unable to finish. Amid the chaos of building, demolition, and rebuilding,

Roy Lichtenstein in his Southampton studio, 1977. Photograph by Nancy Crampton.

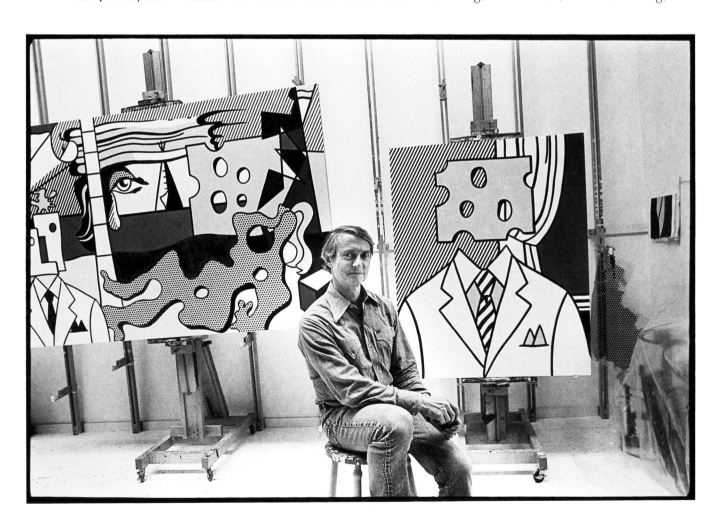

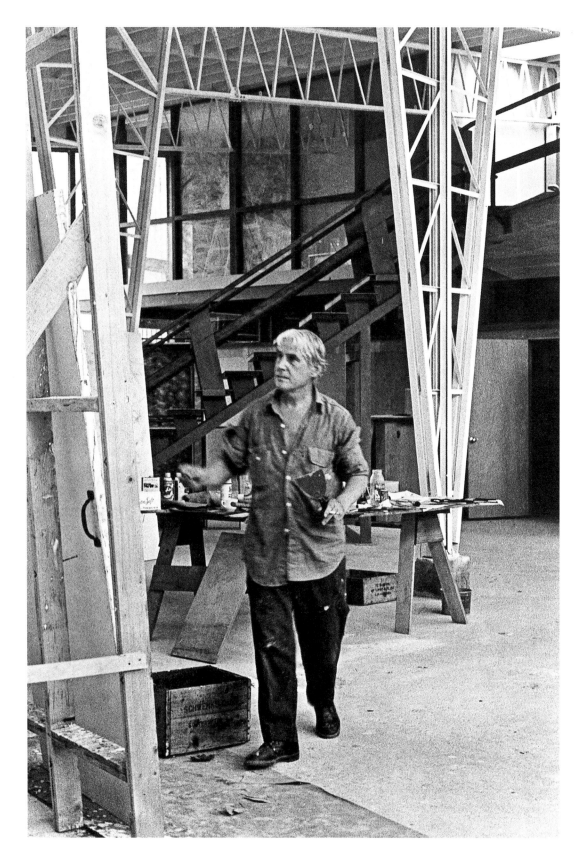

however, his productivity flourished. Figures dissolved by shimmering light and rippling water, floating in rowboats, and sunbathing on the dunes attest to de Kooning's fascination with the interactive character of color, form, and atmosphere. "It was like the reflection of light," he explained. "I reflected upon the reflections on the water, like the fishermen do."

About a mile north of de Kooning's new home, in the barn that had been Pollock's studio, Lee Krasner was also responding to the environment. After years of working in a cramped upstairs room in the house, she now had the luxury of twenty-one-foot walls on which to pin large canvases, abundant natural light, and freedom from Pollock's overwhelming demands. Her first paintings after his death, known as the *Earth Green* series, were exuberant and joyous, like antidotes to her grief. The organic shapes of flowers, seed pods, and voluptuous figures, rendered in lush colors, spoke of fertility and rebirth. By the early 1960s, however, undercurrents of sorrow burst forth in furious brushwork and somber tones, suggesting violent storms as well as emotional turmoil. Throughout the decade, she expanded on both the positive and negative aspects of nature, creating a rich vocabulary of allusions to the cycle of creation, destruction, and regeneration.

WARHOL IN MONTAUK

Although it's commonly referred to as the Warhol property, the Colonial Revival estate on the Montauk bluffs is actually owned by his associate, Paul Morrissey. The five-building complex was built for the Church family in 1932 and decorated with furnishings from Eleanor Roosevelt's Val-Kill workshop. A frequent visitor in the early days was the landscape painter William Langson Lathrop, known as the dean of the New Hope, Pennsylvania, art colony.

After Morrissey acquired the property in 1971, with Warhol as one of the investors in the purchase, it was rented to a succession of famous tenants, including Lee Radziwill, Halston, Mick Jagger, Julian Schnabel, and most recently Peter Brant, a producer of Ed Harris's film *Pollock*. "Andy hardly spent any time out here. He was only a guest, in the third house," says Morrissey, who notes that Warhol never worked in Montauk, but visited when friends like Halston, Jagger, Liz Taylor, or Liza Minnelli, were in residence. "There was a tradition that, in the summer, the wealthy people would 'rough it' in places like this, very low key, very private," Morrissey points out. "It was a real retreat. Even Halston never had a party here."

ABOVE: William King,
THE SWIMMER,
1955-72. Pine with paint,
15 x 16 x 72 inches.

OPPOSITE: Paul Morris-
sey's estate in Montauk.

The spontaneous, intuitive, and deeply subjective approach of Krasner, de Kooning, and the other Abstract Expressionists stood in sharp contrast to the Pop artists' cool detachment and wry appropriation of mass culture. After years of struggling to win acceptance, the older generation was dismayed by the speed with which the likes of Warhol and Lichtenstein had been embraced by influential tastemakers. But Pop art was by no means the only challenge to Abstract Expressionism, and the Hamptons, no less than the wider art world, reflected that plurality. Although often grouped with the Pop artists because of his use of printed source material and advertising imagery, Larry Rivers worked in a style derived from gestural abstraction and the past masters of figurative painting. William King's sheet metal and wood figures, despite their occasional resemblance to cartoon characters, were actually lighthearted but incisive examinations of human behavior. Jack Youngerman's sweeping schematic shapes owed as much to Matisse as to billboard graphics. Li-lan's painted renderings of ruled stationery and notebooks used classic Pop source material but were closer in spirit to Minimalism. Dan Flavin, who rejected the Minimalist label, adapted common fluorescent light fixtures—like Dine's ax heads, available at the local

5B u ikox 1979 III

ABOVE: Howard Kanovitz, HAMPTONS DRIVE-IN, 1974. Acrylic on canvas, 42 x 90 inches.

RIGHT: Jimmy Ernst (right), Dan Welden, and Lorna Logan work on a lithograph, 1982.

OPPOSITE: Chuck Close, SELF PORTRAIT/COMPOSITE/NINE PARTS, 1979. Nine internal dye diffusion (Polaroid) prints mounted on canvas, 76^{1}/$_{2}$ x 61^{1}/$_{2}$ inches.

hardware store—to create dazzling compositions of pure luminosity. Alan Shields, with his gorgeously stitched, stained, and spangled constructions of handmade paper, erased the boundary between craft and art. The Photorealist contingent included Chuck Close, Audrey Flack, Ian Hornak, and Howard Kanovitz. Robert Gwathmey, with his Cubist-inspired studies of rural Southern life; Saul Steinberg, who invented a private calligraphy to communicate his quirky observations; and Jimmy Ernst, a weaver of layered webs of images, fit into no particular category.

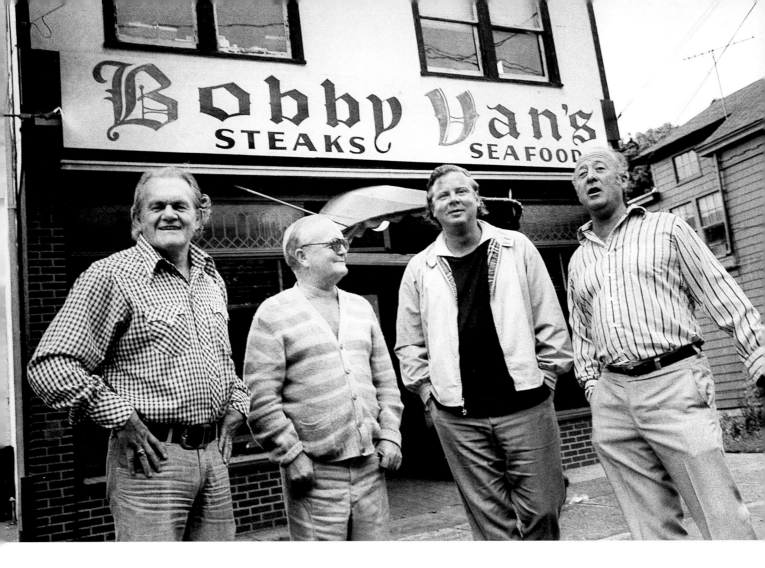

ONE CANNOT SPEAK OF THE CREATIVE HAMPTONS in the 1970s without describing Bobby Van's, the watering hole that served as a kind of club for the country's best-known writers. The list of authors who repaired there for drink, food, and conversation is formidable, and includes Peter Matthiessen, Joseph Heller, Jean Stafford, Shana Alexander, Kurt Vonnegut, Wilfrid Sheed, Betty Friedan, Budd Schulberg, John Knowles, Craig Claiborne, Truman Capote, George Plimpton, Irwin Shaw, *Harper's* editor Willie Morris, and Morris's best friend, James Jones, the celebrated author of *From Here to Eternity*. In his memoir, *New York Days*, Morris tells us that Jones had been searching all his life for a "nice quiet dimly lit old infantry-man's dream of a bar somewhere." He found it in Bobby Van's. Morris describes that saloon as "an angular structure . . . with dark paneling, Tiffany lamps, and old fans suspended from an undistinguished ceiling, a long mahogany bar, and from the back the flickering of candles on small booths and tables covered with red tablecloths." Jones, who had bought a place in Sagaponack, would sit at the bar "stirring vinegar and a dab of mustard

James Jones, Truman Capote, Wille Morris, and John Knowles in front of Bobby Van's. Photograph by Jill Krementz.

for his hamburger and talking books and writers and passing the time of day with his admirers."

Hanging over the bar in the new Bobby Van's, across the street from the original, is a 1975 photograph by Jill Krementz, Kurt Vonnegut's wife. Four friends—Jones, Morris, Capote, and Knowles—smile for the camera. This quartet comprises some of the nation's finest literary voices. Knowles, at that time a summer resident, had had enormous success with his 1959 novel *A Separate Peace*. The reflections of a prep-school boy confronting his friend's death at the dawn of World War II struck a chord with readers on its release, and remained popular through the Vietnam War.

James Jones had achieved considerable fame with the first two novels of his war trilogy: *From Here to Eternity* and *The Thin Red Line*. For a number of writers, including Jones, the indelible impression left by serving in World War II had led to their best work. When Krementz photographed the men, Jones was seriously ill, but he was still trying to complete the last of the trilogy, *Whistle*. A few years later, dying in Southampton Hospital and desperate to finish the novel, Jones unhooked himself from the life-support system and insisted on dictating into a tape recorder that Joseph Heller had given him. He cleared up a few points that were on his mind and then went back to bed. Later that week, Willie Morris brought Jones a poem that he wanted read at his funeral, Yeats's "Lake Isle of Innisfree." "Slowly," Morris remembered, "in the familiar gruff voice, he read it aloud." That was his last full day. When he died, Morris and Matthiessen were there to make final arrangements. His friends—Morris, Matthiessen, Knowles, Capote, Heller, Vonnegut, Shaw—were bereft.

Another Bobby Van's regular was Truman Capote, who also had a place in Sagaponack. Morris described running into him one Saturday afternoon in Bridgehampton: "An enormous Buick with a small man, so small that his nose barely rises above the dashboard, as in the 'Kilroy Was Here' drawings of World War II, stops before me. 'Hop in and let's ride around and *gossip*.'" Morris jumps in. "We are around the block and toward the ocean. Finally we are traveling in long widening circles about the dunes and potato fields." Gesturing wildly and driving recklessly, Capote tells Morris about lunches at La Côte Basque, the Four Seasons, and the Plaza, and who was there and what famous person is having an extramarital affair.

Capote was not always this exhilarated; Morris reported that Capote "often seemed lost and afraid" and adds that he "drove [Capote] home from Bobby Van's . . . a number of times," as much out of protectiveness as friendship. Still, Capote found at least occasional happiness on the East End. In his foreword to *The Potato Book*, a collection of potato lore and recipes by Myrna Davis, he expressed his delight in his Sagaponack house:

In Fall, when harvesting is done and the tractors are gone from the fields, I amble out through the empty rows collecting small, sweet, leftover potatoes for my larder.

Imagine a cold October morning. I fill my basket with found potatoes in the field and race to the kitchen to create my one and only most delicious ever potato lunch. The Russian Vodka—it must be 80 proof—goes into the icebox to chill. The potatoes into the oven to bake. My breathless friend arrives to share the feast. Out comes the icy vodka. Out comes a bowl of sour cream. Likewise the potatoes, piping hot.

We sit down to sip our drinks. We split open steaming potatoes and put on some sour cream. *Now* I whisk out the big tin of caviar, which I have forgotten to tell you is the only way *I* can bear to eat a potato. Then caviar—the freshest, the grayest, the biggest Beluga—is heaped in mounds on the potato. My friend and I set to. This simple tribute to the fruit of Eastern Long Island farming makes an exhilarating country lunch, fuels the heart and soul and empties the pocketbook.

Some of the potato fields, so beautiful, flat and still, may not be here next year. And fewer the year after that. New houses are steadily popping up to mar the long line where the land ends and the sky begins.

Like so many other East End writers, Capote injected a wistful tone into his celebration of this special world. What would he say now if he looked out across his potato field to see dozens of oversized houses?

James Jones, Willie Morris, and Irwin Shaw at a party in East Hampton, July 1976. Photograph by Nancy Crampton.

Howard Kanovitz, Kyle Morris, Larry Rivers, Donald Sanders, and Kenneth Koch (in plane) prepare for THE RED ROBINS, Guild Hall, 1977.

A S THE NUMBER OF ARTISTS in the Hamptons grew in the 1960s and 1970s, their visibility in the community also increased. In 1961, the Museum of Modern Art established a literal beachhead on the shore of Napeague Bay, where the museum's longtime education director, Victor D'Amico, ran an art school in a grounded navy barge. Long Island University opened a campus in Southampton in 1963, with de Kooning, Rivers, Fairfield Porter, Ilya Bolotowsky, and Ibram Lassaw on the art department faculty. In the summers of 1968 and 1969, the college hosted an Artists Theatre Festival, a seasonal incarnation of the project launched in New York City in 1953 by John Bernard Myers, director of the Tibor de Nagy Gallery. Specializing in plays by New York School poets, with décor by their artist friends, the Artists Theatre broadened its scope

for Southampton audiences, mixing adaptations of Ibsen, Nabokov, and Gertrude Stein with new work by James Merrill and Jane Bowles. Among the set and costume designers were Alex Katz, Paul Georges, Robert Goodnough, and Allan D'Arcangelo. Similar experiments were tried at Guild Hall's John Drew Theater, where Kenneth Koch's play *The Red Robins* starred Larry Rivers as a dog and Taylor Mead, a member of the Warhol entourage, as The Slimy Green Thing.

On several occasions, art spilled out of the museums, galleries, and theaters and into the countryside, much to the consternation of the locals. Harking back to the late nineteenth century, when scenic attractions seemed clogged with easels, sunshades, and hordes of bohemian invaders, the artists had become too visible to suit some tastes. In 1965, Allan Kaprow, originator of the Happening, brought his performance-art concept to the Hamptons as "Gas," a series of events unified only by the involvement of helium, compressed air, bubbles, and other gaseous elements. Over Independence Day weekend, Kaprow orchestrated a parade of rolling oil drums, giant balloons, and hovercraft at the Southampton train station; an event on an ocean beach; a car-painting contest for local children; and the conversion of the South Ferry to Shelter Island into a floating laundromat. The Happening climaxed at the East Hampton town dump, where scores of volunteers deployed more oil drums in a sea of firefighting foam, courtesy of the volunteer fire department. Explaining the method behind his madness, Kaprow maintained that his art was both a mature examination of the world around him and an expression of his inner child. Harold Rosenberg opined that it was merely a natural progression from action painting, with its emphasis on process rather than product. Public reaction was mixed, ranging from wild enthusiasm through bewilderment to downright disgust.

Performance art was in the air during the late 1960s, when actress and Off-Off-Broadway producer Gaby Rodgers staged a series of theatrical events in friends' backyards. On various occasions, painter Syd Solomon and writer Robert Alan Aurthur were drafted as hosts, with artists as cast, crew, costume designers, and sometimes writers and directors. Production values were minimal and technical mishaps frequent, but the audience was generally enthusiastic, especially when confronted by such apparitions as Viva, the Warhol "superstar," in the late stage of pregnancy, and Dwight Macdonald, the anarchist and cultural critic, in drag. An especially memorable evening at the Solomon house, in July 1969, celebrated Neil Armstrong's first step on the moon, re-enacted by an ersatz astronaut who sprayed the crowd with a hose mounted between the legs of his improvised space suit. "The thing about artists as actors and/or playwrights," Aurthur observed, "is it's like an octogenarian dentist who tap dances on TV: people applaud wildly simply because he's doing it." The neighbors tended to be less tolerant.

ARTISTS & WRITERS SOFTBALL

It began as a pickup backyard softball game in Three Mile Harbor—probably on a summer Sunday in 1954, although a date as early as 1948 has been suggested. It has evolved into a popular East Hampton charity event that pits a loosely defined group of "artists" against an equally generic "writers" team, both liberally seasoned with celebrity ringers from Broadway, Hollywood, and Wall Street. In the early days, however, such rivalry was unknown, for the game's only writer was Harold Rosenberg, the pitcher, whose limp prevented him from fielding or running the bases. Howard Kanovitz was behind the plate, and the other competitors included Franz Kline, Ludwig Sander, David Slivka, Phillip Pavia, and Willem de Kooning, who always participated, according to Pavia, "despite the fact that he was a lousy player." Pavia, a burly sculptor with a mean swing, took the game seriously—far too seriously, in the eyes of some of his fellow players. Kline, de Kooning, and Sander put their heads together and came up with a punishment that fit the crime. One Sunday they arrived at the game with

several grapefruit, which they had painted to resemble softballs, and persuaded Rosenberg to pitch them to Pavia. As one journalist described the highly effective strategy, "three times the unsuspecting batter swung and connected, only to be spattered by a cloud of finely shredded organic matter and a shower of juice." The camouflaged grapefruit became a staple of all subsequent artist-writer softball games until 1972, when it made its final appearance as a pitch to George Plimpton by the artist Herman Cherry, a veteran of its first outing.

A redefinition of the term *writer* occurred in the 1980s. Originally the writers had declared anyone who earned a living by writing eligible for their team. But a poet objected, arguing that no poet makes a living writing. The rule was changed to include "those whose involvement in writing constitutes a significant part of their life." In recent years the writers' side of the scorecard has included Kurt Vonnegut, Jay McInerney, Ken Auletta, and Ben Bradlee, as well as such interlopers as Ken Burns, Peter Jennings, and Paul Simon.

Franz Kline (left) watches Willem de Kooning bat in an early softball game, ca. 1954. The catcher is Howard Kanovitz.

Stills from Gordon Hyatt's CBS television program, "What I Did on My Vacation," documenting Allan Kaprow's 1965 Happening, GAS.

TOP ROW: Kaprow as Neutron Kid on a hovercraft at the Southampton train station, leading a parade of white balloons and empty oil drums.

MIDDLE ROW: Oil drums and firefighting foam deployed at the East Hampton town dump.

BOTTOM ROW: Charles Fraser's inflatable sky-scraper on an ocean beach; in East Hampton's South End Cemetery, producer Gordon Hyatt (LEFT) questions Kaprow about the Happening; critic Harold Rosenberg weighs in on the subject.

The following year, East Hampton Village decided to restrict parking at Georgica Beach, the artists' favorite hangout. The action appeared to bring to the surface a latent hostility toward the creative community. "I think the whole thing was aimed directly at us, the artists," said Herman Cherry, who saw the move as an attack by conservative residents who felt threatened by the era's permissiveness. A counteroffensive was mounted by William King, organizer of that year's regional exhibition at Guild Hall. King opened the show to "anyone who felt inspired to participate," and liberated it from the cultural center's confines. "Since when does an exhibition include a baseball game, a balloon ascension, a buffet, poetry reading, a house tour, nature walks, painted weeds, [a Happening called] Square Zucchini, and a tea dance?" the *Star* asked its puzzled readers rhetorically, noting that the ten-day series of events, involving a "cast of thousands, artists all," took place at scattered locations from Hampton Bays to Montauk. The controversy intensified at the annual artists and writers' softball game, where $500 was collected for the legal defense fund of Robert Gwathmey, an active critic of the Vietnam War. Gwathmey, who had flown an American flag "defaced" by a peace symbol at his Amagansett home and studio, was being sued by his neighbor, an insurance agent, for desecrating the national emblem. "It is safe to say," Aurthur commented, "that while Peaceniks are in the ascendancy here, the Warniks and Bombniks are in heavy majority." The U.S. Court of Appeals ultimately threw out the state law that declared "customizing" the flag a misdemeanor.

A PROTEST MOVEMENT OF ANOTHER KIND was signaled by the 1963 publication of Betty Friedan's *The Feminine Mystique*. With clear-eyed faith in her own perceptions, Friedan studied the politics of the American family, looking beneath the paternalistic accretions of the past to describe "the problem that has no name": the unhappiness and emptiness of American women's lives. "Millions of women lived their lives in the image of those pretty pictures of the American suburban housewife," she wrote, "kissing their husbands goodbye in front of the picture window, depositing their station wagonful of children at school, and smiling as they ran the new electric waxer over the spotless kitchen floor." As a magazine journalist, Friedan met scores of women who related their dissatisfaction with their children, their houses, or their marriages—though few recognized these complaints as symptoms of a deeper misgiving. "I saw the same signs in suburban ranch houses and split-levels on Long Island and in New Jersey and Westchester County," she reported, and "in colonial houses in a small Massachusetts town; on patios in Memphis; in subur-

ban and city apartments; in living rooms in the Midwest. Sometimes I sensed the problem, not as a reporter, but as a suburban housewife, for during this time I was also bringing up my own three children in Rockland County, New York."

The Feminine Mystique appeared just as the myth of female domestic happiness was showing signs of unraveling. Friedan's detailed descriptions of the actual unhappiness of the American housewife became a lightning rod for the nascent feminist movement, which was beginning to fight not only the shackles of women's domestic roles, but all levels of oppression and discrimination. Friedan became a celebrity after her book came out, and is regarded by many as the mother of the feminist movement. She has continued to work as an activist in the cause of women's rights and as a writer, refining and expanding her original ideas.

Friedan began coming to the Hamptons in 1970. At first, as a member of a commune, she rented in a variety of villages—Sagaponack, Wainscott, East

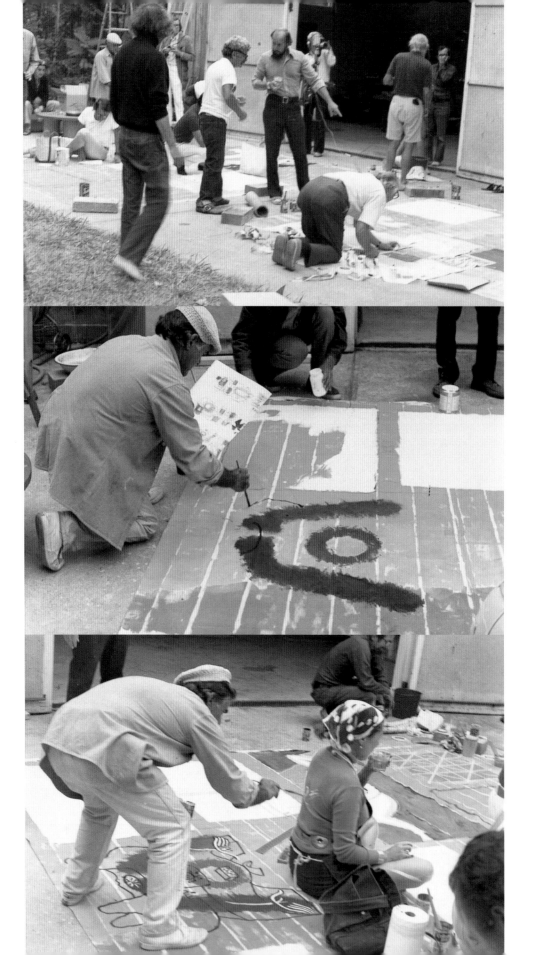

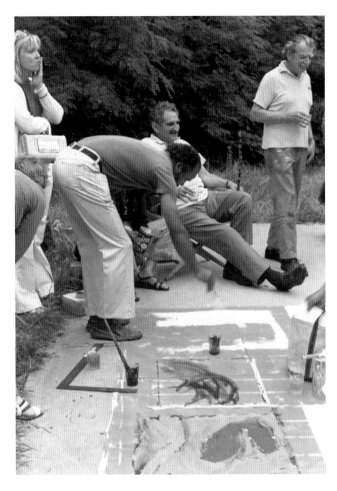

Artists working on a mural to benefit George McGovern's presidential campaign, 1972. Among the crowd are John Opper (painting at top left), Constantino Nivola (in yellow beret), James Brooks (in blue shirt), and Harlan Jackson (painting above). Photographs by Felicia Rosshandler.

Hampton. When the commune broke up in the mid-1970s, she found the house she wanted, in Sag Harbor, on the first day of her search. Friedan eventually became a leader in the formation of the Sag Harbor Initiative, which brought together black and white residents to discuss political and social issues of common interest in an effort to create understanding and overcome the barriers to social justice in the community.

After all that happened after the publication of *The Feminine Mystique*—the marches, the formation of the National Organization for Women, the lectures and books—Friedan is still surprised by what she has wrought: "I had no idea that my book would start a revolution," she noted in her memoir *Life So Far.* "But I did understand that what I had figured out—that the feminine mystique was no longer a valid guide to women's lives, that it was *obsolete*—implied monumental social change."

Activism on the East End extended to national politics during the 1972 presidential election, when George McGovern challenged Richard Nixon on an antiwar platform. Writer David Myers and painter Herman Cherry decided to invite their artist friends to create a huge composite canvas that would be auctioned to raise funds for the McGovern campaign. On August 18, forty-four participants along with family, friends, and the media gathered for an outdoor painting session on a concrete pad behind the Springs studio of the late Wilfrid Zogbaum, where two large canvases were laid out. Some artists chose to work in situ, while others brought or sent prepainted panels that Cherry glued to their assigned spaces. In the next day's *New York Times*, art critic John Canaday reported that the artists "staked their claims to choice spots like homesteaders in a land rush. By 4:30, the canvases were literally crawling with painters, and latecomers were jockeying for places." De Kooning strolled over from his studio next door and contributed a freehand figure sketch that carelessly encroached on the space reserved for Louis Schanker, who promptly drew a border around his image, partly obscuring the de Kooning. Fisticuffs were narrowly averted. The afternoon's antics were videotaped by Larry Rivers, who was "modeling a floppy beret improvised from a pair of women's panties, pale blue with a dainty floral pattern."

The finished work, which required a third section to accommodate all the contributions, was auctioned in Manhattan for an undisclosed sum (actually $15,500), which was donated to the McGovern campaign. The winning bid was made by Guild Hall's director, Enez Whipple, on behalf of collector and art patron Eloise Spaeth, who gave the so-called Artists' Mural to the museum, which thereby acquired a ready-made regional group exhibition. With the notable exception of the Pop contingent, who were not invited to contribute, the mural represents the spectrum of the art community at that time, from traditional figure studies by Alexander Brook and Warren Brandt and landscapes by Jane Freilicher

KEY TO THE ARTISTS MURAL

LONGO	FLORENCE GRIPPE	YEKTAI

and Ralph Carpentier, to James Brooks's gestural abstraction, Perle Fine's minimal grid, and Ilya Bolotowsky's neo-plastic geometry.

As the range of Artists' Mural contributors evidenced, by the 1970s the art community in the Hamptons had become large, diverse, and firmly established. Yet not everyone greeted this expansion with approval, and not all the dissenters were among the Old Guard. In fact, some insiders believed that the colony had lost its identity. Harold Rosenberg, one of Abstract Expressionism's key theorists and a Springs resident since 1944, detected signs of middle age in the art-world body politic. "A law in the development of all art hangouts," he declared, "is that the artists tend to get submerged by the people they attract. East Hampton has reached the stage of diffusion when artists no longer give it its character." In his view, the proliferation of writers, theater people, musicians, and other creative types—as well as their legions of fans—had made the Hamptons indistinguishable from New York City. "But the most ominous influx in the last few years has been the architects," he warned. "I've always maintained that they were tomb builders."

More of Everything

1980 TO
2000

WHEN THE EAST HAMPTON AIRPORT handled a record twenty thousand flights in 1968, it seemed that the tiny municipal field had reached its saturation point. By the end of the twentieth century, though, the number of takeoffs and landings had jumped to forty-five thousand. This increase in air traffic is a good indicator of the explosive growth that the South Fork of Long Island has experienced over the last two decades. The real estate development that threatens to obliterate the region's rural character is the most visible sign of this growth. Running a close second is tourism, which has been a mainstay of the economy since the Long Island Rail Road reached Bridgehampton in 1870, but is now supplanting farming and fishing as the definitive local industry. The townships of Southampton and East Hampton have enacted parking restrictions, dress codes, and group rental regulations in an effort to control the seasonal influx. Still, Montauk Highway is clogged with cars every summer weekend, and the social calendar is filled with gallery openings, plays, concerts, tennis and golf tournaments, charity fundraisers, and private parties populated by Manhattan migrants.

Inevitably, those who have been on the scene for decades now take a proprietary attitude toward "their" Hamptons, although, as columnist Allen Ellenzweig observed, established and recent arrivals alike understand why others seek the same delights. Chuck Close, who first came to the East End in 1975, appreciated the paradox, remarking that "everyone wants it to expand just enough to the point where he moves in and then, 'Stop!'" Where real estate is concerned, however, that expansion has a direct impact on the artists' and writers' ability to

Ross Bleckner, HOT HOUSE, 1995. Detail; see page 148.

131

afford homes and studios in the area, and also on the landscape that many of them prize, either as subject matter or as psychic breathing space. Despite the aggressive efforts of farmland preservation programs and conservation groups, the agricultural landscape seen in canvases by Robert Dash, Sheridan Lord, and others and described by Capote and Koch is succumbing to residential development. Decrying what he dismissively called the suburbanization around his Bridgehampton home, Dan Flavin moved to a cottage near the ocean in Wainscott, only to find his driveway filled every weekend with the cars of beachgoers trying to avoid the parking fee.

While there had been some mobility in the literary and artistic community during the early years of the real estate boom, as prices rose writers and artists no longer played musical chairs with properties and elected to stay put, grateful to have moved to the area at the right moment. The houses they purchased provided insulation from the weekend and summer crowds, and many became more reclusive, appearing primarily at cultural and literary events that had been organized for them by others.

But the area's growth also had beneficial effects on the creative community. The number of galleries rose from a handful in the 1960s—when the area's two oldest survivors, Clayton & Liberatore and the Elaine Benson Gallery, opened in

Sheridan Lord, JUNE, 1992. Oil on canvas, 15 x 20 inches.

An exterior view of the Dan Flavin Institute, Bridgehampton.

Bridgehampton—to fifteen by the mid-1980s. The pioneering Mary Liberatore, who started her gallery in 1961, recently counted fifty-two places in the Hamptons where art is shown, including two full-fledged museums; a gallery at Southampton College; a permanent installation of Dan Flavin's fluorescent light sculpture, sponsored by the Dia Center for the Arts, in a former firehouse in Bridgehampton; libraries, banks, and community art centers; as well as commercial galleries. And as the number of writers increased, local institutions—notably the Hampton Library in Bridgehampton, Southampton College, and the Rogers Memorial Library in Southampton—began hosting events that brought the region's writers a greater, and more immediate, audience.

IN ONE WAY OR ANOTHER, most of the writers who came to the Hamptons after World War II put down roots. Some purchased houses and made the area their permanent home. Others kept an apartment in New York City and thought of their places in the Hamptons as second homes. A smaller number rented houses along the South Fork during the summer months or off-season. Among this generation of longtime literary residents were Kurt Vonnegut, Joseph Heller, James Salter, and E. L. Doctorow.

Vonnegut—who can often be spotted bicycling near his Sagaponack home, always ready with a warm greeting and smile to strangers who recognize him—is one of the very few East End authors to use the locale specifically in a work of fiction: his 1987 novel *Bluebeard* is set right in the middle of the Hamptons art scene. Deftly satirizing the Abstract Expressionists, Vonnegut makes his hero, Rabo Karabekian, their somewhat ambivalent defender. A refugee and a failed painter, Rabo at least has had both the good fortune to marry a woman with some money and the good sense to have early acquired, at small cost, a large number of paintings by the Abstract Expressionist masters. Visitors to his large East Hampton house are very interested in his collection as well as puzzled by it. Rabo reflects:

> Just as a paid museum guard would have to do, I answer as best I can the question put to me by visitor after visitor, stated in various ways, of course: "What are these pictures supposed to *mean?*" . . .
>
> I may have been a lousy painter, but what a *collector* I turned out to be!

With references to familiar landmarks and very much rooted in the world of the Hamptons, *Bluebeard* is an inside joke with broad appeal. Although it is a very funny book, it clearly articulates the humane values that made Vonnegut a guru of the 1960s counterculture. He is for peace, but he sees man's inhumanity to man everywhere; he is sympathetic to the gullible and outraged by the pompous; he is open to the world but conscious of the bitterness he often finds in it.

SAGG GENERAL STORE

The rialto for this crowd is the pint-sized Sagg General Store, which also serves as a post office. I often run into Kurt Vonnegut on his way to get his morning paper. We stop and chat about the model airplanes with their whiny gnat-buzz engines that fly over our houses on weekends. The model airplane club meets at the Potter Farm and its grass airstrip. We plot our various strategies to knock their planes out of the sky. Kurt's is that he will arrange for a miniature submarine to be settled into his swimming pool so that it can rise up from the depths, fire off its heat-seeking missiles, and then submerge from sight. My fancy is this: I have an English friend who trains falcons; my notion is to get him to bring his birds to Sagaponack, hide them in the hedgerows, and then send them aloft to duel with the model airplanes that the submarine's heat-seeking missiles have missed and spin them out of the sky. Kurt and I whisper on Sagg Main like the conspirators we are."

—George Plimpton, in *The Hamptons*, 1993

Kurt Vonnegut in East Hampton, 1973.
Photograph by Jill Krementz.

Joseph Heller began summering in the Hamptons in the 1970s, but it took a painful personal ordeal to make the area his permanent home. In 1986, while living in Sagaponack, he was struck by Guillain-Barré syndrome, a potentially fatal type of nerve paralysis. During his recovery, Heller married his nurse, Valerie Humphries, moved permanently to East Hampton, and, with Speed Vogel, wrote an account of his terrifying affliction in *No Laughing Matter*.

Heller was one of the Bridgehampton writers—along with James Jones and John Knowles—who had served in World War II and had written a great novel about it. *Catch-22*, published in 1955, became an American classic. Three of Heller's novels were published during his years on the East End: *Something Happened* (1974), *Good as Gold* (1979), and *God Knows* (1984). His last novel, *Portrait of the Artist, as an Old Man*, was published in 2000, a year after his death. Although the text is preceded by the usual disclaimer ("any resemblance," etc.), a reader might assume that Heller is confessing his own ennui when he describes the elderly novelist Eugene Pota searching for the subject of his next work:

Joseph Heller on the beach, 1974. Photograph by Jill Krementz

What next then? . . .

How many naps can a reasonable person take a day—in the late morning, the early afternoon and late afternoon, before dinner, then after dinner on a couch in the living room preceding bedtime—before he fairly judges himself stagnant, moribund?

Heller's death, in 1999 at age seventy-six, left a void in the Hamptons, for he could often be seen at one or the other of his favorite restaurants—the Blue Parrot, in East Hampton, or the café at the Poxabogue golf course—revered as much for his personal charm as for his literary works.

The work of novelist E. L. Doctorow, a Sag Harbor resident, always evokes a vivid feeling of a particular era. His *World's Fair*, published in 1985, conjures up the fantasies of an earlier age. Staged in Flushing Meadow-Corona Park in Queens, just east of and visible from Manhattan, the 1939 New York World's Fair

represented to many a kind of utopian tomorrow, possible and not too distant. To city residents without cars, who knew little of the idyllic resort a hundred miles farther east on Long Island, it was about as close as many of them would get to experiencing the good life.

World's Fair tells the story of Edgar (Doctorow's first name), a second-generation Jewish boy growing up in the Bronx before the world of tomorrow comes into being. Doctorow uses the boy's reaction to the Fair to sketch his coming of age. In his first visit, with a friend and her mother, Edgar is all innocence and anticipation and joy. On his second visit, with his family, who are going for the first time, he is wiser, more sensitive, more aware:

> Even though it was Saturday, the Fair was not as crowded as it had been on my first trip, and with fewer people filling the avenues it wasn't as pretty a place. With fewer people in their dress-up clothes the Fair wasn't as clean looking or as shiny, I could see everywhere

signs of decay. . . . the officials who ran the exhibits seemed less attentive to the visitors, their uniforms not quite crisp. Many empty stroller chairs stood about in banks, their operators in their pith helmets talking to one another and smoking cigarettes. Now the tractor-train horn playing "The Sidewalks of New York" seemed plaintive because so few people were aboard. I hoped my family didn't notice any of this. I felt responsible for the Fair.

In Doctorow's hands, the Fair changes Edgar's perception of the world, igniting in him aspiration and desire. Doctorow's life may be seen as a continuation of Edgar's. To the extent that he feels responsible for the dream of the Fair, for what it represents, Doctorow may himself stand for an entire generation of New Yorkers who were shaped by the vision of the "World of Tomorrow": after

Installation view of the "Poets and Artists" exhibition, Guild Hall, 1982, including work by (LEFT TO RIGHT) Sheila Isham, Syd Solomon, Della Weinberger (sculpture), David Porter, Natalie Edgar, Percival Goodman (sculpture), Leatrice Rose, Elaine de Kooning, Audrey Flack, Darragh Park, and William Tarr (sculpture).

achieving a degree of material success, they (and he) adopted the East End as an idyllic place beyond the city, a place to live out a fully realized existence.

Novelist and short-story writer James Salter, who lives in Bridgehampton, first experienced the East End in the 1950s when he was in the service and stationed at Westhampton. In his 1997 memoir *Burning the Days*, Salter writes, "I saw my first Stanford White houses, and the ocean on every kind of day: frothing with huge waves in the distance; green and veined like marble; calm, with the waves far out and a slow, majestic sound." Thirty years later he came east again, driving from Colorado; when he arrived, "It was the season of bleached telephone poles and hordes of black sparrows perched on the wires. In the afternoon haze the sea burst white where bluefish were feeding. Inland were fields of rye." He had discovered a profound happiness.

Salter has told of the area's literary scene as well as its beauty. In his memoir, he reveals the kindness of the sometimes irascible Irwin Shaw. At a party one night, Shaw saw a writer who, he knew, had just published a book. "I read your book," Shaw told him. "It's a great book. A masterpiece." Years later the grateful writer spoke about this encounter with Shaw and how anxious he had been about his book. "He didn't say it's a good book. He said great. A masterpiece." The book was *Something Happened*, the writer Joseph Heller. Salter admired Shaw's generosity in encouraging the younger writer and was touched by the pleasure Heller took in it.

While novelists like Heller, Vonnegut, and Salter were as widely known as the famous artists who were their neighbors, some felt that the many major poets living in the Hamptons were not getting proper recognition. Jimmy Ernst, who vividly recalled the creative stimulus of interaction in his father's Surrealist circle, proposed an ambitious series of collaborations between poets and artists, culminating in an exhibition at Guild Hall Museum in the summer of 1982. "Poets and Artists" included a few examples from the 1950s, when the New York School painters and poets regularly engaged in such projects; but most of the forty-three works were made for the show. The requirement that the art include some or all of the chosen poem caused misgivings among a few participants, who feared, as Robert Dash put it, "the poem becoming a thing and the painting acquiring speech." But most embraced the concept, and some found it quite exhilarating. One poet spoke for many when she said that the finished work was not as important as the interactive experience, and the artists endorsed Ernst's belief that "the aims of the poet and the artist are essentially the same."

Frank Wimberley,
AUGUST TREES, 1985.
Acrylic on paper collage,
39 x 35¹/₄ inches.

A S *New York Times* ART CRITIC Michael Brenson pointed out in 1982, "the number of artists in the Hamptons has not so much grown as multiplied." For the first time, the artists began to organize formal art associations which, although a common feature of other art colonies, were new to the Hamptons. Three were established within a five-year period. The first, Eastville Artists, had its genesis nearly a decade earlier, when painters from the communities of Sag Harbor Hills, Azurest, and Ninevah Beach began exhibiting together informally. Almost entirely African American, the group included Nanette Carter, Alvin Loving, Frank Wimberley, and Robert Freeman. Like many such associations, its main purpose was to expand artists' exhibition opportunities and raise their profile, without requiring them to subscribe to a particular aesthetic program. Indeed, the battle of abstraction versus representation that had so polarized the earlier generation no longer seemed relevant, and other issues—in particular, access to exhibition space—demanded to be addressed through group action.

One focus of artists' attention was the group exhibitions mounted by Guild Hall and the Parrish Art Museum. By the 1980s, about three hundred artists were submitting their work to Guild Hall's annual members' exhibition, held since 1938, and even more entered the Parrish's juried competition, which traditionally awarded a one-person show as its top prize. Although participation was not limited to area artists, the exhibitions were dominated by local residents, who saw them, and the one-person exhibition especially, as stepping stones along their career path.

In September 1982, the Parrish's juried show became the focus of organized protest. Of the 468 entries it received that year, only 22 were chosen, and the top prize was $500 rather than the coveted solo show. Adding insult to injury, the museum's new administration announced that the juried format would henceforth be scrapped in favor of invitational exhibitions, chosen by its curators—effectively shutting out many participants. Outraged artists picketed the museum, wrote angry letters to the *Southampton Press*, collected some two hundred signatures on a petition to the museum's trustees, and organized a Salon des Refusés at the Art Complex East in nearby Riverhead, where works rejected by the Parrish were installed. As a compromise, the museum agreed to hold alternating annual juried and invitational exhibitions. To clarify the museum's recognition of its artist constituency, a "region council" was established and a series of Beaux-Arts Balls—for which revelers were invited to dress as their favorite works of art—was instituted. The controversy also gave birth to the Southampton Artists, an association that provides its members with both an alternative exhibition venue and a forum for issues affecting the art community.

Community activism was the motive behind the Jimmy Ernst Artists' Alliance, founded in 1984 as a memorial tribute to the painter and advocate for artists' causes, who had suffered a fatal heart attack that February. Based in East Hampton, the group lobbied town officials, who proved sympathetic to several of their proposals, including the use of the Town Hall lawn for sculpture. An outdoor

Poster for the Parrish Art Museum's 1983 Beaux-Arts Ball, showing the previous year's winner for best costume: Rocco Liccardi and friends as Jackson Pollock's LAVENDER MIST.

THE PARRISH ART MUSEUM

THE BEAUX-ARTS BALL
DRESS AS YOUR FAVORITE WORK OF
A R T

DANCE TO THE LIVE MUSIC OF THE EAST THIRTEENTH STREET BAND
FEATURING : HOWARD BROFSKY, PAUL BROWN, HOWARD KANOVITZ,
DAVID C. LEVY, RUTH McFADDEN, LARRY RIVERS,
MYRON SCHWARTZMAN, CHARLIE TOOR & EARL WILLIAMS

SATURDAY, OCTOBER 26TH
FROM NINE PM TO ONE AM

25 JOB'S LANE · SOUTHAMPTON, NY 11968 · 516 283 2118 · TICKETS: $10

Fred Fickera's sculpture BANANA SPLIT, on the lawn of East Hampton's Town Hall, 1987.

exhibition installed there in 1987 occasioned a storm of protest from those who considered it a traffic hazard (drivers on the busy highway slowed to gawk at it), a drain on the public purse (the town was insuring them), and a threat to the traditional character of the village (most pieces were abstract). Protests escalated from furious letters to the *Star* to a petition, signed by 920 residents, demanding the sculptures' removal and the program's cancellation. A public forum was convened, but the protesters were not mollified by assurances that the artists were civic-minded citizens seeking to beautify their community.

Anonymous dissidents took matters into their own hands by leveling Gary Rieveschl's *Temporary Subdivision*, an environmental installation of surveyor's stakes and mown sections of lawn that called attention to land use issues and touched some raw nerves in Town Hall. "Maybe whoever did it was exercising their own form of creative expression, which is sort of right up my alley," said the artist generously as he repaired his damaged piece. But the damage to the public art program was not so easily mended, and it was allowed to die quietly, if not unmourned by the well-meaning artists.

Outdoor sculpture was alive and well in Amagansett in 1982, however, thanks to the dedication of Roger Wilcox, who created an art park called Sculpturesites on his sixteen-acre property that year. At his own expense, Wilcox installed work by Phillip Pavia, Arthur Weyhe, A. C. Mim, Penny Kaplan, and others on the grounds of the home he had shared with his wife, Lucia, the former Surrealist. Open to the public for several summers, Sculpturesites was a labor of love that Wilcox maintained as long as his resources allowed. After his death in 1998, the property was reopened by Lucia's grandson as Artists' Woods, where indoor and outdoor art exhibitions, workshops, and classes are held and Lucia's role in revitalizing the art colony is acknowledged.

On the spacious grounds of The Creeks, Alfonso Ossorio had long pursued an ambitious program of outdoor constructions and environmental installations that complemented his world-renowned collection of specimen evergreens and other rare plantings. Ossorio reportedly discovered the sculptural possibilities of reinforced concrete while building a retaining wall to protect his waterfront property from erosion. From 1970 until his death twenty years later, he used it and other materials to refashion his surroundings into what garden designer Leslie Rose Close (wife of painter Chuck Close) has described as "an enigmatic landscape of contradiction and surprise."

Colorful assemblages of scrap metal, plastic, old tires, driftwood, and other found objects sprouted from the gardens like bizarre plants, while massive painted concrete, brick, and sheet metal structures punctuated the lawns and the shoreline of Georgica Pond. Ossorio often opened this wonderland to visitors, whom he might guide through the grounds in his golf cart, sharing his delight in the unexpected and occasionally shocking them with the sexual explicitness of his imagery. Although much of the work was dismantled when the estate was sold after the artist's death, the Ossorio Foundation in Southampton maintains an extensive archive documenting The Creeks and

Ossorio's fantastic creations there, together with a comprehensive collection of his paintings, sculptures, watercolors, and prints.

With a longstanding commitment to diversity and fond memories of his Signa Gallery experiment in the 1950s, Ossorio was an advisor to the East Hampton Center for Contemporary Art, a nonprofit exhibition space and resource center, which ran an ambitious program of exhibitions and events from 1985 to 1990. The center was conceived and financed by Susan Levin Tepper, an eccentric heiress and artist who modeled it on Manhattan organizations like Artists Space. "It was formed," she said, "to provide exhibition opportunities for emerging artists, including East End artists who have worked for many years and whose work merits wider recognition." With its lively mix of artists from the community and elsewhere, its focus on new and challenging work by rising and established professionals, and a board dedicated to furthering the artists' cause, the center seemed destined to provide a valuable alternative to the museums and commercial galleries. But the untimely death of its founder, and Ossorio's soon after, left it without funds and guidance, and the center closed at the end of its fifth season, having lasted one year longer than Signa.

Ossorio's death in 1990 was a reminder that his generation's influence on the Hamptons was diminishing. However, notwithstanding soaring real estate prices, new arrivals continued to revitalize the art community. After Fairfield Porter's death in 1975, Paton Miller began using his Southampton studio and continues to paint there today. Ross Bleckner bought Truman Capote's former property in Sagaponack and converted it for use as a

The Creeks, aerial
view, ca. 1988.

painter's work place. A longtime tenant at Paul Morrissey's Montauk property, painter and filmmaker Julian Schnabel found his own place nearby—an 1882 shingled cottage, one of the original Montauk Association houses designed by Stanford White, which he is lovingly restoring. Painter David Salle recently moved into a new studio-residence in Sagaponack, and after years of renting in the area, sculptor Keith Sonnier bought a house in Bridgehampton. Lynda Benglis built a soaring sculpture studio in Northwest Woods, where painters Joe Zucker and Harry Kramer are neighbors. Elaine de Kooning had settled there a few years earlier, after reconciling with her estranged husband, Willem, while maintaining her artistic and personal independence. Following her death, the studio was bought by John Chamberlain, renowned for his sculptures made of crushed car bodies; it now belongs to painter Richmond Burton.

ABOVE: April Gornik, CLOUD LAKE, 2000, Oil on linen, 76 x 95 inches.

OPPOSITE, TOP: April Gornik and Eric Fischl, 1997. Photograph by John Jonas Gruen.

OPPOSITE, BOTTOM: Eric Fischl, THE BED, THE CHAIR, TURNING, 2000. Oil on linen, 76 x 108 inches.

In Sag Harbor, Susan Rothenberg turned a nondescript bungalow into an eye-catching home and painting studio complex, which she later passed along to Louisa Chase. The conversion was designed by architect Lee Skolnick, who also renovated property nearby for Eric Fischl and April Gornik and later built the two painters a residence—described in *Vanity Fair* as "a 10,000-square-foot minimalist dream house"—in North Haven. In the village proper, photographer Cindy Sherman is a recent arrival, painter Donald Sultan owns a charming early-nineteenth-century

Ross Bleckner, HOT
HOUSE, 1995. Oil on
canvas, 108 x 72 inches.

RIGHT: Lynda Benglis, CLOAK-WAVE/PEDMARKS, 1998. Bronze, black patina, $85\frac{1}{2}$ x 86 x $42\frac{1}{2}$ inches.

BELOW: Olatz and Julian Schnabel at a Guild Hall opening.

cottage, and sculptor Donald Lipski has a historic house on East Hampton Turnpike, where painter Roy Nicholson built a barnlike studio-residence in the woods outside the village. Earlier, Nicholson shared a Noyac atelier with Dan Welden, a master printmaker, who founded Hampton Editions there in the late 1970s, bringing specialized graphics facilities to the community and encouraging fellow artists to experiment under his guidance.

In the early 1990s, fabric designer Jack Lenor Larsen acquired sixteen acres adjacent to his East Hampton home and built LongHouse, a structure modeled on a Shinto shrine and surrounded by landscaped gardens designed for sculpture installations

LEFT AND BELOW:
The grounds of the
LongHouse Reserve.

OPPOSITE: Robert Wilson's
Water Mill Center, a
former telegraph station
now home to experi-
mental theater projects.

and performances. Open to the public as the Long-
House Reserve, the property hosts changing exhibi-
tions in an indoor gallery and around the grounds, as
well as music, dance, and theater. In Water Mill,
Robert Wilson converted a former Western Union
telegraph station into a laboratory for experimental
theater and innovative design projects. During the
summer months, a small army of staff and students
develops Wilson's concepts and works on his numer-
ous commissions, including theatrical productions
and museum installations, surrounded by the
founder's vast and varied collection of folk art, tribal
objects, and chairs from all cultures.

IN 1986, Robert Long organized and edited *Long Island Poets*, an anthology of the poets of the South Fork. Each poet contributed several poems and a statement describing how his or her work related to the East End. Their comments as much as their poems reveal the vitality of the area as a source of inspiration. Howard Moss catalogued the images the landscape provided him: "cows, barns, horses, a silo, and small mountains in the distance (the Shinnecock Hills) . . . fishing boats . . . strung out in a line . . . trees and the illusion . . . of deep woods." He described how much his poetry owes to "the stars, the birds, to random drives through the countryside, to the bays and beaches."

New York School poets James Schuyler and Kenneth Koch also appear in the anthology. Schuyler's "In January" offers a winter scene, an unusual subject for the poets of the East End:

> The yard has sopped into its green-grizzled self its new year whiteness.
> A dog stirs the noon-blue dark with a running shadow and dirt smells
> > cold and doggy
> As though the one thing never seen were its frozen coupling with the air
> > that brings the flowers of grasses.
> And a leafless beech stands wrinkled, gray and sexless—all bone and
> > loosened sinew—in silver glory
> And the sun falls on all one side of it in a running glance, a licking gaze,
> > an eye-kiss
> And ancient silver struck by gold emerges mossy, pinkly lichened where
> > the sun fondles it
> And starlings of the anthracite march into the east with rapid jerky
> > steps pecking at their shadows.

When Harvey Shapiro was looking through his work to choose a few poems for the volume, he was surprised to find how much the eastern shore had inspired him. "I started coming out to the East End [in 1960]," he wrote, "and spent more vacations either on the north or south forks than anywhere else in my adult life." His poem "At the Shore" re-creates a familiar experience: "The bugs batting against the lamp, the midges, / in an old house, in summer." In "July," he describes the "eastern sky . . . streaked with red" where "linkages of bird song make a floating chain / In a corner of the world, walled in by ocean and sky." Dual elegiac notes creep into "Battlements," a poem on the death of a friend and set at Louse Point. He writes: "Summer eternal, though after we go, / it may all be paved over." And in an earlier work, "Ditch Plain Poem," published in 1976 in *Street Magazine*, Shapiro celebrates a beach in Montauk.

Ditch Plain Poem

To be there when day breaks on the sea's reaches,
The full moon still hung there. At Ditch Plain,
For example, before the surfers appear,
Water over rock and gravel. Shingle sound.
Beautiful enough in this end of July
Drought of fish to make me stand there,
Hungry for a text—in the water, on the sand.
Something to bring back to my desk like
Beach glass or polished stone. I want
My happiness to be visible.
I want to bless this day with meaning.
Let the rest of my life take care of itself
So long as it can hover there.

Harvey Shapiro at a Happening on the beach, 1970s.

In her *Long Island Poets* statement, Grace Schulman, who does much of her writing at her house in Springs, explained that she sees "things of the natural world as metaphors for human deeds and principles." But Schulman is sensitive to everything in her environment. Her poem "American Solitude," published in the *Paris Review*, focuses on the three derelict gas pumps in front of the Springs General Store.

Founded in 1996 by Barbara Stone and Joseph Mintzer and edited by Daniel Stern, *Hampton Shorts: Fiction Plus from the Hamptons and the East End* collects short fiction, poetry, drama, and interviews by and with local writers, both established and novice, with a particular eye toward finding young talent from regional schools. Over the past five years *Hampton Shorts* has published fiction by Linda Wolfe, Joseph Heller, and Diana Chang; plays by Bruce Jay Friedman, Murray Schisgal, and Joe Pintauro; poetry by Harvey Shapiro and David Ignatow; and interviews with Edward Albee and Spalding Gray, as well as the works of dozens of other writers.

David Ignatow, who bought his house in Springs in 1967 because of its proximity to other writers and artists, confessed in *Long Island Poets* an ambivalence about living in the Hamptons. He noted that he often had to resist "the calm and quiet" and "the wonder of the trees, bays, and ocean" to keep in mind "the tension, turmoil, and slaughter of people in the cities and in the Third World." Yet he also admitted to the pleasures he finds there, as well as the place's peace, which he described in "The Bay," published in *Hampton Shorts* shortly before his death in 1997.

American Solitude

"The cure for loneliness is solitude."
 —Marianne Moore

Hopper never painted this, but here
on a snaky path his vision lingers:

Three white tombs, robots with glassed-in faces
and meters for eyes, grim mouths, flat noses,

lean forward on a platform like strangers
with identical frowns scanning a blur,

far off, that might be their train.
Gas tanks broken for decades face Parson's

smithy, planked shut now. Both relics must stay.
The pumps have roots in gas pools, and the
 smithy

stores memories of hammers forging scythes
to cut spartina grass for dry salt-hay.

The tanks have the remove of local clammers
who sink buckets and stand, never in pairs,

but one and one and one, blank-eyed, alone,
more serene than lonely. Today a woman

rakes in the shallows, then bends to receive
last rays in shimmering water, her long shadow

knifing the bay. She slides into her truck
to watch the sky flame over sand flats, a hawk's

wind arabesque, an island risen brown
Atlantis, at low tide; she probes the shoreline

and beyond grassy dunes for where the land
might slope off into night. Hers is no common

emptiness, but a vaster silence filled
with terns' cries, an abundant solitude.

Nearby, the three dry gas pumps, worn
survivors of clam-digging generations,

are luminous, and have an exile's grandeur
that says: in perfect solitude, there's fire.

One day I approached the vessels
and wanted to drive on, the road ablaze

with dogwood in full bloom, but the contraptions
outdazzled the road's white, even outshone

a bleached shirt flapping alone
on a laundry line, arms pointed down.

High noon. Three urns, ironic in their outcast
dignity—as though, like some pine chests,

they might be prized in disuse—cast rays,
spun leaf-covered numbers, clanked, then wheezed

and stopped again. Shadows cut the road
before I drove off into the dark woods.

— Grace Schulman, 1995

David Ignatow.

The Bay

So much of something lying calm,
self-possessed, taking the sun,
the ships, the wind and the gulls,
not letting itself be troubled
or turn upon itself. It is the bay
in its place on the map
and in the world, and it has its work,
to uphold ships and to let the eye
roam across a wide expanse
for a moment of release and calm.

The 1997 edition also featured a historical overview of literary life in the Hamptons by George Plimpton, James Salter, Daniel Stern, and Barbara Stone, from the first meetings of *Paris Review* authors after World War II to the more recent avalanche of writers to the East End. Plimpton, the earliest resident contributing to the issue and the one with the longest memory, was especially informative. Speaking of Irwin Shaw, with whom he had become friends in Paris, he noted that after the writer left Europe he gravitated to the Hamptons "because so many of the people he had befriended and cared for in Paris were all there, most of them living along Sagg Main Street." Plimpton described the last days of Shaw's life, when he had a house in Southampton. "We took care of him, entertained him, went around to see him. It was sad to walk in and see him there playing solitaire," Plimpton recalled. "Hour after hour of solitaire in that marvelous houseBut his eyes would always shine when all the old Paris people would come around."

Sagg Main Street was indeed full of writers. In addition to Plimpton, James Jones, Kurt Vonnegut, Peter Matthiessen, Truman Capote, and John Irving lived there or nearby. Also close by were Joseph Heller, Linda Bird Franke, and Bruce Jay Friedman. James Salter, who had a rental there, commented on the benefit to writers of such propinquity. "Somebody, I think it was Max Ernst, said 'art is produced by groups,'" Salter observed, "and I think the important thing is not that they're here talking about their work to each other but just their existence, just their presence there reinforces and stimulates."

Many of the East End's institutions help to encourage and continue the area's literary tradition, doing for writers what galleries have for artists—providing exposure and access. The Hampton Library in Bridgehampton hosts weekly lectures and readings by well-known writers throughout the summer. Each Friday at five P.M., an audience gathers on the library's lawn to listen to speakers such as Berton Roueché, Lewis Thomas, Betty Friedan, Kurt Vonnegut, and E. L. Doctorow—and those were simply the lineup for the first summer's series.

In 2002, the Bay Street Theatre, located on the Long Wharf in Sag Harbor, enters its eleventh season. During its first decade, the Bay Street afforded audiences more than the typical "straw hat" experience of many summer stages. Taking full advantage of the local talent and its proximity to the New York theater world, the Bay Street has commissioned works by established, resident playwrights, producing their new plays as well as earlier works. Each year it has assembled an admirably eclectic list of offerings—from Jon Robin Baitz's adaptation of Ibsen's *Hedda Gabler*, for example, to a new production in 2001 of Edward Albee's *Seascape*. By doing so, the Bay Street Theatre has responded to the expectations of its sophisticated audience. At the same time, the theater's commitment to local playwrights and its high standards of production have significantly enlarged the cultural world of the Hamptons.

The bookshops of the Hamptons, especially Bookhampton and Canio's, host popular lectures, readings, and signings. Canio's, for more than twenty years Sag Harbor's favorite literary gathering place, is a treasure trove of used and new books, with a box of freebies left outside the front door. Southampton College, where a master's degree program in creative writing is headed by essayist Roger

Lanford Wilson, playwright and winner of the first John Steinbeck Award, center, with Long Island University president David Steinberg and Elaine Steinbeck, 1990.

RAY JOHNSON

Sag Harbor, a community that prides itself on being off the art-world's radar screen, attracted international attention in 1995 when Ray Johnson—founder and sole proprietor of the New York Correspondence School, an ongoing mail-art marathon—leapt from the North Haven bridge. He was last seen backstroking into the frigid waters of Sag Harbor Cove on the night of January 13, a Friday. A precursor of Pop art and an early member of the Warhol circle, Johnson had long before assumed the mantle of "most famous unknown artist in New York." For nearly thirty years, he had lived quietly, like a latter-day Joseph Cornell, in the suburban town of Locust Valley, New York, but maintained close ties to his many artist friends in the Hamptons, where he was a frequent visitor. Far from being unknown, though, his cult following was a kind of Who's Who of celebrities and artists. In addition to his voluminous correspondence, which disseminated his quirky drawings, multiples, and collages, he was widely exhibited and published, and he regularly staged arcane performance-art events that he called Nothings. For reasons that remain unclear, he decided to kill himself, and he chose Sag Harbor as the venue for his carefully orchestrated suicide. Media coverage was extensive, and his death continues to invite speculation, since he was not ill, depressed, or in debt, and he left no note. Johnson's ultimate Nothing remains as enigmatically motivated as his other performances.

Ray Johnson drawing Chuck Close's silhouette, 1982.

Rosenblatt, each year presents the John Steinbeck Award to an East End writer for "contributions to literature and humanity." The honorees make up a distinguished roster, including E. L. Doctorow, Terrence McNally, Betty Friedan, David Ignatow, Wilfrid Sheed, Edward Albee, James Salter, and Dava Sobel. The award is given each May at the Elaine Benson Gallery's annual Meet the Writers Book Fair, which celebrates local writers who have published during the previous year.

Before the 1998 fair, a group of old friends gathered for lunch at Bobby Van's: Peter Matthiessen, Joseph Heller, Shana Alexander, Wilfrid Sheed, and Elaine Benson, who started the fair more than twenty years ago. Benson related how Matthiessen broke the group up with a saying of his father's: "Halitosis is better than no breath at all." Their laughter was testament to the pleasure they took in each other's company.

Today, even as the Hamptons' creative community continues to grow, evidence of the area's artistic history is often in jeopardy. Several former artists' studios—most notably The Creeks, but also those of William Merritt Chase, Childe Hassam, Adolph Gottlieb, Balcomb Greene, Syd Solomon, and Jimmy Ernst—have been converted to private homes. A few, like Robert Motherwell's Quonset hut complex in Georgica, have been destroyed. Before selling the property to Grove Press publisher Barney Rosset in 1952, Motherwell had begun his renowned *Elegy to the Spanish Republic* series in the arch-roofed studio. In spite of his subsequent disaffection with East Hampton, and four productive decades in Provincetown and Greenwich, Motherwell later said, "I did the best pictures of my life there." The people who bought the land in 1985, though, wanted a posh location, not peculiar buildings. Over the protests of architectural historians, who cited it as Pierre Chareau's only work in the United States, and art historians, for whom it was an Abstract Expressionist monument, the house was leveled. The studio came down a few years later. Only a cinderblock cottage that Chareau built for his own use survives, although renovated almost out of recognition.

Robert Dash at Hampton Editions, Noyac, 1982.

While community preservation efforts in the Hamptons have been devoted almost exclusively to the area's colonial, agricultural, and maritime heritage, national attention has focused on its artistic past. Of the area's three National Historic Landmarks (the highest rank a site can achieve), two are artists' homes: the Moran studio and the Pollock-Krasner property. Unfortunately, that status carries with it no federal protection against alteration or destruction, nor does it provide funds for repairs. But with the image of the demolished Motherwell house as a reminder, some artists are taking matters into their own hands. Elizabeth Lamb, widow of the portrait painter Condie Lamb and current owner of the Moran studio, has willed it to Guild Hall. Ibram Lassaw, whose improvisational welded sculptures took Abstract Expressionism into the third dimension, plans to preserve intact his purpose-built working environment in Springs. Elizabeth Strong-Cuevas is making provisions for a monographic museum and sculpture park for her work on her property in Amagansett. Madoo, Robert Dash's complex

of eighteenth- and nineteenth-century buildings in Sagaponack, reflects his longstanding interest in landscape, both as a subject and as a work of art in itself. A few years ago, the artist deeded his property to the Garden Conservancy, a national organization that offers tours on a limited basis and will maintain it in perpetuity. Willem de Kooning's studio, complete with his materials and several late canvases, is being preserved by his estate.

Perhaps the most far-sighted planner was Lee Krasner, who began to think about the fate of her property in the late 1970s. At a time when few people realized the significance of Pollock's move to the country and the profound effect the surroundings had on his work, as well as her own, Krasner saw the need for a memorial that would address those issues. More than that, she believed that the importance of the Hamptons as America's premier art mecca had been eclipsed by its reputation as a playground of the rich and famous. Accordingly, her will established what she modestly described as a "museum and library" to preserve the place where she and her husband created their masterpieces, and to encourage study of the region's history as an art colony. Under the aegis of the State University of New York at Stony

Ibram Lassaw in his Springs studio, 1984.

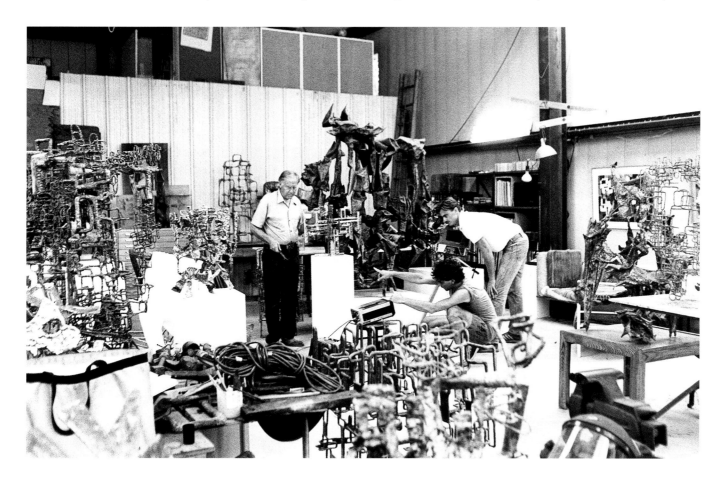

Brook, which took over the site after Krasner's death in 1984, the Pollock-Krasner House and Study Center interprets their property as the locus of their greatest artistic achievements, and maintains a research collection there.

Pollock-Krasner House and Study Center.

The site and its archives proved especially valuable to actor Ed Harris, whose independent feature film, *Pollock*, was released in February 2001. During the project's ten-year gestation, Harris, who played the title role, immersed himself in the artist's milieu, including firsthand experience of his living and working environment. "I even slept in Pollock's bedroom," he told an interviewer, "although I didn't have the epiphany I'd hoped for. I did get a good night's sleep." Harris—who directed the film, coproduced it, and contributed to the script—opted to shoot on the actual location, despite the logistical problems of working on a historic site. His evocation of the artists is remarkably convincing. With his sensitive direction, Marcia Gay Harden in the role of Lee Krasner earned an Academy Award for best supporting actress. But the authentic atmosphere that permeates the resulting footage is nowhere stronger than in Harris's incarnation as Pollock, the painter of "energy made visible"—a performance that earned him an Oscar nomination as best actor.

Pollock is the latest in a long string of attempts to tell at least part of the story of the Hamptons' creative community. Aspects of both Pollock and Krasner have been fictionalized in novels—he in Kurt Vonnegut's *Bluebeard*, she in Sanford Friedman's *A Haunted Woman* and Evelyn Toynton's *Modern Art*, and both (together with many of their contemporaries) in May Natalie Tabak's *But Not For Love*. Stephen Gaines has chronicled The Creeks in *Philistines at the Hedgerow*, John Gruen has cast a wider literary net over the Hamptons art scene in *The Party's Over Now*, and Larry Rivers has washed the colony's dirty laundry in his memoir, *What Did I Do?* In these examples and many more, artists and writers play their parts in the context of their singular social and aesthetic milieu, no less than in their physical environment. Their stories weave together, if not seamlessly, then in parallel and overlapping strands that form the multicolored, richly textured fabric of creative life in the Hamptons—a work in progress, now in its third century.

Marcia Gay Harden and Ed Harris filming POLLOCK at Pollock-Krasner House, April 1999.

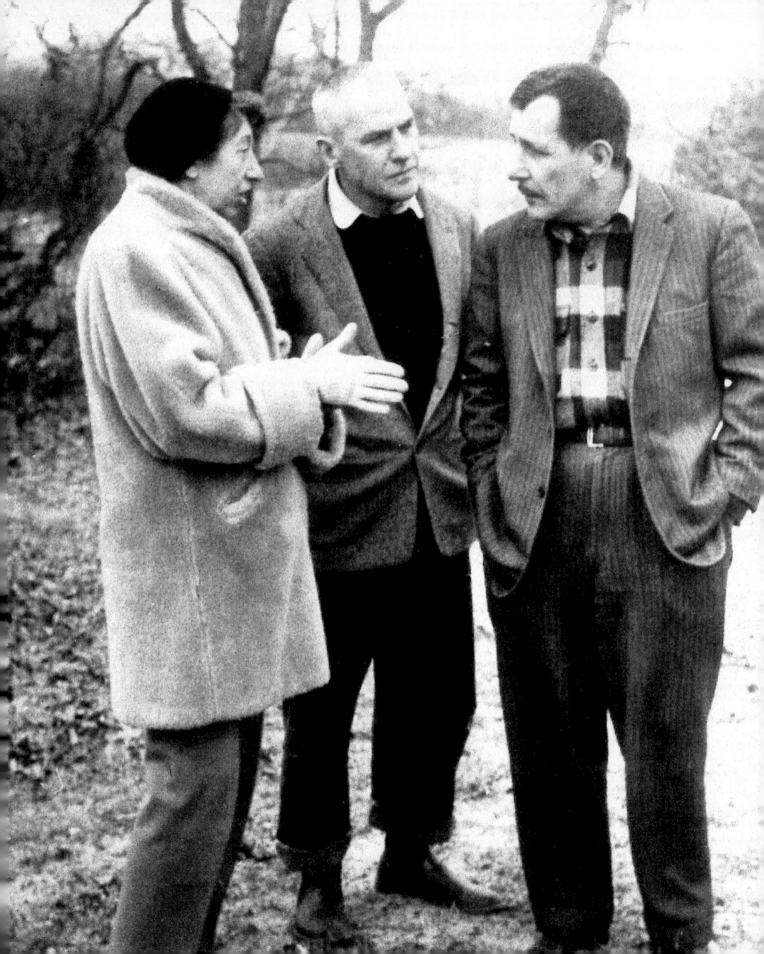

Green River Cemetery

THERE'S NO RIVER, GREEN OR OTHERWISE, in the small graveyard on Accabonac Road in Springs. But however modest its scenic attractions, Green River Cemetery has become the resting place of choice for the East End's artists and writers. Chartered in 1902, the nonsectarian burial ground was originally occupied by Bonackers, mostly members of the King, Miller, Lester, and Parsons clans. That changed in 1956, when Lee Krasner chose Green River, a little more than a mile from the home she had shared with Jackson Pollock, as his final resting place. "I really had no choice in the matter," she explained. "We used to visit the cemetery on walks in the neighborhood, and Jackson many times expressed a desire to be buried there." For a man estranged from his Western roots, ill at ease in the art world, but relaxed and comfortable with the natives of his adopted community, Green River was perhaps the only place Pollock might truly rest in peace.

Ironically, once Pollock became the first resident artist, the art world began to buy up plots nearby. One of the first to join him was the so-called Social Surrealist painter O. Louis Guglielmi, a summer resident of Amagansett and a fellow WPA Federal Art Project alumnus, who died later the same year. "When friends came to help," Guglielmi's widow, Ann, recalled, "I said, 'Put him in that cemetery where Pollock was buried.'" Stuart Davis's widow, Roselle, evidently felt the same impulse, despite the fact that Davis, who died in 1964, never spent time in the Hamptons. "The place is getting so famous that people are dying to go there," quipped Ad Reinhardt in 1967, a few weeks before he became one of the cemetery's permanent tenants.

Lee Krasner, Willem de Kooning, and Franz Kline discuss the placement of Jackson Pollock's gravestone, Green River Cemetery, Spring 1957.

A visitor to Green River will also encounter the tombstones and grave markers of several of the art colony's celebrated couples: critic Harold Rosenberg and his wife, novelist May Tabak; the one-time Surrealist Lucia and her husband, inventor Roger Wilcox; painter Abraham Rattner and his wife, sculptor Esther Gentle; Perle Fine, an abstract painter, and her husband Maurice Berezov, who sidetracked his own art career to foster hers. Krasner, who had bought the entire hummock of land at what was then the cemetery's northwesterly border, joined Pollock there in 1984. Also occupying the original acreage are James Brooks, Martin Craig, Jimmy Ernst, John Ferren, Arnold Hoffmann Jr., Frederick Kiesler, Julian Levi, John Little, Wilfrid Zogbaum, and Alfonso Ossorio, a portion of whose ashes were scattered at The Creeks. Elaine de Kooning, who died in 1989, rests near the old cemetery's southwestern edge, but she does not share the plot with her husband, whom she predeceased by eight years. The story goes that when Willem lived across from Green River in the late 1950s, he would scan the graveyard from his window each morning to reassure himself that Pollock, his onetime rival, was still under the huge boulder that serves as his tombstone.

Plots in the original three-and-a-half-acre burial ground sold out in the 1970s, but the cemetery's management rejected the high-rise style of layered interment as an alternative to expansion. Instead, they acquired an additional acre to the west in 1989 and began selling plots three years later. This new section immediately began to sprout monuments to art world notables, including painter John Opper, conceptual artist Hannah Wilke, and curator Henry Geldzahler. The section also accommodated the wait-listed deceased. Sculptor Johanna

Granite boulders mark the graves of Jackson Pollock (LEFT) and Lee Krasner (RIGHT).

OPPOSITE: Jeffrey Potter (left) and his crew unload Pollock's gravestone, Spring 1957.

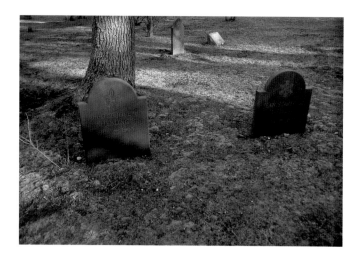
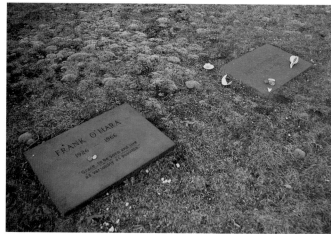
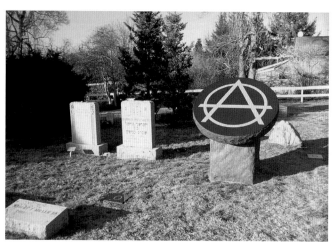
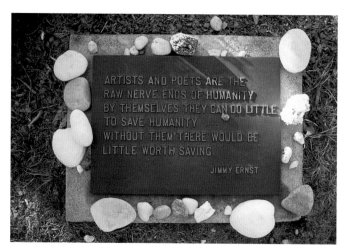

ARTISTS AND POETS ARE THE
RAW NERVE ENDS OF HUMANITY
BY THEMSELVES THEY CAN DO LITTLE
TO SAVE HUMANITY
WITHOUT THEM THERE WOULD BE
LITTLE WORTH SAVING

JIMMY ERNST

Vanderbeek was relieved to have found a resting place for her late husband, Stan, an avant-garde filmmaker, whose ashes she had been keeping since 1984. "His last ego trip was to be buried in Green River," she told the *New York Times*.

Pollock's trailblazing at Green River Cemetery attracted writers, as well. When A. J. Liebling died in 1963, his widow, Jean Stafford, placed his ashes there beneath an austere slate headstone that records his name and dates and bears the inscription "Blessèd—he could bless" and a fleur-de-lis, to honor his love of France. Stafford's own ashes are marked by a similar stone; side by side, these monuments recall the happiness the incongruous pair brought to each other. Nearby lie two longtime friends, Frank O'Hara and Patsy Southgate—their twin slate markers resting flat on the ground. O'Hara's is inscribed with a line from one of his poems: "Grace to be born and live as variously as possible."

CLOCKWISE FROM TOP
LEFT: Grave markers for
A. J. Liebling and Jean
Stafford; Frank O'Hara
and Patsy Southgate;
Jimmy Ernst; and
Alfonso Ossorio, Harold
Rosenberg, and May
Natalie Tabak.

Walking among the graves in the usually deserted cemetery is a reminder both of the rich artistic past of the Hamptons and of a creative tradition that is still vital. The contributions of these artists and writers continue to inspire efforts that express, enhance, and sometimes ennoble the present. Jimmy Ernst's marker echoes this thought with a sobering note of wisdom:

Artists and poets are the raw nerve ends of humanity.
By themselves they can do little to save humanity.
Without them there would be little worth saving.

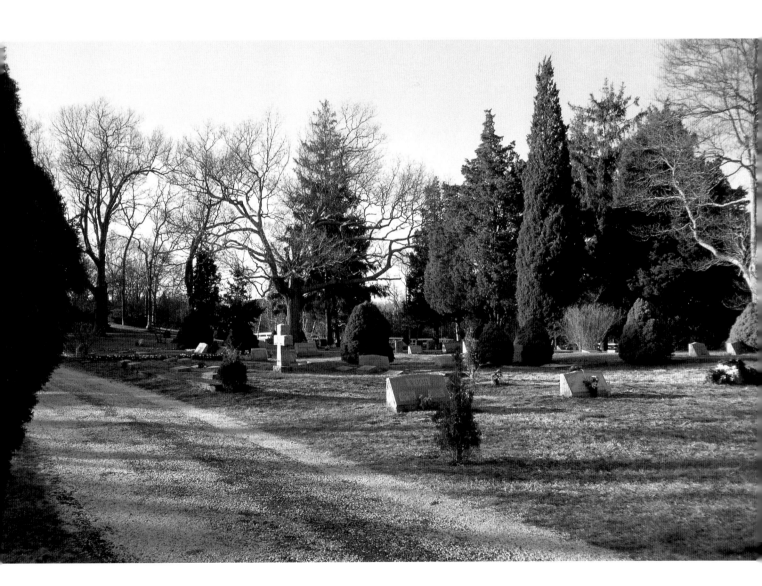

Bibliography

CHAPTER 1: Paumanok Rising

Adams, James T. *History of the Town of Southampton*. Bridgehampton, N.Y.: Hampton Press, 1918.

Allen, Gay Wilson. *The Solitary Singer*. New York: Grove Press, 1955.

Assael, Alyce. *Singular Visions: Long Island Folk Art From the Late 18th Century to the Present*. East Hampton, N.Y.: Guild Hall Museum, 1985.

Beard, James F., ed. *The Letters and Journals of James Fenimore Cooper*. Vols. I, VI. Cambridge, Mass.: Belknap Press, 1960, 1968.

Berbrick, Joan D. *Three Voices From Paumanok*. Port Washington, N.Y.: Ira J. Friedman, Inc., 1969.

Beecher, Lyman. *The Remedy for Duelling*. New York: J. Seymour, 1809.

Bookbinder, Bernie. *Long Island: People and Places, Past and Present*. New York: Harry N. Abrams, 1983.

Brainard, Charles H. *John Howard Payne*. Boston: Cupples, Upham & Co., 1885.

Britton, Barbara, and Ursula Britton. *James Britton (1878–1936): A Sag Harbor Diary*. Privately published, 1999.

Bunce, O.B. "Scenes in Eastern Long Island." In *Picturesque America or the Land We Live In*. New York: D. Appleton & Co., 1872.

Christman, Henry M. *Walt Whitman's New York*. New York: Macmillan, 1963.

Cooper, James Fenimore. *The Sea-Lions: or the Lost Sealers*. New York: James G. Gregory, 1864.

Cooper, Susan Fenimore. "Small Family Memories." In *Correspondence of James Fenimore Cooper*. 2 vols. New Haven, Conn.: Yale University Press, 1922.

Cross, Barbara M., ed. *The Autobiography of Lyman Beecher*. 2 vols. Cambridge, Mass.: Belknap Press, 1961.

Duffield, Samuel Willoughby. *English Hymns: Their Authors and History*. New York: Funk & Wagnalls, 1888.

Finckenor, George A., Sr. *Enjoy Your History*. Sag Harbor, N.Y.: Sag Harbor Whaling and Historical Museum, 1986.

Fitzgerald, F. Scott. *The Great Gatsby*. New York: Charles Scribner's Sons, 1925.

Fordham, Hubbard Latham. Biographical file, East Hampton Library.

Gardiner, Lion. Letter to Governor John Winthrop. Copy in Massachusetts Historical Society Collections, East Hampton Library.

Grossman, James. *James Fenimore Cooper*. Stanford, Calif.: Stanford University Press, 1949.

Hedges, Henry P. *A History of the Town of East-Hampton, N.Y.* Sag Harbor, N.Y.: J.H. Hunt, 1897.

Huntington, Cornelia. "Diary, 1826–27." East Hampton Library.

——. *Odes and Poems and Fragmentary Verses*. New York: A. Huntington, 1891.

——. *Sea-spray: A Long Island Village*. New York: Derby & Jackson, 1857.

James, Thomas. Letter to John Winthrop, November 25, 1667. Transcription of original, East Hampton Library.

Melville, Herman. "Benito Cereno." In *The Heath Anthology of American Literature*. Vol. 1. 3rd ed. Edited by Paul Lauter, et al. Boston: Houghton Mifflin, 1998.

"Mrs. Annie C. Boyd Dies: Historian, Painter, Poet." *Sag Harbor Express*, 20 March 1941, p. 1.

Niles, Nath. (sic). *Samson Occum, The Mohegan Indian Teacher, Preacher and Poet, with a Short Sketch of his life*. Madison, N.J.: privately printed, 1888.

Occum, Samson. "Account of the Montauks." *Collections of the Massachusetts Historical Society*. Vol. 10. Boston: The Massachusetts Historical Society, 1809.

——. "Diary." Special Collections, Dartmouth College Library, Hanover, N.H. Transcription in East Hampton Library.

Overmyer, Grace. *America's First Hamlet*. New York: New York University Press, 1957.

Pennypacker, Morton. "Cost a fortune to redeem first kidnapped maid. Rev. Thomas James in 1654 directed payment of ransom money." Pennypacker Papers. East Hampton Library.

——. "East Hampton's Second Pastor Came in 1696." *East Hampton Star*, 7 July 1933.

Peyer, Bernd. "Samson Occum: Mohegan Missionary and Writer of the 18th Century." *American Indian Quarterly*, Vol. 6, nos. 3–4 (1982), pp. 208–17.

Pisano, Ronald G. *Long Island Landscape Painting 1820–1920*. Boston: Little, Brown and Company, 1985.

Rattray, Everett T. *The South Fork: The Land and the People of Eastern Long Island*. New York: Random House, 1979.

Ringe, Donald A. *James Fenimore Cooper*. New York: Twayne Publishers, 1962.

Reynolds, David S. *Walt Whitman's America*. New York: Alfred A. Knopf, 1995.

Stein, Donna. *Colonial East Hampton 1640–1800*. East Hampton, N.Y.: Guild Hall Museum, 1999.

Stone, Gaynell. "The Material History of the Montaukett." In *Awakening the Past: The East Hampton 350th Anniversary Lecture Series*. New York: Newmarket Press, 1999.

Tatham, David. *Abraham Tuthill: Portrait Painter in the Young Republic*. Watertown, N.Y.: Jefferson County Historical Society, 1983.

Twomey, Tom, ed. *Awakening the Past: The East Hampton 350th Anniversary Lecture Series 1998*. New York: Newmarket Press, 1999.

Walker, Warren S. *James Fenimore Cooper*. New York: Barnes & Noble, 1962.

Whitman, Walt. *Leaves of Grass*. New York: W.W. Norton & Co., 1973.

Wollstonecraft, Mary. *A Vindication of the Rights of Women*. New York: W.W. Norton & Co., 1988.

Wortis, Helen Zunser. *A Woman Named Matilda and Other True Accounts of Old Shelter Island*. Shelter Island, N.Y.: The Shelter Island Historical Society, 1978.

Zaykowski, Dorothy Ingersoll. *Sag Harbor: The Story of an American Beauty*. Sag Harbor, N.Y.: Sag Harbor Historical Society, 1991.

CHAPTER 2: American Barbizon

Adams, Adeline. *Childe Hassam*. New York: American Academy of Arts and Letters, 1938.

Andrews, Marietta M. *Memoirs of a Poor Relation*. New York: E. P. Dutton, ca. 1927.

Atkinson, D. Scott, and Nicolai Cikovsky, Jr. *William Merritt Chase: Summers at Shinnecock 1891–1902*. Washington, D.C.: National Gallery of Art, 1987.

Braff, Phyllis. *Thomas Moran: A Search for the Scenic*. East Hampton, N.Y.: Guild Hall Museum, 1980.

———. *Artists and East Hampton: A 100 Year Perspective*. East Hampton, N.Y.: Guild Hall Museum, 1976.

Bush-Banks, Olivia Ward. *The Collected Works of Olivia Ward Bush-Banks*. Edited by Bernice F. Guillaume. New York: Oxford University Press, 1991.

Cameron, Katharine. *The Moran Family Legacy*. East Hampton, N.Y.: Guild Hall Museum, 1998.

Champney, Lizzie W. "The Summer Haunts of American Artists." *The Century Magazine* XXX:90 (October 1885), pp. 848–60.

Cobb, Irvin S. *New York*. New York: George H. Doran Co., 1924.

De Kay, Charles. "East Hampton the Restful." *The New York Times Illustrated Magazine*, 30 (October 1898), pp. 1–4.

———. "Summer Houses at East Hampton, L.I." *The Architectural Record*, XIII, 1 (January 1903), pp. 21–29.

East Hampton: The American Barbizon 1850–1900. East Hampton, N.Y.: Guild Hall Museum, 1969.

Esten, John. *Childe Hassam: East Hampton Summers*. East Hampton, N.Y.: Guild Hall Museum, 1997.

Fountain, Charles. *The Life and Times of Grantland Rice*. New York: Oxford University Press, 1993.

Geus, Averill Dayton. *From Sea to Sea: 350 Years of East Hampton History*. West Kennebunk, Maine: Phoenix Publishing, 1999.

Harper, William A. *How You Played the Game: The Life of Grantland Rice*. Columbia, Mo.: University of Missouri Press, 1999.

Harrison, Helen A. "Guild Hall and East Hampton: A History of Growth and Change." In *Crosscurrents*. East Hampton, N.Y.: Guild Hall Museum, 1986.

———. "East Hampton's Artists, in Their Own Words." In *En Plein Air: The Art Colonies at East Hampton and Old Lyme, 1880–1930*. East Hampton, N.Y.: Guild Hall Museum, 1989.

Jacobs, Michael. *The Good and Simple Life: Artist Colonies in Europe and America*. Oxford: Phaidon Press, 1985.

Knickerbocker, Cholly. "These Fascinating Ladies." *New York Journal-American*, 8 June 1939.

Laffan, William Mackay. "The Tile Club Ashore." *The Century Magazine* XXIII:38 (February 1882), pp. 481–98.

Laffan, William Mackay, and Edward Strahan. "The Tile Club at Work." *Scribner's Monthly* XVII:33 (January 1879), pp. 401–9.

———. "The Tile Club at Play." *Scribner's Monthly* XVII:38 (February 1879), pp. 457–78.

Lardner, Ring. "A Summer in the Life of a Man Who Mingled." *Hearst International-Cosmopolitan*, June 1929, pp. 76–79.

Miller, James Jr. "America's Epic." In *Whitman: A Collection of Critical Essays*. Englewood Cliffs, N.J., Prentice-Hall, 1962.

Miller, Linda Patterson. *Letters From the Lost Generation*. New Brunswick, N.J.: Rutgers University Press, 1991.

Newton, Francis. "East Hampton, Oldest Art Colony, Exchanges Shows with Newport." *The Art Digest* IX:19 (1 August 1935), p. 14.

Pisano, Ronald G. *The Students of William Merritt Chase*. Huntington, N.Y.: Heckscher Museum, 1973.

———. *The Tile Club and the Aesthetic Movement in America*. New York: Harry N. Abrams/The Museums at Stony Brook, 1999.

Rice, Grantland. *The Tumult and the Shouting*. New York, A.S. Barnes & Co., 1954.

Speed, John Gilmer. "An Artist's Summer Vacation." *Harper's New Monthly Magazine* LXXXVII:517 (June 1893), pp. 3–14.

Todd, Charles Burr, "The American Barbison [sic]." *Lippincott's Magazine* V:22 (April 1883), pp. 321–28.

Whipple, Enez. *Guild Hall of East Hampton: An Adventure in the Arts*. New York: Harry N. Abrams, 1993.

Yardley, Jonathan. *Ring*. New York: Random House, 1977.

CHAPTER 3: Old Guard to Vanguard

Albee, Edward. *The Ballad of the Sad Café: The Play*. Boston: Houghton Mifflin, 1963.

———. *A Delicate Balance*. New York: Atheneum, 1967.

———. *Who's Afraid of Virginia Woolf*. New York: Atheneum, 1962.

Alexander Brook. New York: Salander-O'Reilly Galleries, 1980.

Auchincloss, Louis. *Pioneers & Caretakers: A Study of 9 American Women Novelists*. Minneapolis: University of Minnesota Press, 1965.

Becker, Lloyd. "Two Local Studies by Jeannette Edwards Rattray." *Street Magazine* II, 2 (1976), pp. 39–42.

Benson, Jackson J. *The True Adventures of John Steinbeck, Writer*. New York: Viking, 1984.

Braff, Phyllis. *The Surrealists and their Friends in Eastern Long Island at Mid-Century*. East Hampton, N.Y.: Guild Hall Museum, 1996.

Breton, André. *Young Cherry Trees Secured Against Hares*. Translated by Edouard Roditi. Ann Arbor: University of Michigan Press, 1969.

Clemente, Vince, ed. *Paumanok Rising*. Port Jefferson, N.Y.: Street Press, 1981.

———. "John Hall Wheelock: Poet of Death and Honeysuckle." *Long Pond Review*, January 1976.

Cole, William, comp. *The Most of A. J. Liebling*. New York: Simon and Schuster, 1963.

De Salvo, Donna, et al. *Past Imperfect: A Museum Looks at Itself*. Southampton, N.Y.: Parrish Art Museum, 1993.

Drawing on the East End, 1940–1988. Southampton, N.Y.: Parrish Art Museum, 1988.

Ernst, Jimmy. *A Not-So-Still Life*. New York: St. Martin's Press, 1984.

Edwards, Everett, and Jeannette Edwards Rattray. *"Whale Off!" The Story of American Shore Whaling*. New York: Frederick A. Stokes, 1932.

Feldman, Alan. *Frank O'Hara*. Boston: Twayne Publishers, 1979.

Goodman, Charlotte Margolis. *Jean Stafford: The Savage Heart*. Austin, Tex.: University of Texas Press, 1990.

Guggenheim, Peggy. *Out of This Century*. New York: The Dial Press, 1946.

Gussow, Mel. *Edward Albee: A Singular Journey*. New York: Simon and Schuster, 1999.

Harrison, Helen A. *David Burliuk: Years of Transition, 1910–1931*. Southampton, N.Y.: Parrish Art Museum, 1978.

———. *East Hampton Avant-garde: A Salute to the Signa Gallery*. East Hampton, N.Y.: Guild Hall Museum/East Hampton Center for Contemporary Art, 1990.

Harrison, Helen A., ed. *Such Desperate Joy: Imagining Jackson Pollock*. New York: Thunder's Mouth, 2000.

Hulbert, Ann. *The Interior Castle: The Art and Life of Jean Stafford*. New York: Alfred A. Knopf, 1992.

Keene, Robert. "Hamptons Past: Rivers' World." *Hamptons*, Labor Day 1991, p. 57.

Kerins, Anabelle. "The Artists." *Newsday*, 4 September 1971.

Kiernan, Thomas. *The Intricate Music: A Biography of John Steinbeck*. Boston: Little, Brown and Company, 1979.

Kingsley, April. *The Turning Point*. New York: Simon and Schuster, 1992.

Koumbaroi: Four Artists of the Shinnecock Hills. Southampton, N.Y.: Fine Arts Gallery, Southampton College, 1990.

Lieber, Edvard. *Willem de Kooning: Reflections in the Studio*. New York: Harry N. Abrams, 2000.

Liebling, A. J. *Liebling Abroad*. New York: Playboy Press, 1981.

———. *Liebling At Home*. New York: Wideview, 1982.

Mayo, Lucinda A. "'One of Ours': The World of Jeannette Edwards Rattray." In *Long Island Women: Activists and Innovators*. New York: Empire State, 1998.

Museum of Fine Arts, Boston. *Fairfield Porter: Realist Painter in an Age of Abstraction*. Boston: Little, Brown and Company, 1982.

Parini, Jay. *John Steinbeck*. New York: Henry Holt, 1995.

Pisano, Ronald G. *The Long Island Landscape 1914–1946: The Transitional Years*. Southampton, N.Y.: The Parrish Art Museum, 1982.

Polizzotti, Mark. *Revolution of the Mind: The Life of André Breton*. New York: Farrar, Straus and Giroux, 1995.

Porter, Anne. *An Altogether Different Language: Poems 1934–1994*. Cambridge, Mass.: Zoland, 1994.

Potter, Jeffrey. *To a Violent Grave: An Oral Biography of Jackson Pollock*. New York: G. P. Putnam's Sons, 1985.

Rattray, Everett T. *The Adventures of Jeremiah Dimon: A Novel of Old East Hampton*. Wainscott, N.Y.: Pushcart, 1985.

———. *The South Fork: The Land and the People of Eastern Long Island*. New York: Random House, 1979.

Rattray, Jeannette Edwards. *East Hampton History*. Garden City, N.Y.: Country Life, 1953.

———. *Perils of the Port of New York: Maritime Disasters from Sandy Hook to Execution Rocks*. New York: Dodd, Mead, 1973.

———. *Ship Ashore! A Record of Maritime Disasters off Montauk and Eastern Long Island, 1640–1955*. New York: Coward-McCann, 1955.

———. *Up and Down Main Street*. East Hampton, N.Y.: The East Hampton Star, 1968.

Robbins, Ken, and Bill Strachan, eds. *Springs: A Celebration*. East Hampton, N.Y.: Springs Improvement Society, 1984.

Roberts, David. *Jean Stafford*. Boston: Little, Brown and Company, 1988.

17 Abstract Artists of East Hampton: The Pollock Years, 1946–56. Southampton, N.Y.: Parrish Art Museum, 1980.

Sokolov, Raymond. *Wayward Reporter: The Life of A. J. Liebling*. New York: Harper & Row, 1980.

Southgate, Patsy. "The Eastern Long Island Painters." *The Paris Review* No. 21 (1959), pp. 104–8.

Spring, Justin. *Fairfield Porter: A Life in Art*. New Haven, Conn.: Yale University Press, 2000.

Stafford, Jean. *The Collected Stories of Jean Stafford*. New York: Farrar, Straus and Giroux, 1969.

Steinbeck, Elaine, and Robert Wallsten, eds. *Steinbeck: A Life in Letters*. New York: Viking, 1975.

Steinbeck, John. *Of Mice and Men*. New York: Covici-Friede, 1937. New York: Penguin, 1993.

———. *Travels with Charley: In Search of America*. New York: Viking, 1962.

———. *The Winter of Our Discontent*. New York: Viking, 1961.

Swanberg, W. A. "The Spies Who Came in from the Sea." *American Heritage*, Vol. XXI, No. 3 (April 1970), pp. 66–69, 87–91.

Tanner, James. "East Hampton: The Solid Gold Melting Pot." *Harper's Bazaar*, August 1958, pp. 96–97, 144, 146.

Valjean, Nelson. *John Steinbeck: The Errant Knight, an Intimate Biography of His California Years*. San Francisco: Chronicle Books, 1975.

Waldman, Diane. *Willem de Kooning in East Hampton*. New York: The Solomon R. Guggenheim Museum, 1978.

Wolfe, Judith. *Willem de Kooning: Works from 1951–1981*. East Hampton, N.Y. : Guild Hall Museum, 1981.

CHAPTER 4: Pop Go the Hamptons

"A Region-Full of Artists." *East Hampton Star*, 10 September 1970, p. 1.

Artists' Theatre Festival. *Annual Program*. Southampton, N.Y.: Southampton College of Long Island University, 1968, 1969.

Ashbery, John. *Selected Poems*. New York: Viking, 1985.

Aurthur, Robert Alan. "Hitting the Boiling Point, Freakwise, at East Hampton." *Esquire*, June 1972, pp. 94–96, 200–218.

Barnes, Clive, ed. *Best American Plays, Eighth Series, 1974–1982*. New York: Crown, 1983.

Capote, Truman. *A Capote Reader*. New York: Random House, 1987.

Garson, Helen S. *Truman Capote*. New York: Ungar, 1980.

Clarke, Gerald. *Capote: A Biography*. New York: Simon and Schuster, 1988.

Doctorow, E. L. *Ragtime*. New York: Random House, 1975.

———. *World's Fair*. New York: Random House, 1985.

Gifford, Mary-Elizabeth. "A Montauk Barn Becomes Edward Albee's Creative Haven." *East Hampton Star*, Summer Books, 22 May 1986.

Glueck, Grace. "Artists Follow Sun to the Hamptons and Followers Follow Artists." *The New York Times*, 16 August 1965, p. 24.

Friedan, Betty. *The Feminine Mystique*. New York: Norton, 1963.

———. *The Fountain of Age*. New York: Simon and Schuster, 1993.

——. *Life So Far*. New York: Simon and Schuster, 2000.

——. *The Second Stage*. New York: Summit, 1981.

Harrison, Helen A. *Silkscreen: Arnold Hoffmann Jr. and the Art of the Print*. Stony Brook, N.Y.: The Museums at Stony Brook, 1995.

Heller, Joseph. *Catch-22*. New York: Simon and Schuster, 1961.

——. *Now and Then: From Coney Island to Here*. New York: Alfred A. Knopf, 1998.

——. *Portrait of an Artist, as an Old Man*. New York: Simon and Schuster, 2000.

Horowitz, Daniel. *Betty Friedan and the Making of The Feminine Mystique*. Amherst, Mass.: University of Massachusetts Press, 1998.

Heller, Joseph, and Speed Vogel. *No Laughing Matter*. New York: Putnam, 1986.

Hyatt, Gordon, producer. "What I Did on My Vacation." Eye on New York, CBS Television, 1965.

Jenkins, McKay, ed. *The Peter Matthiessen Reader*. New York: Vintage, 2000.

Knowles, John. *Double Vision: American Thoughts Abroad*. New York: Macmillan, 1962.

——. *A Separate Peace*. New York: Macmillian, 1960.

——. *Spreading Fires*. New York: Random House, 1974.

Morris, Christopher D., ed. *Conversations with E. L. Doctorow*. Jackson, Miss.: University Press of Mississippi, 1999.

Morris, Willie. *James Jones: A Friendship*. Garden City, N.Y.: Doubleday, 1978.

——. *New York Days*. Boston: Little, Brown and Company, 1993.

Moss, Howard. *Selected Poems*. New York: Atheneum, 1971.

Naylor, Natalie A., and Maureen O. Murphy, eds. *Long Island Women: Activists and Innovators*. Interlaken, N.Y.: Empire State, 1998.

Perloff, Marjorie. *Frank O'Hara: Poet Among Painters*. New York: Braziller, 1977.

——. *Truman Capote*. New York: Doubleday, 1997.

Rivers, Larry, with Arnold Weinstein. *What Did I Do? The Unauthorized Autobiography*. New York: HarperCollins, 1992.

Salter, James. *Burning the Days: Recollection*. New York: Random House, 1997.

Schulberg, Budd. *Love, Action, Laughter and Other Sad Tales*. New York: Random House, 1989.

Schuyler, James. *Collected Poems*. New York: Farrar, Straus and Giroux, 1993.

——. *Selected Poems*. New York: Farrar, Straus and Grioux, 1988.

"The Summer Place." *Time*, 14 August 1964, p. 46.

The Victor D'Amico Institute of Art/The Art Barge. *Annual Bulletin*. Summer 2000.Vonnegut, Kurt. *Bluebeard*. New York: Delacorte, 1987.

——. Foreword to *Love, Action, Laughter*, by Budd Schulberg. New York: Random House, 1989.

"Who's Who: The Hamptons 200." *LI*, *Newsday's Magazine for Long Island*, 2 July 1978.

Wilson, Lanford. *Collected Plays 1965–1970*. Lyme, N.H.: Smith & Kraus, 1996.

CHAPTER 5: More of Everything

Brenson, Michael. "Galleries and Artists Burgeoning in Hamptons." *The New York Times*, 13 August 1982, sec. C, pp. 1, 22.

Close, Leslie Rose. "The Garden." In *Alfonso Ossorio: Congregations*. Southampton, N.Y.: Parrish Art Museum, 1997.

Colacello, Bob. "Studios By the Sea." *Vanity Fair*, August 2000, pp. 138–54.

East Hampton Center for Contemporary Art archives, Pollock-Krasner House and Study Center, East Hampton, N.Y.

Ellenzweig, Allen. "The Art Scene." *Long Island Life*, August 1982, pp. 42–43.

Ferren, Rae. *Eastville Artists*. East Hampton, N.Y.: Guild Hall Museum, 1979.

Gaines, Steven. *Philistines at the Hedgerow: Passion and Property in the Hamptons*. Boston: Little, Brown and Company, 1998.

Guernsey, Otis L. Jr., and Jeffrey Sweet, eds. *The Best Plays of 1995–1996*. New York: Limelight, 1996.

Harris, Edward. Interview with John Anderson. East Hampton, N.Y.: John Drew Theater of Guild Hall, Hamptons International Film Festival, 14 October 2000.

Harrison, Helen A. "Shift on Parrish Show Protested." *The New York Times*, 3 October 1982, sec. LI, p. 23.

——. "With a Nod to the Economy, the Art Market Is Flourishing." *The New York Times*, 23 May 1999, sec. LI, p. 33, 51.

Ignatow, David. *Against the Evidence: Selected Poems 1934–1994*. Middletown, Conn.: Wesleyan University Press, 1993.

Kalb, Jonathan. "Robert Wilson's 21st-Century Academy." *The New York Times*, 13 August 2000, sec. AR, pp. 1, 8.

Klaus, Barbara. "East End Art World: Paint It Competitive." *The New York Times*, 6 July 1986, sec. LI, p. 4–5.

Matthiessen, Rue. "Town Hall Sculpture?" *East Hampton Star*, 29 January 1987, sec. II, p. 5.

——. *The One in the Many: A Poet's Memoirs*. Middletown, CT: Wesleyan University Press, 1988.

McNally, Terrence. *15 Short Plays*. Lyme, N.H.: Smith & Kraus, 1994.

——. *Three Plays by Terrence McNally*. New York: Plume, 1990.

Mills, Ralph J. Jr., ed. *The Notebooks of David Ignatow*. Chicago: Swallow Press, 1973.

Plimpton, George. Introduction to *The Hamptons: Long Island's East End*, by Ken Miller. New York: Rizzoli, 1993.

Revson, James A. "Razing The Roof Where Motherwell Once Lived." *Newsday*, 6 June 1985, sec. III, pp. 4–5.

Shapiro, Harvey. *National Cold Storage Company: New and Selected Poems*. Middletown, Conn.: Wesleyan University Press, 1988.

Silverman, Irene. "Public Pans Art For Its Sake." *East Hampton Star*, 25 June 1987, pp. 1, 28

Suiter, John. "Last Post." *The (London) Independent*. 4 June 2000, pp. 16–20.

Trager, James. "The Making of a Resort." *Seven Days*, 17 August 1988, pp. 16–22.

Weinreich, Regina. "On the East End, Renovations by Schnabel." *The New York Times*, 13 September 1998, sec. LI, p. 2.

Index

Text Credits

Picture Credits

Collection of Mrs. James Abbe Jr.: 20
Archive Photos: 60 right, 125
Art Institute of Chicago: 78–79
© Bettman/Corbis: 54, 59, 60 left, 88, 89
Bowdoin College Museum of Art, Brunswick, Maine, bequest of the
　Honorable James Bowdoin III: 19
© Britton, private collection: 58
Collection of The Broad Art Foundation, Santa Monica, Calif.;
　courtesy Mary Boone Gallery, New York: 130 (detail), 148
Cheim & Read Gallery, New York: 149 top
Photograph by Herman Cherry, courtesy Joan Ward: 162, 165
© Corbis: 37, top
Photograph by Nancy Crampton, © 2002: 109, 118
Culver Pictures: 25, 60 middle
Courtesy DIA Center for the Arts, New York: 133
© Estate of Honoria Murphy Donnelly: 64, 65, 70
Collection of the East Hampton Library: 12, 14 (photo Gary J.
　Mamay), 16 (photo Gary J. Mamay), 17, 21 bottom, 24, 28 (photo
　Gary J. Mamay), 34, 45 bottom, 46
The *East Hampton Star*: 72 top and bottom, 91, 96, 142
Photograph by Patricia Fabricant: 154
Fenimore Art Museum, Cooperstown, N.Y.: 27
Courtesy Eric Fischl: 147
Courtesy Debra Force Fine Art, Inc., New York, and Mr. Sidney
　Bressler, Royal Galleries, Englewood, N.J.: 50
Collection of Bernice Elizabeth Forrest, Colorado Springs, Colo.: 53
Courtesy April Gornik and Danese Gallery, New York: 146
Photographs by John Jonas Gruen: 2–3, 84–85, 94, 147 top
Guild Hall Museum, East Hampton, N.Y.: 10–11, 21 top, 42 (photo
　Gary J. Mamay), 45, top, 47, 48 (photo Jay Hoops), 56 (photo Jay
　Hoops), 62 (photo Noel Rowe), 63 (photo Noel Rowe), 68 (cour-
　tesy Dallas Ernst), 74, 79 (photo by Dave Edwards), 93 (photo by
　Jay Hoops), 101, 110 (photo by Wayne Seese), 113, 119, 126–27
　(photographs by Felicia Rothshandler), 128, 138 (photo Jay
　Hoops), 159
Helen A. Harrison: 160, 161 top and bottom, 164 left and right,
　166 all, 167
Henry Art Gallery, University of Washington, Seattle, Wash.; Horace
　C. Henry Collection: 57
Hirshhorn Museum and Sculpture Garden/ARS: 81
June Kelly Gallery, New York: 140

Courtesy John Jermain Memorial Library, Sag Harbor, N.Y.,
　photographs by Gary J. Mamay: 22, 51
Collection of Howard Kanovitz: 4–5, 115 top, 121
Collection of Barbara and Michael Kratchman: 95
© Jill Krementz: 9, 116, 135, 136, 137
Photograph by Laurie Lambrecht, New York, 151 all
© Estate of Roy Lichtenstein: 102 (detail), 108
© LongHouse Reserve, East Hampton, N.Y.: 150 top and bottom
The Long Island Museum, Stony Brook, N.Y.: 44
Courtesy Sara Matthiessen: 87
© Francis G. Mayer/Corbis: 49
© Thomas D. McAvoy/Timepix: 36, top
Photo by Morgan McGivern: 149 bottom
© Hans Namuth Estate, courtesy Pollock-Krasner House and Study
　Center: cover (detail), 82, 106–7
© 1991 Hans Namuth Estate, Center for Creative Photography,
　University of Arizona, Tucson: 77, 80, 83
National Gallery of Art: 69 (photo Bob Grove), 111 (with ARS)
New Haven Colony Historical Society: 37, bottom
Roy Nicholson: 115 bottom, 157, 158
North Wind Picture Archives: 55
Courtesy Ossorio Foundation, © 2002: 100, 144–45
Courtesy *Paris Review*: 86
Philadelphia Museum of Art, unknown photographer: 66
Picturesque America; courtesy of Constance Denne: 36 bottom
Pollock-Krasner House and Study Center: 76 (photo by Ronald J.
　Stein), 141 (photographer unknown, gift of Rocco Liccardi)
Collection of Helen Rattray, photo Gary J. Mamay: 31
Courtesy Pamela Lord; photograph by John Reed, East Hampton,
　N.Y.: 132
Courtesy Larry Rivers: 98
Collection of the Robert Hull Fleming Museum, University of
　Vermont, Burlington, Vt., Schnakenberg Bequest: 32–33
Collection of the Sag Harbor Whaling and Historical Museum,
　photo Gary J. Mamay: 23
Photos by Ryan Schmitter, courtesy Gordon Hyatt: 122–23
Courtesy Harvey Shapiro: 153
Scribners Monthly, February, 1879, courtesy Sarah Longacre: 40, 41
Southampton College, photo Gary J. Mamay: 156
Collection of Cynthia Grant Tucker; courtesy Sarah Longacre: 38
© Underwood & Underwood/Corbis: 59
© The Andy Warhol Foundation, Inc./Art Resource, N.Y.: 112
Wesleyan University Press: 155
Whitney Museum of American Art/ARS: 104–5
　(photograph by Sheldan C. Collins), 114
Courtesy Jane Wilson: 97
Collection of Ron Ziel: 35

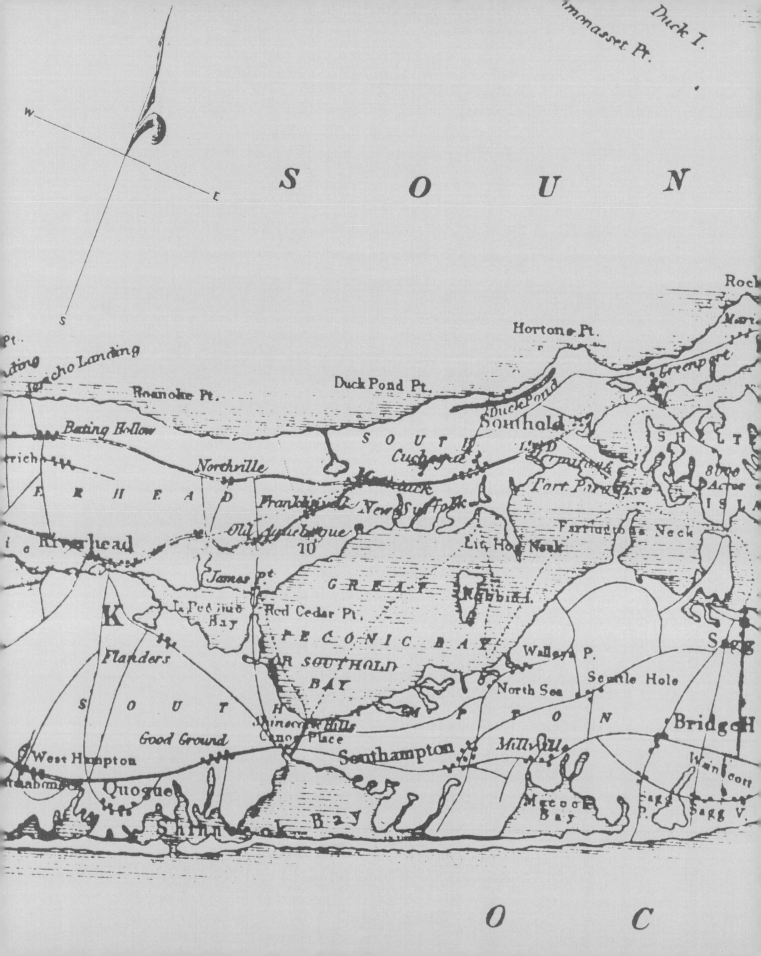